Silks

for Th

and Altars

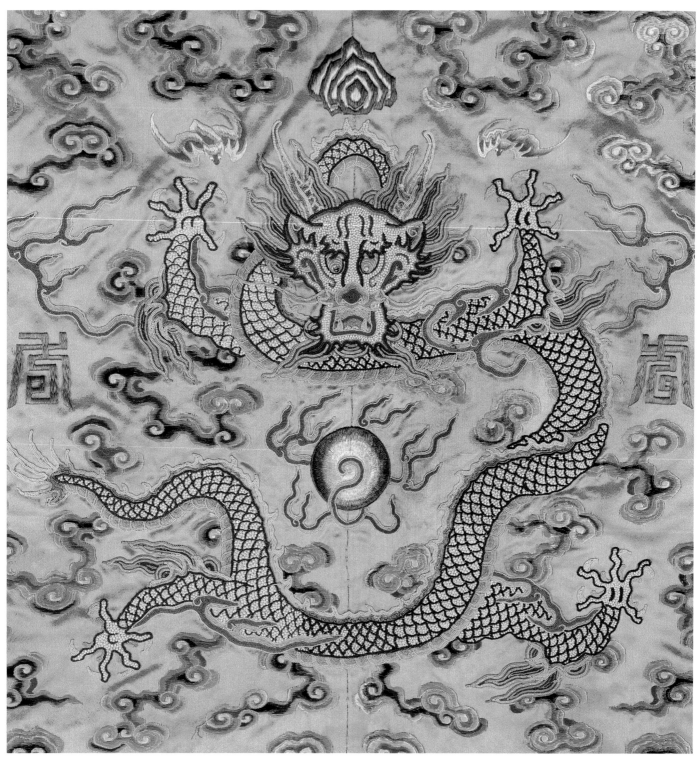

Emperor's Twelve Symbol Robe (detail)
18th century

Silks
for Thrones
and Altars

Chinese Costumes
and Textiles

from the Liao through

the Qing dynasty

by John E. Vollmer

Myrna Myers

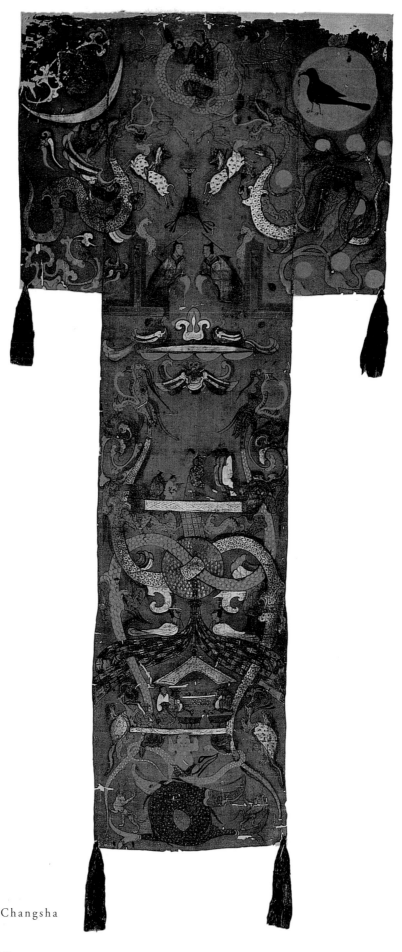

Painted banner,
ink and colors on silk
Tomb no 1, Mawangdui, Changsha
Western Han dynasty,
2nd century BC
Hunan Provincial Museum

Strolling through the Maastricht Fair in 1974, we were struck at first sight of the unusual silks shown by Moke Mokotoff, when textiles from Tibet were beginning to appear in the West. They aroused our curiosity and their rich colors and designs seemed the perfect complement to the subdued palette of classic Chinese porcelain I had been exhibiting. After our initial acquisitions, we found searching for the then little shown Far Eastern silks added to their appeal. Chinese textiles soon became a special if eccentric feature of my gallery.

Inevitably, Krishna Riboud, the Paris-based textile scholar and collector came to see my display. She was just then contemplating the foundation of an Asian textile study center, the AEDTA. She and the AEDTA were thereafter an incalculable encouragement to concentrate on textiles. I was a regular visitor to the Center, became familiar with the collections and attended conferences there. Eventually, Krishna Riboud suggested my contributing an essay on her Chinese furnishing silks for the publication In Quest of Themes and Skills and later entrusted me with the introduction and legends for her album Chinese Buddhist Silks. At the Center or in informal gatherings in her exotic, connoisseur's apartment, Krishna Riboud was a regal presence evoking her future projects in an incense-fragrant atmosphere in which everything seemed possible. It is to her that I owe my initiation into the circle of textile enthusiasts and the beginning of a real apprenticeship in Asian textiles.

Early on, I was fascinated by the idea, discovered in John Vollmer's texts, that the dragon robe might be read as a cosmic vision, since Ming and Qing costumes and costume fragments were at the core of our developing collection. Jean-Paul Desroches, senior curator of Chinese art at the Musée Guimet, further stimulated my interest in dragon robes when he shed an unusual new light on them. In the course of lectures at the Ecole du Louvre on Chinese costume in 1989, he included the 2nd century BC banner of Mawangdui as a symbolic substitute for clothing, pointing out that it even retained the T-shaped cut of a garment. This famous silk is painted with a scene interpreted as depicting the journey of the soul in the afterlife: the defunct, accompanied by mythical creatures, is pictured between the netherworld and the celestial realm. Called a feixi or flying robe, this banner, in the view of Jean-Paul Desroches, might be considered one of China's earliest cosmic image garments and as such prefigured dragon robes of the Ming and Qing dynasties. This suggested link endowed later court robes with a new aura of spiritual significance as heirs to the feixi. Just how the cosmic image coalesced to reemerge in the decor of dragon robes has seemed to me ever since one of the most intriguing aspects of Ming and Qing textile arts.

At the conference of the Hong Kong Textile Society in 1995, we met John Vollmer, author of the first work we had consulted on Chinese costume, the pioneering catalogue In the Presence of the Dragon Throne. *His surprisingly youthful demeanor and good humor belied his impressive academic credentials and his years of curatorial experience. Our paths then crossed often, and in Paris we had several opportunities to examine our collection with him and to discuss an eventual in-depth study. In accepting the project, John Vollmer felt that many of the historical factors influencing later Chinese costume and textile development could be illustrated through our pieces, most of which had never been published. In organizing the material, he also took into consideration my interest in the leitmotif of the reappearance of the cosmic vision in Ming and Qing court costume. We are immensely grateful to John Vollmer for the depth and breadth of this publication, his generous participation in every step of its production, his unfailing patience and his delightful company.*

The achievement of this catalogue and exhibition depended as well on the contributions of other talented professionals: Christophe Ibach, whose elegant touch as graphic designer is visible in each page of this publication; Thierry Prat, a photographer who coaxes the most elusive materials to reveal their secrets in his images; Richard Sheppard for his drawings which Phil Wood of Ten Speed Press kindly gave us permission to use; Marie-Hélène Guelton, whose analysis on structure will prove precious to specialists; Blanchard Printing, whose staff expended considerable energy to assure a publication of museum quality; Françoise Isackson who untiringly prepared and processed innumerable texts; and Béatrice Girault-Kurtzemann, Caroline Turner, Alice Vrinat and Gloria Pinto da Mota, who restored, protected and helped present the silks at the heart of this project.

We would like to acknowledge here the pleasure we have had in knowing our textile colleagues in Paris, London, the United States and Hong Kong and, in addition to those mentioned previously, we want to thank Robert Burawoy, Diana Collins, Marie-Pierre Foissy-Aufrère, Hans Koenig and Zhao Feng, who have each added a silken thread to our story.

MYRNA AND SAMUEL MYERS

Introduction

Silk, jade, bronze, lacquer and porcelain are the materials which gave form to Chinese cultural expression, distinguishing it from other civilizations. Silk, like jade, was present from the beginning of cultural development on the North China plain and exerted a profound influence on the ritual, political and social conduct that came to characterize Chinese aristocratic society. These luxury materials defined notions of refinement and were perceived as embodiments of the virtues established as the ideals of Chinese society.

Jade involved the working of rare minerals extracted from the earth, which at times were transported across vast distances. In contrast, silk was a resource that was locally obtainable and annually renewable. Silk was made from the filament of the cocoons of the *Bombyx mori* moth, which Neolithic farmers domesticated toward the end of the 4th millennium BC, roughly 5000 years ago.[1] During the following centuries, these farmers learned to unwind the hard, durable cocoon filaments to make threads, thus discovering a source of textile fiber unlike any other. By the end of the 3rd millennium BC, silk textiles had become a prerogative of rank and were inextricably linked to the ruling elite.

By the time Qin Shihuangdi founded the first Chinese empire in 221 BC, sericulture had assumed a mythic origin, as a gift from the First Empress, Xilingshi, consort of the legendary Yellow Sovereign, Huangdi.[2] During the Han dynasty (206 BC-AD 220), rites honoring the God of Silk had been incorporated into the cycle of ritual sacrifices conducted by the imperial clan on behalf of the state. As the counterpart to the plowing rituals conducted by the emperor, the empress gathered the principal ladies of the court at an altar north of the capital to make sacrifices and pray for the success of the year's silk production. These state rituals formalized the ancient practices of individual households where private supplications to the silk god continued to be performed well into the 20th century.

Silk is formed of a proteinous substance secreted by the *Bombyx mori* larvae as a viscous fluid. This dries upon contact with the air into a smooth hard filament to form the enveloping cocoon in which the insect passes its pupal stage. It is this continuous filament, at times measuring over 1000 meters in length, that can be unwound to form threads. Since these long reeled threads are smooth and without the

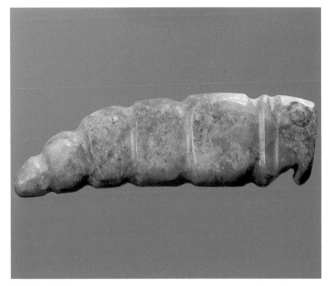

Jade silk worm length 4.7 cm
Western Zhou period

irregularities created by spinning shorter fibers, as in the case of wool, cotton or linen, they reflect light, imparting a remarkable luster. Weavers exploit these reflective properties in weave structures like satin and damask.

Silk filaments are very thin, but extremely durable, possessing tensile strength greater than steel. As a result, weavers can fabricate very thin tissues sheer enough to permit the passage of light. Gauze weaves, created by repeated physical manipulation of threads during weaving, produce a fabric with tiny voids. Air can pass through gauze fabrics, making them ideal for curtains and summer

garments; their translucency adds to their allure, exploiting the tension between modesty and sensuality.

If left to mature, the *Bombyx mori* pupa metamorphoses into a chrysalis, which at maturity excretes an acidic substance dissolving the cocoon wall and emerges as an adult moth. When this occurs, the long filaments are broken and can only be processed for thread by carding and spinning. In this form, known as spun silk, it is not dissimilar

Damask robe (detail) CAT. 8
16th century

from other textile fibers and much less highly valued. The process of stifling the pupa and reeling the silk from the undisturbed cocoon in a continuous length is called sericulture.[3]

Once established, sericulture became a resource of singular importance to the development of Chinese civilization. Among the rural Chinese, silk was a cash crop which supplied money for tax payments for land and for other needs. As a finished textile, silk was a coveted luxury that distinguished the material life and appearance of the ruling elite. At each of the many steps in its production, from

reeled fiber to finished cloth, as well as its sale within China and internationally, silk generated revenues for the state.

The seventy-seven Chinese textiles presented here are arranged and discussed in three groups. The first group consists of clothing and furnishing fabrics made for and used by the ruling elite of China. Regardless of their dates or the ethnic origins of various dynastic rulers, these trappings of nobility served the political and social goals of those in power. Many of the ideas embodied in these pieces can be traced to the very origins of Chinese civilization. However, as this study reveals, the manner of expressing these traditional notions changed over time. The second group contains Chinese silks found beyond the borders of the empire, specifically in Tibet, Japan and Western Europe. The presence of Chinese luxury textiles in a foreign context, whether the result of commerce or diplomacy, affected local ideas of status and prestige. While some exported Chinese fabrics were manufactured to meet foreign tastes, incorporating decidedly non-Chinese notions of design and imagery, others were drawn from reserves of prestige court textiles and sent as tokens of the emperor's largesse. The last group presents textiles made for Daoist and Buddhist liturgical use. Within the Buddhist traditions of Tibet and Japan, secular textiles found new uses without losing the prestige with which they had originally been imbued.

JOHN E. VOLLMER

1 *China, The Maritime Customs* 1917, pp. 46-68; Kuhn 1988, pp. 61-78; Nunome 1973, pp. 74-95; Xia 1972.
2 *Shiji* (Historical Record), 1/2b, 1 in Watson 1961. See Bodde 1975, p. 270.
3 This discovery may in fact have been accidental, since the earliest archaeological evidence for silk is little more than half of a cocoon, probably cut to extract the pupa for food. Indeed in many parts of South and East Asia, various types of larvae continue to supply a source of dietary protein. See Chang 1986, p. 95.

Chronology

Neolithic China
c. 14,000 - c. 2100 BC

Early dynastic period
Xia	c. 2100 - c. 1500 BC
Shang	c. 1500 - 1050 BC
Zhou	1050 - 221 BC

Imperial China

Qin	221 - 206 BC		
Han	206 BC - AD 220		
Three Kingdoms	220 - 280		
Six Dynasties	220 - 589		
Zhou	557 - 581		
Sui	581 - 618		
Tang	618 - 907		
Liao	907 - 1125		
Song	960 - 1279		
Tangut Xia (Xixia)	1032 - 1227		
Jin	1115 - 1234		
Yuan	1279 - 1368		
Ming	1368 - 1644	Hongwu	1368 - 1398
		Jianwen	1399 - 1402
		Yongle	1403 - 1424
		Hongxi	1425
		Xuande	1426 - 1435
		Zhengtong	1436 - 1449
		Jingtai	1450 - 1456
		Tianshun	1457 - 1464
		Chenghua	1465 - 1487
		Hongzhi	1488 - 1505
		Zhengde	1506 - 1521
		Jiajing	1522 - 1566
		Longqing	1567 - 1572
		Wanli	1573 - 1620
		Taichang	1620
		Tianqi	1621 - 1627
		Chongzhen	1628 - 1644
Qing	1644 - 1911	Shunzhi	1644 - 1661
		Kangxi	1662 - 1722
		Yongzheng	1723 - 1735
		Qianlong	1736 - 1795
		Jiaqing	1796 - 1820
		Daoguang	1821 - 1850
		Xianfeng	1851 - 1861
		Tongzhi	1862 - 1874
		Guangxu	1875 - 1908
		Xuantong	1909 - 1911

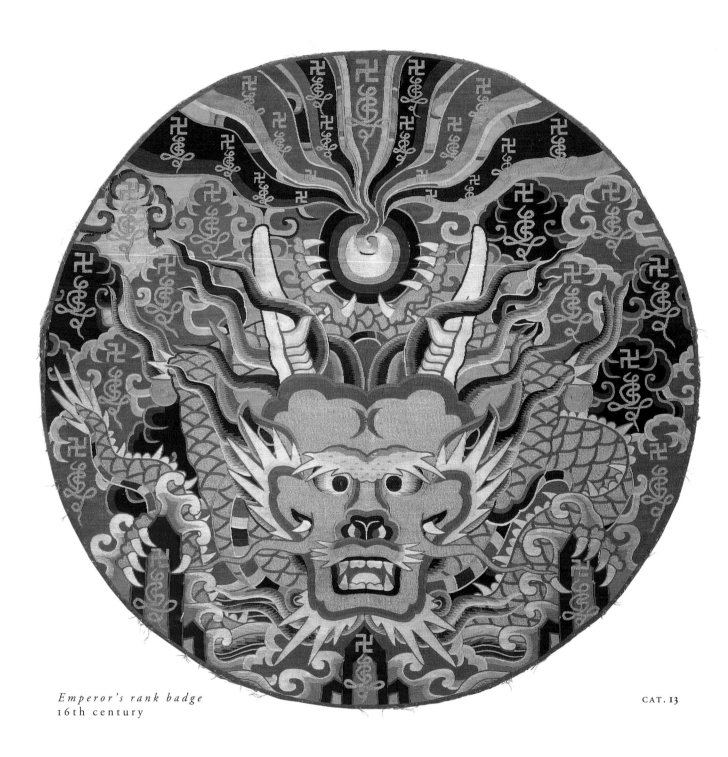

Emperor's rank badge
16th century

Silks for Court and Palace

Using silk to create images of authority

In 221 BC the king of the Qin state completed the conquest of a number of smaller kingdoms on the North China plain and along the Yangtze River. He declared himself Emperor of the Qin dynasty, Qin Shihuangdi, the first Chinese sovereign to claim the imperial title. Although the Qin dynasty was short-lived (221-206 BC), the Han dynasty (206 BC - AD 220) built on its foundations and forged an empire, ultimately extending Chinese control from the Mongolian steppe and Korea in the north to Vietnam in the south and the Tarim Basin to the west. The early Han emperors opened China to international trade, which enriched the empire; they also stimulated domestic economic growth. For example, as mulberry leaves are the sole food of silk-making larvae, the state fostered silk production by encouraging the planting of mulberry trees on the land between fields. Silk became a commodity with a fixed value.[1] Official salaries were set in numbers of bolts of silk textiles and taxes could be paid in specified quantities of silk.[2] Sericulture spread from northeastern China in what is now Shandong, Hebei and eastern Henan provinces, to the south and west to include Hubei and Sichuan provinces.[3]

In contrast to the Qin emperor who attempted to rewrite history by destroying books, the early Han emperors used China's written history selectively to effect change, arguing they were restoring the harmonious order of previous eras. In particular, the Han rulers endorsed works compiled or written by the teacher Confucius or Kongfuzi (551-479 BC), who had lived two and a half centuries earlier. These writings, known today collectively as the Confucian Classics, described and celebrated an idealized period of social stability and peace under the Western Zhou kings (c. 1050-771 BC), which was considered China's golden age.[4]

The Classics provided models for imperial rule. Confucius argued that while a sovereign's power was unquestioned, he was morally obliged to govern for the benefit of all society. Moral authority was expressed through ritual. The *Shujing* (Book of History) noted the significance of proper ritual attire:

From Heaven are the social distinctions with their several ceremonies (li), from us proceed the observances of those five ceremonies, and then do they appear in regular practice! When sovereigns and ministers show a common reverence and respect

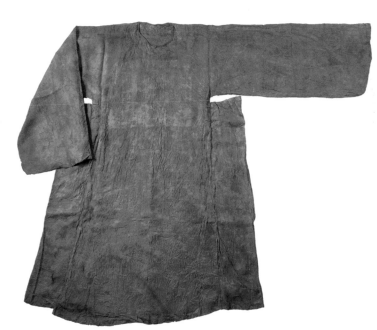

Court rank robe
16th century

CAT. 9

for these, do they not harmonize the moral nature of the people? Heaven graciously distinguishes the virtuous – are there not the five habilements (official robes) and the five decorations on them?[5]

Ritual affected the balance between an unseen heaven and the tangible world assuring social harmony and political stability. According to Zhou royal custom, ceremonial and ritual clothing, together with a rich variety of accessories and furnishings, were regarded as absolutely necessary to maintain the proper hierarchical order in society. The *Zhouli*

(Book of Rites of the Zhou) described the ruler's clothing, listing nine sets of ceremonial attire – six were *mianfu* or sacrificial robes, and three were *pianfu* or ordinary clothes for attending to government affairs, when hunting and in warfare. The official wardrobes of the highest-ranking nobles and ministers were composed of three types of *pianfu*, but they were entitled to only five sets of *mianfu*; and each lesser rank was entitled to one less set of ritual attire.[6]

Kesi *fragment* (detail) CAT. 7
13th century

From the Confucian perspective, proper clothing ensured that virtue was recognized and praised so that commoners would not encroach upon their superiors. As the Han dynasty historian Bangu (d. AD 92) noted, "[T]he ancients used clothing for the purpose of distinguishing between the noble and the common and to illustrate virtue so as to encourage the imitation of good example."[7] Thus, proper clothing contributed to harmony in society, politics and the religious sphere, and supported the civilizing authority of the state.

Color distinguished costumes for specific rituals. Color choices were influenced by the *wuxing* or Five Phases system drawn from the ancient *yin-yang* philosophy.[8] According to this belief, five elements of the universe – earth, metal, wood, fire and water – had direct correspondence to the seasons, directions, musical scales and colors. The natural sequence of colors was black, blue, red, yellow and white. Each succeeding Chinese dynasty would explain its coming to power in terms of the *wuxing* cycle and adopt the color corresponding to its characteristic element. Among its first acts, a new dynasty promulgated edicts to harmonize official robes with the newly adopted imperial color.[9]

Patterns also distinguished Han silk textiles, expressing meaning both through motifs and their arrangements. Motifs included real plants and animals, mythical beasts and celestial symbols, even characters used for written Chinese, all of which were immediately identifiable whether they were woven or embroidered.

Unlike many other textile creators, Chinese designers used oblique or diagonal arrangements of motifs to communicate energy. Needleworkers produced repeating patterns of fantastic animals, floral forms and elaborate hooked scrolls using chain stitch techniques like late Zhou dynasty embroiderers. Contemporary historians noted the link between the linearity of embroidery and drawing, citing the *Liji* (Book of Rites), in which it was stated that painting and embroidery had been united under the same directing office, since whatever was embroidered had to have been painted.[10] This link profoundly influenced technological developments in silk production. It affected both the very exacting drafting of textile patterns and the complex weaving strategies developed to execute them, as well as their precise "readings", embracing the multifaceted meanings that characterize Chinese textile ornament.

Han silk patterns often involved very specific auspicious messages, which were of consequence to both the wearer and the observer. Among the most celebrated of Han textiles were compound warp-faced tabbies woven in brilliant colors with complex, layered patterns, such as the five-color textile excavated from tomb 8 at Niya in Central Asia.[11] Undulating cloud scrolls extend across the fabric against which appear two birds and two animals, including a winged one-horned beast within this landscape-like band. Above are five discs with concentric rings interspersed with eight written characters forming an inscription which has been translated as: "The five planets all appear in the east. This is very auspicious to the central kingdom and the barbarians will be defeated." While this has been interpreted as an imperial wish relating to a Central Asian military expedition in 61 BC,[12] it more likely refers to the group of Central Asian kingdoms that existed on the western border and reflected the extraordinary measures Chinese diplomacy could take during the Han dynasty.

Such Han silk textiles with complex iconography set a standard of deluxe production and contributed to the creation of images of imperial authority, sustaining ritual obligations. They reflected a Chinese vision of the cosmos in which man played a part in upholding a hierarchic and ordered universe, where moral actions of rulers ensured Heaven's benevolence.

The decorative patterns on official robes and furnishing fabrics demonstrated the balance between the terrestrial and celestial realms. The *Shujing* quotes the legendary Emperor Shun:

> [My] ministers constitute my legs and arms, my ears and eyes. I wish to help and support my people; – you give effect to my wishes. I wish to spread the influence [of my government] through the four quarters; – you are my agents. I wish to see the emblematic figures of the ancients, – the sun, the moon, the stars, the mountain, the dragon and the flowery fowl, which are depicted (painted?) [on the upper garment]; the temple cup, the aquatic grass, the flames, the grains of rice, the hatchet, the symbol of distinction (fu) which are embroidered [on the lower garment: – I wish to see] all these displayed with the five colors, so as to form the [official robes]; it is yours to adjust them clearly.[13]

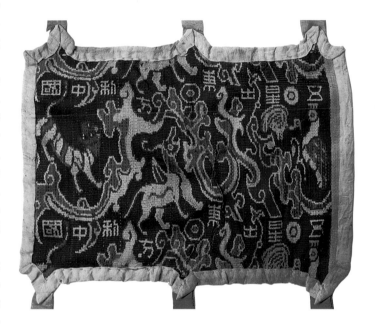

Warp-faced tabby
1st-3rd century

Niya, Xinjiang

Influences from the West modify the imperial image

Over the 350 years following the collapse of the Han dynasty, fourteen different governments claimed the Han imperial legacy. Despite the chaos of the period, during which China lost its monopoly on sericulture, silk continued to play a central role in defining the imperial image and celebrating its prestige. State-sponsored silkworks preserved Han dynasty patterns and techniques.

The non-Chinese Sui dynasty (581-618) reunited North and South China, but it was the Tang dynasty (618-907) that re-established the empire, extending Chinese control into Central Asia. International trade again flourished, opening the way for foreign influences, including new textile patterns and technological innovations from the West. The most celebrated of these foreign textiles featured large roundels with paired animals, birds or human figures enclosed in beaded or pearled medal-

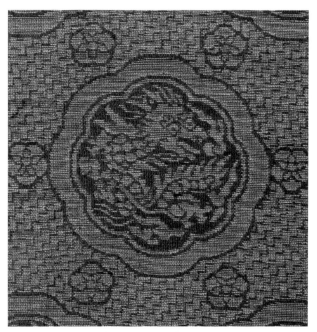

Dragon medallion (detail) CAT. 3
14th century

lions or elaborate rosettes and palmettes. With these fabrics came new ideas about sovereignty and prestige, which modified the image of the Chinese emperor. Formerly Chinese imperial silks and costumes emphasized the ritual obligations of the emperor. These new heraldic patterns confirmed the majesty of the sovereign and the splendor of his court. Medallion or roundel designs with birds and animals came to celebrate rank and status at the Tang court.[14] References to dragon-patterned textiles for the emperor and his family appeared for the first time. Possibly in emula-

tion of the Yellow Sovereign, Huangdi, yellow was prescribed for the emperor's robes.[15]

Initially Tang silk production closely followed Iranian and Byzantine models, but by the 8th century Chinese weavers were producing medallion-patterned textiles with more realistically rendered birds and animals – some paired, others single – in floral or foliate frames.[16] By the 9th century they had developed formal designs of rosettes composed of blossoms, leaves and butterflies. Thereafter, roundel motifs, often widely spaced on an expanse of plain ground fabric, denoted status (see nos. 1, 2, 3, 13, 14, 15 and 16).

These new patterns were only possible because of the drawloom imported from the West with its complex shedding mechanism, which facilitated weaving large-scale, repeating patterns.[17] New weave structures, like samit and other compound weft-faced weaves, compound twills, damask and satin, gradually replaced the older Han dynasty warp-faced compound tabby weaves.[18] In embroidery, the linear chain stitch technique also waned with the collapse of the Han dynasty. It was replaced by a stitch repertory including satin, split, stem and knot stitches seen on Central Asian, Iranian and Byzantine embroideries. Specialized Tang workshops produced spectacular Buddhist needleworks and weavings following iconographic models developed for painting.[19] These textiles, among the oldest examples of *mandala* and *thanka* images in China, became another focus for imperial patronage (see nos. 65, 66, 67, 68, 69 and 70).

Refining the imperial image

Within fifty years of the collapse of the Tang dynasty, the empire was reestablished on a smaller scale by the Song dynasty (960-1279). Under the Song, the focus of the empire, under pressure from Northern invaders, moved south where Confucianism was revitalized and a new civil order emerged emphasiz-

ing a secular viewpoint. A class of professional government administrators eclipsed the power of traditional aristocratic families, who had been largely of military origin. Educated in the Classics and wishing to emulate the Confucian scholarly ideal, this group developed literati culture which stressed in-depth knowledge of Chinese literature and proficiency in calligraphy and ink painting, prizing in particular connoisseurship and anti-quarian tastes.

This shift in cultural emphasis was reflected in silk as well: the bold exotic Tang silks were reconsidered and refined. Patterns were reduced in scale and were more subtle, often relying on texture rather than color for their effect. Song weavers perfected satin weaves based on a variation of twill construction and damask, which uses the face and reverse sides of twill and satin weaves, to produce monochromatic patterns. In the case of satin, where long warp floats create a shiny surface, the reverse is marked by the presence of many short weft crossings that are comparatively dull. By interchanging these two faces in specific areas, a subtle but nonetheless distinct pattern emerges (see nos. 8 and 9).[20]

By the Song period, there existed a rich repertory of decorative motifs and nearly every motif used on textiles could convey multiple meanings. The same motif in different contexts implied different interpretations; for example, a dragon might symbolize the east, the emperor, the *yang* principle or a bride-groom. Each meaning was separate, but all meanings were implied by the presence of one.

Because Chinese words have a single syllable, many words are homophones, sharing the same or similar pronunciations. Orally, meanings rely on context, intonation and placement within a phrase. Despite this, a certain ambiguity exists and verbal puns became a common feature of the spoken language. The written language, on the other hand, is extremely precise, with different characters to

represent each word. The symbolic language of decorative motifs is equally precise, yet it lent itself to verbal puns which worked as rebuses. Pictorial images having the same pronunciation as other words evoked phrases of auspicious wishes for happiness, long life or wealth. Among the most common was the bat, *fu,* the pronunciation of which is the same as the character meaning "abundance" and "happiness". A bat carrying a peach therefore implied wishes for happiness and long life.

Bat rebus (detail)
18th century

CAT. **26**

The organization of motifs communicated meaning. The Chinese were very fond of categories and frequently used them in numbered sets. These sets of symbols reflected the Chinese interest in numerology. For example, the number eight represented phases in the progression of time and space symbolized by the *bagua* or Eight Trigrams. This number was also significant in Buddhism as the Eight-fold Path to Enlightenment. Buddhism used the *bajixiang* or Eight Buddhist Emblems to symbolize elements of the faith (see no. 60). In a similar manner, Daoism paid tribute to

the *baxian* or Eight Immortals, often depicted by their attributes. By the Song dynasty, both Buddhist and Daoist symbols had lost their strictly religious connotations and were used to express wishes for prosperity embodied in a more ancient group called *babao* or Eight Precious Things.

Pairs of images recalled the *yin-yang* dualism fundamental in Chinese thought since the Zhou dynasty. The balance of coexisting negative and positive components

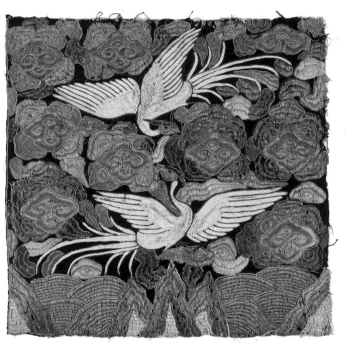

Civil official's badge CAT. II
16th-17th century

implied unity in several ways. For example, the mythical beasts, the dragon and phoenix, could represent the male and female principles, the emperor and empress, the groom and bride, as well as the elements, water and fire.

Song garment construction reflected similar notions of positive and negative contrast. Typically, coats such as those excavated at the tomb of Huang Sheng (d. c. 1234), in Fuzhou, Fujian province, were made of monochromatic patterned fabrics.[21] The external facings, applied as borders to the edges of the sleeves, around the neck and

along the front openings, complemented the floral designs of the main fabrics, but frequently contrasted in color, texture and the scale or density of patterns.

Song dynasty culture revered written language and education; pattern and decoration extended the awareness of the importance of literacy throughout society. Han dynasty silks had expressed wishes literally by weaving in the characters of inscriptions. Song textile designs employed motifs as rebuses which could themselves be read as sentences to express wishes for happiness, wealth, long life and social advancement, introducing another level of sophistication to Chinese pattern-making. The production and marketing of silk textiles expanded dramatically during a period of increased prosperity and population growth. In addition to the imperial workshops, the surpluses of which were often sold to the public, many smaller private factories throughout the empire produced a great variety of specialized silk textiles.[22] The wide distribution of patterned silk textiles carried literati tastes of the court and the educated elite to larger audiences.

Contributions from the North

Northern peoples reigned in China from the 10th to the 14th century. In the 10th century, the Qidan from the Mongolian steppe founded the Liao dynasty (907-1125), followed by the Jurchen, a Tungus-speaking group from what is today Manchuria, who proclaimed the Jin dynasty (1115-1234). Both owed their conquests to their superbly trained cavalry, but the success of their emperors depended on their adopting Chinese-style administration while preserving their nomadic cultural heritage.[23] They used Chinese language and script for official business and the Chinese civil service examination system to determine the best qualified candidates for government appointment. These professional

administrators, who supported the goals of imperial government, claimed access to the ritual and ceremonial trappings of political power. Many of the textiles in this catalogue reflect the need of successive imperial governments to differentiate rank and position within civil and military administrations.

During the Liao dynasty, compound weaves – samit, weft-faced compound twills and complex gauzes – continued to be the principal weave structures. By the 12th century, the use of supplemental wefts in different colors on twill, gauze and tabby weaves, known as brocades, became increasingly popular. Both northern dynasties supported silk workshops to supply ever-increasing domestic and international demand for luxury silks. In such workshops, Han Chinese and Central Asian craftsmen labored beside local weavers exchanging styles and techniques.[24] Initially Tang style roundel or medallion designs decorated prestige textiles, but from the 11th and 12th centuries there were many variations in medallion shapes: round with lobed outlines, three and four petalled shapes, oval, shuttle and tear-drop shapes. These changes reflected the taste for naturalism which characterized Northern and Central Asian art styles, the tradition of the Qidan and Jurchen. Birds and animals were accurately represented on textiles; even their natural settings were suggested (see nos. 4 and 5).

Northern peoples introduced *kesi*, slit silk tapestry weave, into the range of fabrics favored for costume (see no. 7).[25] *Kesi* probably developed first in Central Asia from wool tapestry weaving, which originated further west. The Liao and Jin weavers passed the technique to the Northern Song court, where pictorial tapestry weaving flourished under imperial patronage. The Jin eventually forced the Song imperial court to withdraw to Hangzhou where they coexisted with Jin rule as the Southern Song dynasty (1127-1279), but

in effect the Chinese were vassals, compelled to supply an annual tribute of silver and bolts of silk to the Jin court.[26]

Jin weavers influenced by fabrics from the Iranian world experimented with gold threads (see nos. 2, 3 and 5). Supplementary gold weft threads, either as strips of gilt animal substrate or paper, or as gold strips wrapped around a silk core, enhanced many patterns. In embroidery a variety of gold and gold-wrapped threads could be laid on or

Djeiran *medallion* (detail) CAT. 5
12th-13th century

couched and held by small stitches to a woven ground. Gold leaf could also be printed or painted on textiles (see no. 4).[27] Gold embellishment thereafter became an important feature of Chinese imperial textiles.

Imperial image defined

The Mongol conquest reunited North and South China in a single empire under the Yuan dynasty (1279-1368). Subsequently, the Han Chinese rebelled against a century of Mongol domination to establish the

Ming dynasty (1368-1644). Another northern people, the Manchu, conquered the Ming in the 17th century and founded the Qing dynasty (1644-1911). However, the effects of these dynastic changes on the underlying structure of Chinese culture were in some respects negligible. The Song-Yuan model of government, including its civil bureaucracy divided into six ministries, a centralized military organization and a hierarchy of censors, continued to govern at the local level on

Cloth of gold (detail)
17th century

CAT. 23*b*

behalf of the throne. While embracing the style of an imperial court, Yuan emperors also nurtured the Song dynasty literati ideals.

In textile production, the Yuan set standards which would continue to affect the image of the Chinese emperor over the next five centuries. Following the Jin experiments with gold threads, Yuan emperors embraced the use of gold to amplify the magnificence of court regalia. They particularly favored sumptuous gold brocades for clothing, tents, cushions and other furnishing fabrics. The Yuan initially established the *zhiranju,* offices

for weaving and dyeing, at Xunmalin in Central Asia and at Besh Baliq in Mongolia, where Muslim weavers from West and Central Asia were resettled to work in imperial workshops.[28] The workshops at Besh Baliq eventually moved to Dadu, present-day Beijing, producing "cloth of gold" textiles, known as *nasij,* which originated in Central Asia and Eastern Iran. Robes of state made of *nasij* were important tokens of imperial favor, conferring prestige and status. These dazzling garments contrasted sharply with the elegant, understated court robes which reflected the subdued literati tastes of Song emperors. The Ming and Qing courts continued Yuan dynasty initiatives by establishing *jizaoju,* imperial silkworks, in Beijing and Nanjing and, in the late 17th century, the Qing added two more in Suzhou and Hangzhou.[29]

The Ming and Qing also continued the large-scale patterns, bold color schemes and showy technical execution, which characterized imperial textiles at the Yuan court. In embroidery, combinations of stitches as well as techniques for padding, contouring and shading produced dramatic effects with richly textured surfaces contrasting with the ground fabrics on which they were often worked (see nos. 18, 19 and 21). Woven designs, both with supplemental weft patterning and in *kesi,* achieved similar brilliance. Qing textiles of the 17th century continued large-scale motifs (see nos. 21 and 22), but by the early 18th century a taste for smaller scale and more subtle effects emerged as the Qing consciously redefined themselves as the emperors of China (see nos. 24, 25, 26, 27 and 28). Like the Song, the Yuan, Ming and Qing courts patronized pictorial *kesi* and embroidery workshops which produced works for the imperial art collection and special diplomatic gifts (see nos. 47, 58, 60, 65 and 67).[30]

The Yuan decorative innovations in court garments, like the yoke and band decoration which contrasted distinct areas of

densely worked pattern with expanses of solid colored fabric, influenced all later prestige garments (see nos. 17, 18, 19 and 20). Under the Yuan, the five-clawed *long* dragon became emblematic of the emperor himself. This imperial symbol was displayed on all manner of works used by, or which represented, the emperor, from porcelain to furniture, from carpets to clothing.

Dragon-patterned robes gave substance to the image of imperial authority and became the signature garment of the Chinese court, as well as the most prestigious form of diplomatic gift within the sphere of vassal states along the borders (see nos. 20 and 45).[31] Court robes of the Yuan imperial family displayed large-scale five-clawed *long* dragons. In the yoke decor, dragons' bodies looped over the shoulders, their heads appearing on the chest and back, while a band on the skirt featured smaller running dragons. Although early Ming emperors restored the cut of the Song dynasty costume in a gesture to reestablish links with the indigenous Chinese tradition, they retained the Yuan decorative schemes for dragon robes. Yuan dragons, as in previous representations, were shown chasing flaming pearls among clouds. This continued unchanged until the early 16th century when Ming pattern designers added waves breaking against rocks along the lower edges of decorative areas, creating a cosmic landscape for the imperial dragon. By the end of the century, Ming weavers and embroiderers were freely experimenting with the dragon image, eliminating all unpatterned areas to create a single decorative field for very large dragons which unwound from the shoulders and unfurled full-length on the front and back of spectacular robes.

The Qing inherited these bold dragon styles, but by the end of the 17th century a process of rethinking the imagery of dragon robes began to emphasize a vision of the emperor's centrality within the cosmos and

the purpose of imperial government.[32] Dragon robes of the early 18th century displayed a design of nine dragons, four radiating from the neck on the chest, back, and shoulders, which pointed to the directions of the cardinal points on the compass when a courtier was aligned with the axial organization of the Forbidden City. Four additional dragons on the skirts – two at the front and two at the back – indicated the intermediate directions.

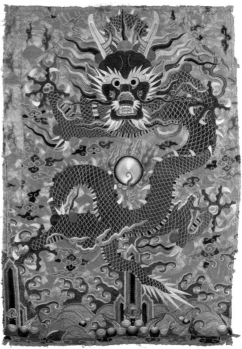

Dragon robe fragment CAT. 21
17th century

A ninth dragon, unseen, was placed on the inner flap. This pattern organization embodied an ancient concept of ideal land division, as envisioned by Confucius, called the *qingtien* or "well-field system". The name *qingtien* derives from the character for wellhead – a pair of horizontal lines crossing a pair of verticals, marking off nine sections symbolizing an idealized relationship between working farmers and the lord who owned the land. The eight fields protected the ninth by encircling it. Those sharing contiguous borders with the central field, if viewed as occupying

the cardinal points of the compass, established the harmonious balance implied by the *wuxing* system. These four created a protective ring and provided the first line of defense against external threat. The other four outlying fields, occupying the intermediate points of the compass, created a second ring of power. In traditional Chinese numerology, nine, the sum of three threes, suggests infinity and symbolizes heaven.

The pattern of the dragon robe also served as a schematic diagram of the universe.[33] The lower border of diagonal bands

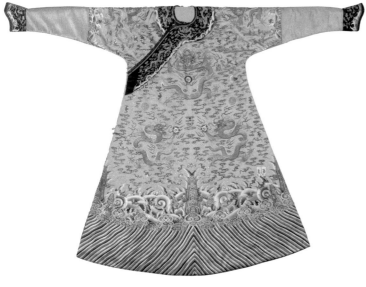

Emperor's Twelve Symbol Robe CAT. 26
18th century

and rounded billows represents the universal ocean surrounding the earth. At the four axes of the coat, or the cardinal points, prism-shaped rocks symbolize the earth mountain. Above is the cloud-filled firmament in which the dragons, the symbols of imperial authority, coil and twist. The symbolism is complete only when the coat is worn: the human body becomes the world's axis supporting the visible universe, the neck opening can be read as the gate of heaven or the apex of the universe, the wearer's head representing the higher order of the invisible heavens beyond.

Like dragon robes, costume accessories, such as badges applied to the chest and back of coats and special headwear and hat ornaments indicating rank, appropriate for significant court events and festivals, also have Yuan dynasty precedents. The Ming emperors were the first to adopt a system of rank insignia (see nos. 10, 11, 12 and 13)[34] and the Qing dynasty, 277 years later, reconfirmed the court rank system. Typically, badges bore in miniature an image of the cosmos against which the emblematic animal or bird was displayed.

Although court rank continued to be the most significant indicator of status in imperial China, by the end of the 18th century abuse of the examination system, which, since the Tang period, had served the needs of successive dynasties to fill administrative posts with the most qualified Confucian-educated scholars, impinged upon Qing imperial ambitions. A population explosion, the decline of Manchu fortunes, the ascendancy of a merchant class and the economic and political pressures of Western powers severely affected the flow of revenue into the imperial treasury. As a consequence, the Qing government often sold court rank, undermining its authority and control.

Imperial silk textile production standards declined precipitously during the 19th century as the rules of entitlement and privilege eroded and private silk factories proliferated. Except for the private court of China's last Dowager Empress, Cixi (1835-1908), the brilliant silk textiles, such as no. 34, which extolled the virtue of China's imperial heritage, largely disappeared. Within three years of Cixi's death, the Chinese Empire also faded away.

1 The official workshops' exacting standards applied to all levels of production. During the Han dynasty, fabric widths were set at a combination of two *chi* and two *cun,* roughly 50 cm, and bolt length set at forty *chi,* a little over nine meters. See Liu 1941 and Lubo-Lesnichenko 1961, pp. 18-19.

2 Kuhn 1988; Wang Zhongshu 1982.

3 Shih 1976, p. 1.

4 The Five Classics include: *Shijing* (Book of Poetry/Songs), *Shujing* (Book of History), *Yijing* (Book of Divination), *Chun Qiu fanlu* (Spring and Autumn Annals) and *Liji* (Book of Rites). According to Confucius, during China's golden age people understood their assigned roles and place in society, deferring to superiors, but the needs of inferiors were acknowledged. He proposed a code of conduct based on the family with its precisely defined gender and generational relationships. The family patriarch was at the apex of authority and respect. By extension, the patriarchal family was the basis for an ordered political life. As in the family, every member of the imperial court looked to the emperor as father of "all under Heaven".

5 *Shujing* 1971, pt. II, bk. III, ch. III.6, p. 68. See Lauman 1984, p. 16.

6 *Zhouli* 1971, p. 221.

7 Bangu 1963, vol. 14, p. 8203.

8 Fang 1981, p. 49.

9 Lu Buwei 1987, vol. 13, p. 6.

10 *Liji* 1964. See Mailey 1978, p. 9.

11 Yu Zhiyong 1998. See Zhao 1999, p. 78.

12 Zhao *op. cit.,* p. 78.

13 *Shujing* 1971, pt. II, bk. IV, ch. I.4, p. 281.

14 *Tang huiyao* 1968, ch. 32.2, p. 582.

15 Cammann 2001, p. 6.

16 Zhao *op. cit.,* p. 127.

17 Kuhn 1977.

18 Zhao *op. cit.,* pp. 94-122.

19 *Ibid.,* pp. 125-149.

20 Matsumoto 1984, pp. 111-125.

21 Fujian Provincial Museum 1982.

22 Shiba 1970, pp. 111-121.

23 Rossabi in Watt and Wardwell 1997, pp. 11-14.

24 Watt and Wardwell *op. cit.,* pp. 23-24.

25 *Ibid.,* pp. 53-63.

26 250,000 ounces of silver and 250,000 bolts of silk were sent annually to the Jin by the Song emperors. See Vainker 1996, pp. 161-162.

27 Watt and Wardwell *op. cit.,* pp. 107-111.

28 *Ibid.,* pp. 127-141.

29 Shih 1976, p. 2.

30 National Palace Museum 1981.

31 Cammann 2001, pp. 20-24.

32 Vollmer 1998, pp. 49-54.

33 Vollmer 2002, pp. 103-108.

34 Cammann 1944, pp. 71-130.

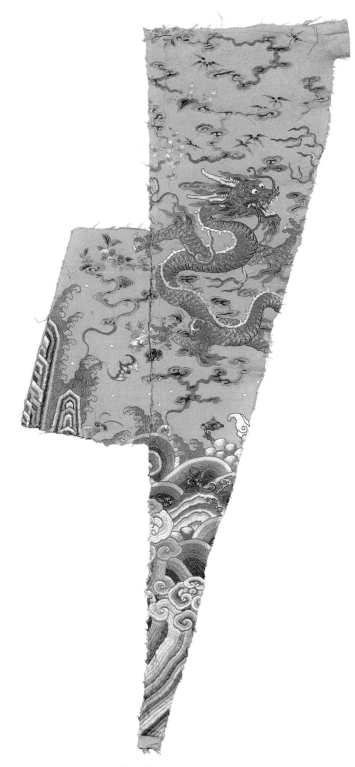

Dragon robe fragments
early 18th century

Silks for Court and Palace

1 *Fragment of a sleeve*
 samit[1]
 Liao dynasty, 10th-11th century
 length 48 cm; width 41 cm

2 *Fragment*
 brocaded tabby
 Jin dynasty, 12th-13th century
 length 72 cm; width 32 cm

3 *Fragment*
 figured tabby
 Yuan or Ming dynasty, 14th century
 length 24 cm; width 44.5 cm

2 (detail)

3 (detail)

Roundel designs derived from West Asian models became the most celebrated silk patterns in China during the Sui (581-618) and Tang (618-907) dynasties. Considered emblematic of status and prestige, those featuring birds or animals were often assigned to specific court ranks.[2] Roundel patterns had a lasting influence on Chinese imperial tastes (see nos. 13, 14, 15 and 16). Sui and Tang roundels, like their western antecedents, were arranged on a square grid in vertical and horizontal rows. Although the Tang roundel tradition continued under the northern dynasties of Liao (907-1125), Jin (1115-1234) and Yuan (1279-1368), new design ideas and technical innovations changed the character of these patterns significantly. Motifs became smaller and more animated. Other less rigid profiles were added

to the traditional medallion or roundel shapes, expanding the repertory to include three, four, six and eight-lobed shapes, as well as teardrop and leaf shapes. When arranged in staggered horizontal rows these patterns recalled Han dynasty designs with their emphasis on diagonal movement in the pattern. Discontinuous supplemental wefts in colored silk floss, but particularly gold wefts made of strips of gilded membrane or threads made of gilded paper wrapped spirally around a silk core, gave weavers new materials to create lively designs.

The small roundels on the Liao samit no. 1 are composed of pairs of circling parrots in a dramatic shift from the static presentation of single or paired animals and birds which characterized Tang design. The rows of parrot roundels[3] alternate with rows of small rosettes shifted by half a unit to form a new alignment. While this samit fabric continued the Tang tradition of polychrome silk weaving, the gold brocaded tabby no. 2 suggests future trends in prestige silks. Medallions, each with a coiled five-clawed profile dragon chasing a pearl, are organized in staggered rows. Reversing the orientation of the dragons in alternating rows further animates

1 Technical analysis of the textiles by Marie-Hélène Guelton is provided at the end of the catalogue. Legend identifications describe only the principle fabric; all textiles in this catalogue are silk with the exception of the ground fabric of no. 55.
2 See *Tang huiyan* 1968, ch. 32.2, p. 582.
3 A related fragment with circling parrots was recovered at Famen Temple (FD4:017-2). See Zhao 1999, pp. 148-149, no. 4.10.

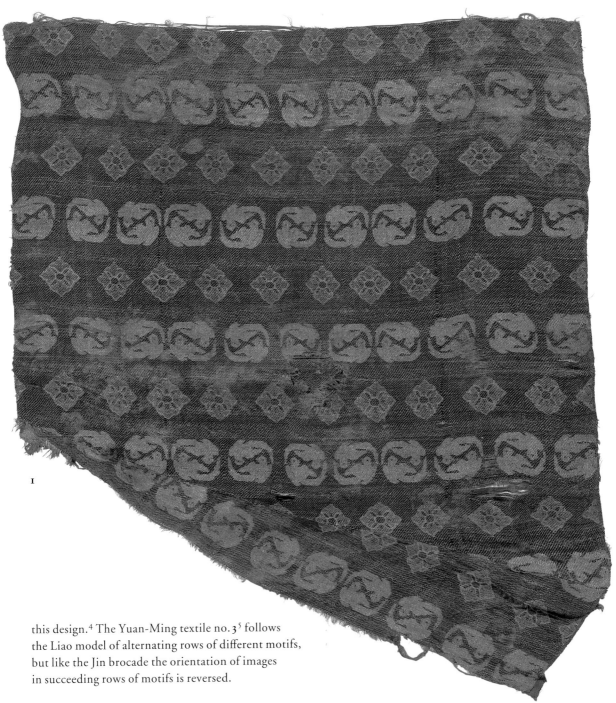

1

this design.[4] The Yuan-Ming textile no. 3[5] follows
the Liao model of alternating rows of different motifs,
but like the Jin brocade the orientation of images
in succeeding rows of motifs is reversed.

The theme of the dragon and pearl, which was to be
a ubiquitous motif in Chinese decorative arts from
this period onward, can be traced in literature to
the Han dynasty. The motif appeared in metalwork
in the early Tang dynasty, and by the 10th century was
present in various decorative arts including textiles.[6]
Coiled dragons were mentioned in a list of patterns
decreed in 694 for robes of senior officials and princes
of the Tang imperial household.[7] In imitation of
Chinese practice, other Asian cultures also adopted
dragon patterned robes as prestige garments.[8]

4 A panel of the same fabric is in The Metropolitan Museum of
 Art, (1989.205). See Watt and Wardwell 1997, pp. 116-117, no. 30.
5 Related textiles are in The Deutsches Textilmuseum, Krefeld
 and in The Cleveland Museum of Art (1995.73). See Zhao *op. cit.*,
 pp. 198-199, no. 6.07, and Watt and Wardwell *op. cit.*, p. 153, no. 42.
6 A portrait of Emperor Taizu, the first emperor of the Song dynasty,
 which shows the sleeves of the inner robe patterned
 with dragons, is in The National Palace Museum, Taipei.
 See Fong and Watt 1996, facing p. 141, pl. 63 and detail.
7 See *Tang huiyan, op. cit.*
8 For fragments of a 10th or 11th century silk gauze robe with
 embroidered roundels with pairs of three-clawed dragons,
 one ascending and the other descending, encircling a flaming pearl,
 see Zhao *op. cit.*, pp. 270-271, no. 9.01. A figure identified
 as the King of the Tangut Xia dynasty (1032-1227), depicted
 as a donor in Cave 409 at Dunhuang in northwest China,
 is wearing a full-length robe with an allover pattern of coiled
 dragons. This image is roughly contemporary with the Jin design
 and represents one of the earliest images of a dragon robe.
 See Liu Yuquan 1982, pp. 273-318.

4 *Garment fragment*
 stencilled and gilded figured complex gauze
 Liao dynasty, 10th-11th century
 length 24.5 cm; width 24 cm

5 *Fragment*
 brocaded tabby
 Jin dynasty, 12th-13th century
 length 65 cm; width 31.2 cm

4

In contrast to the formal roundel or medallion patterns which characterized prestige textiles during the Tang dynasty, patterns like these – one with a pair of fanciful flying birds and the other with a recumbent Central Asian antelope called a *djeiran*[1]– reveal new directions in imperial silk production. Most animal motifs prior to the late 10th century were shown without a setting. During the Liao and Jin dynasties, weavers and textile designers explored more natural renderings of floral and animal images in response to Central Asian influences. Consequently, medallions were given more organic shapes and presented like miniature scenes without frames. Birds fly through clouds, while the *djeiran* reclines on a grassy knoll surrounded by foliage, his head turned back to gaze at the moon.

Gold-embellished textiles reflect the tastes of northern groups, which had been influenced by textiles from the Iranian world. Liao and Jin textile workers used a variety of gold threads, such as the gold-leafed parchment strip supplemental wefts on the *djeiran* fabric. The Liao also applied gold leaf directly to the fabric after painting motifs with an adhesive. These glittering fabrics redefined Chinese imperial textiles. The motif of birds in no. 4, resembling the curly-tailed phoenix, continued to be popular in Chinese art (see nos. 17 and 43). In contrast, the *djeiran* motif, first seen on Sogdian metalwork of the 7th century,[2] introduced in the arts of the Jin dynasty, reappeared only on Yuan dynasty porcelains before disappearing from the Chinese design repertory.

1 An example of a similar *djeiran* pattern was excavated from Mingshui, Damaoqi, Inner Mongolia. See Zhao 1999, pp. 172-173, no. 5.8. Another example of this fabric is in The Metropolitan Museum of Art (1989.205); see Watt and Wardwell 1997, pp. 116-117, no. 30. For this pattern on a yellow ground, formerly in The AEDTA Collection, Paris, see Krahl 1997, p. 47, fig. 4.
2 See a bowl in The State Hermitage Collection, Saint Petersburg, Watt and Wardwell *op. cit.,* p. 114.

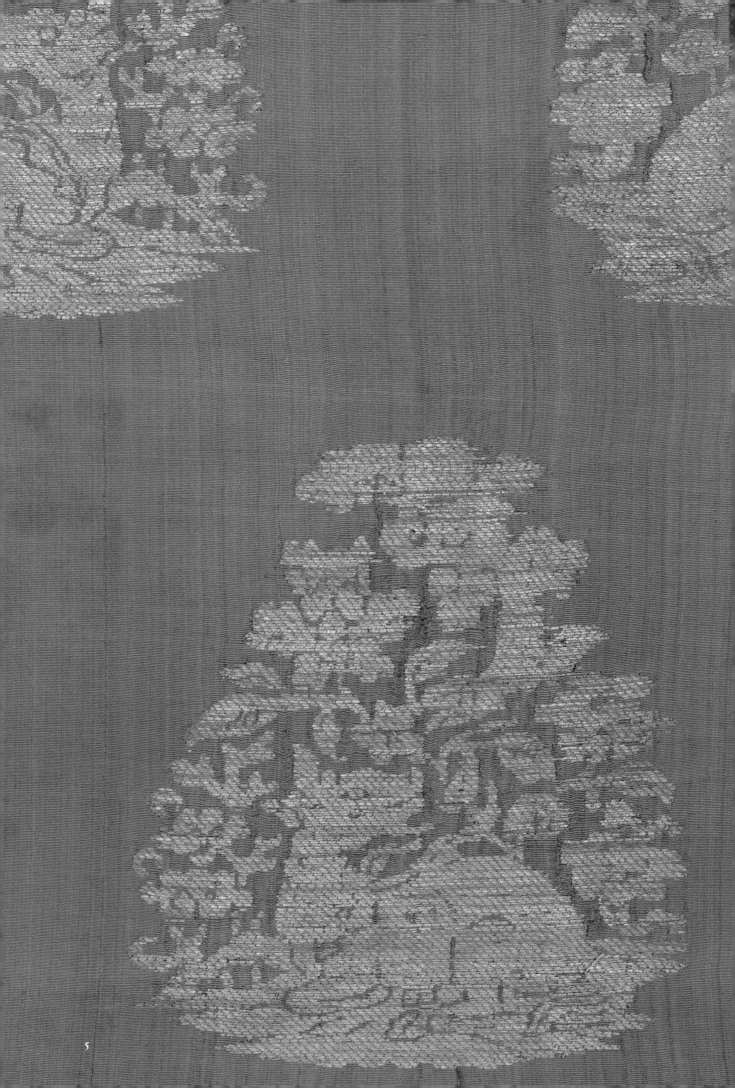

6 *Pair of knee pads*
embroidered tabby
Yuan dynasty, 13th-14th century
length 18.5 cm; width 23 cm; tie length 17.5 cm

PUBLISHED Zhao Feng. "The Chronological Development of Needleloop Embroidery." *Orientations,* vol. 31, no. 2, February 2000, pp. 44-53, figs. 4 and 4a.

The decorative plan for this pair of textiles utilizes a different variety of flower for each quadrant of the design. Reading clockwise from upper left, these motifs represent what seem to be camellia, peony, chrysanthemum and lotus. This design evokes the cycle of seasonal change. The floral sprays with tendrils, stems and leaves and a bird in flight, worked in satin and stem stitches, are treated naturally and are indebted to styles that evolved in Central Asia and western China during the late 11th through the early 13th centuries.[1] Floral and animal images were significant components of the Chinese decorative repertory since the late Zhou dynasty and were revitalized during the Northern and Southern Song dynasties, when more naturalistically rendered floral motifs were used to convey complex symbolic messages.

These accessories are padded and shaped along the upper section of the vertical seam. They would have been worn tied behind the knee,[2] above the swell of the calf, holding them in place during the kowtow or ritual kneeling and prostration, which marked many solemn Chinese ceremonies. The border of triangles has been identified as an early type of needleloop embroidery[3] (see no. **59**). Comparison to an excavated embroidery from Kharakhoto in Inner Mongolia[4] and the single knee pad[5] worked on green silk from a cache of Yuan dynasty textiles recovered at Dove Cave, Longhua in Hebei province suggest a late 13th or 14th century date for this pair of pads. There is a similar pair of textiles in The Cleveland Art Museum,[6] also worked on green silk tabby but without the needleloop borders.

1 Watt and Wardwell 1997, pp. 172-174.
2 This identification was proposed by Sun Huijun, the archeologist of Dove Cave, at the symposium, Textile Archaeology in China, Hangzhou, November 5-6, 2002 (unpublished paper).
3 Zhao 2000, pp. 44-53, figs. 4 and 4a.
4 The site of Kharakhoto in western Inner Mongolia was destroyed by Ming troops in 1368, providing a terminus ante quem. See Zhao 1999, pp. 166-167, no. 5.05.
5 Dove Cave can be dated from textual records found at the site bearing the date of 1362. See Zhao 2002, pp. 144-145, no. 61.
6 Watt and Wardwell proposed a Liao dynasty date for the pair of pads in The Cleveland Museum of Art (1995.109ab) and identified them as headwear based on comparisons with excavated Liao dynasty material and a gold replica found in a tomb dating to the Northern Wei dynasty (368-524). See Watt and Wardwell *op. cit.,* pp. 180-181, no. 52.

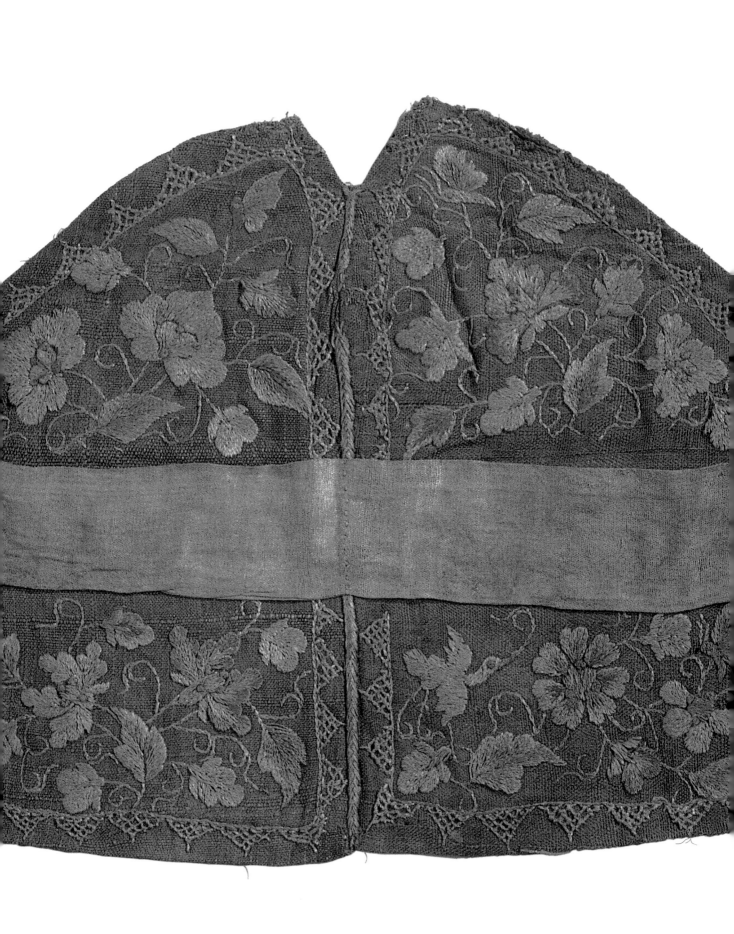

7 *Garment fragment*
kesi, *slit tapestry weave*
Central Asia, 13th century
length 58 cm; width 16.5 cm

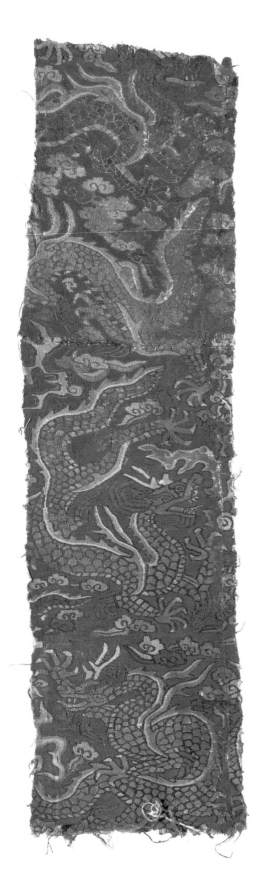

This fragment of silk tapestry with dragons chasing pearls is woven in colored silks and gold- and silver-wrapped threads on a purple ground. It is one of several that survive from a yardage[1] that includes two panels with a partial quatrefoil cloud collar yoke framing the same motifs on a brick-red field.[2] Although never sewn into a garment, it is possible to suggest a hypothetical construction based on the evidence of other *kesi* garments *(see fig. 1)*.[3]

The basic pattern unit consists of pairs of dragons, one ascending, the other descending, chasing flaming pearls amid clouds. The design is Chinese in origin and can be related to dragon and pearl medallion patterns of the previous century (see no. 2), but here the treatment of filling the space uniformly reflects vestiges of Central Asian tastes, which often incorporated animal and bird motifs within dense floral patterns. The design layout with pattern repeats in tapestry weave, where they must be hand produced, imitates drawloom woven fabrics originally coming from the Iranian world.

During the Yuan dynasty, design organization of either an allover dragon pattern or a quatrefoil yoke and band evolved as two separate strategies for decorating court garments. The quatrefoil yoke remained one of the enduring elements of dragon robes for formal court attire (see nos. 17, 20 and 45); the allover pattern was revived at the end of the Ming dynasty (see nos. 21-28).

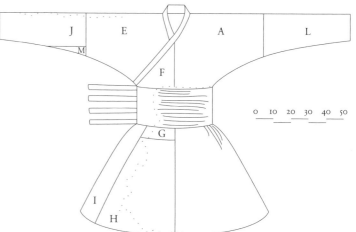

fig. 1 Mongol coat construction

<div style="writing-mode: vertical">ARTIST : RICHARD SHEPPARD</div>

1 For fragments of the same textile, see The Cleveland Museum of Art (1988.33), Watt and Wardwell 1997, pp. 75-79, nos. 17 and 18; Simcox 1994b, pp. 6-7, no. 1; McGuinness and Ogasawara 1988, no. 2.
2 For yoke fragments, see Watt and Wardwell *op. cit.*, p. 75, figs. 26 and 27.
3 See Vollmer 2002, pp. 42-45.

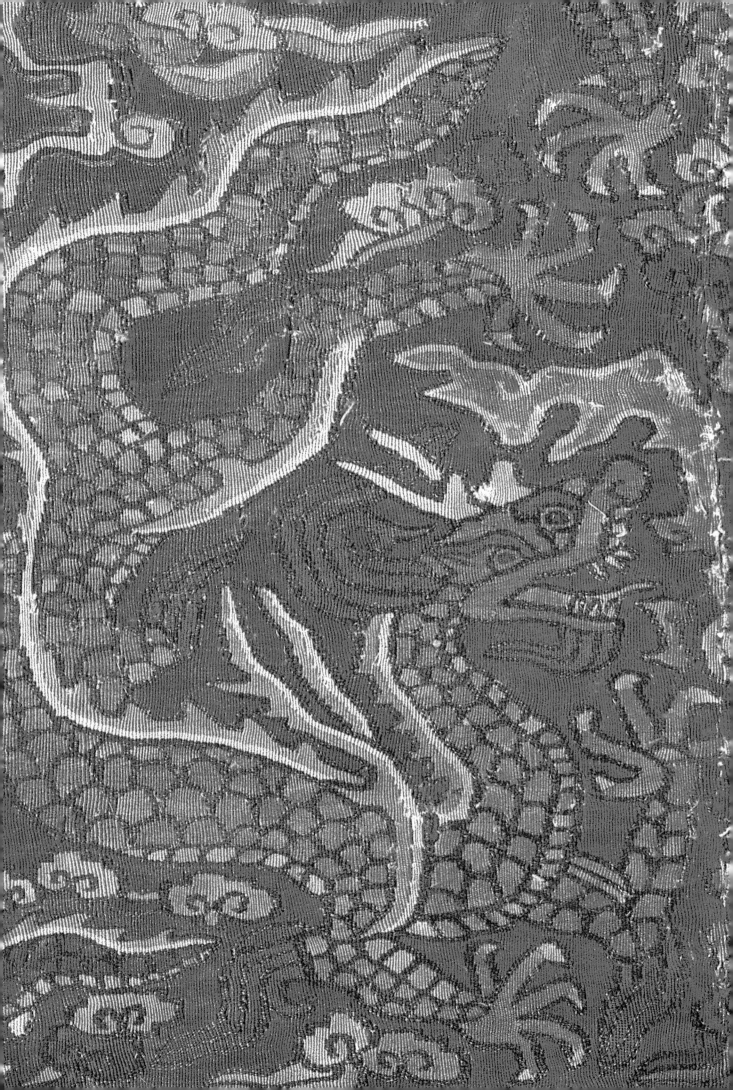

8 *Man's* c h a n g p a o *or unofficial robe*
 damask
 Ming dynasty, 16th century
 length 133 cm; width across shoulders 245 cm; sleeve width 70 cm

PUBLISHED John E. Vollmer. *Ruling from the Dragon Throne: Costume of the Qing dynasty (1644-1911).* Berkeley and Hong Kong 2002, pp. 28-29.

9 *Man's* b u f u *or court rank robe*
 damask
 Ming dynasty, 16th century
 length 140 cm; width across shoulders 240 cm; sleeve width 40 cm; traces of rank badge 33 × 35 cm

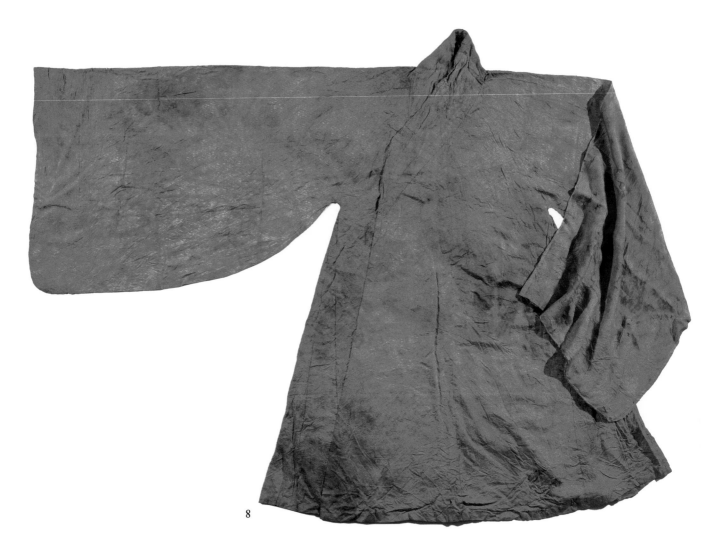

8

The *Yijing* (Book of Changes) compiled between the 4th century BC and the 2nd century AD noted, "Huangdi, Shun and Yao [all mythical founders of Chinese civilization] ordered everything under heaven by the drape of its attire."[1] This obtuse reference to order and decorum was preceded by Confucius in the 5th century BC. He taught that the virtue of the sage flowed freely from his inner person to the material form of the body, expressed through

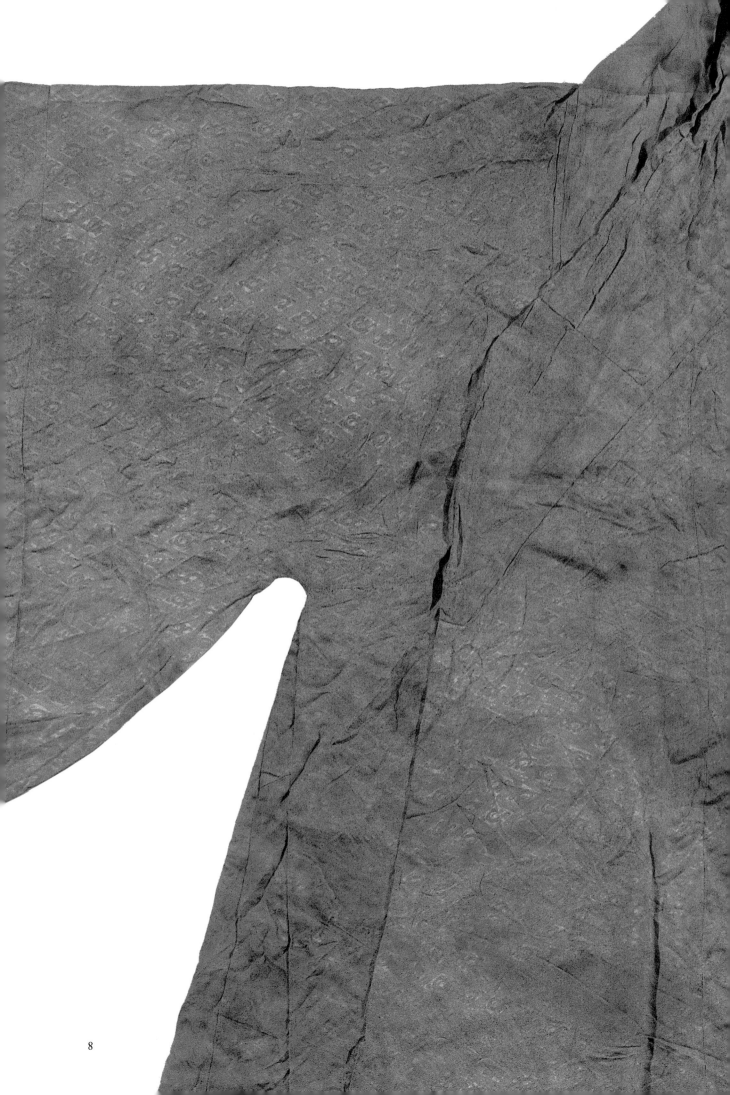

8

demeanor and movement.[2] When virtue reached perfection, it was experienced as effortless and was manifested with perfect ease and grace. Virtue emanated from noble bearing, including the elegance with which one's sleeve was draped.

Full-length coats with long, wide sleeves expressed Han Chinese ideals of cultural superiority. The extremely voluminous sleeves of this rare *changpao* served as the perfect metaphor for the virtuous Confucian gentleman. Probably ordered for the burial of a member of the governing elite during the 16th century,[3] its construction duplicated that used for garments of the living, using over thirteen meters of fine silk damask *(see fig. 2)*. It is cut with the back panel hanging free from the waist so it can be moved to the side to prevent creasing when the wearer is seated. Underneath, an elaborately pieced and pleated section at each side wraps around the lower body to ensure modesty.

Under the Ming dynasty, official garments were consciously patterned on those used during the Song dynasty, exemplifying Han Chinese style in contrast to garments introduced under the alien Liao, Jin and Yuan dynasties. The self-patterned damask design of dragons organized on a diagonal lozenge grid in no. 8 also acknowledged ancient Chinese design precedents.

Throughout the history of Chinese textile production, the technologies employed for silk far surpassed in complexity those used for other fibers. Patterns evolved logically from loom technology in which warp and weft threads interlace at right angles with precise mathematical predictability and fall easily into geometric figures on a square grid. However, even during the late Bronze Age, Chinese silk weavers sought innovative ways to imbue geometric patterns with dynamism.[4] Despite the technical challenges, they managed to rotate individual square or rhomboid motifs 90 degrees so they rested on a corner instead of a side, an effect visible in the dragon patterned lattice of no. 8. They also spaced horizontal rows of motifs, then arranged them so that those in alternate rows were shifted half a unit to the left or right of the previous row. The same structural device when applied to naturalistic motifs, like the peonies and foliage on no. 9, enhanced the dynamism of the pattern.[5]

Although garments such as nos. 8 and 9 use prodigious amounts of expensive cloth, their constructions are extremely economical to avoid waste. Rather than cutting away and eliminating excess cloth, a system of cutting, folding and seaming was devised to retain the entire yardage and create an ample, elegantly shaped garment. These very rare robes are still intact and preserve their complicated constructions and careful stitching.

ARTIST: RICHARD SHEPPARD

fig. 2 Changpao *construction*

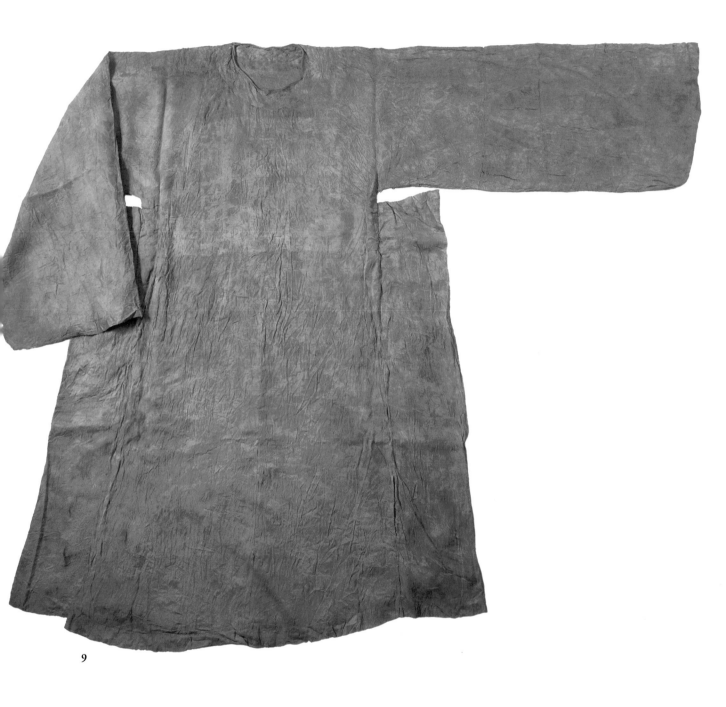

9

In death, as in life, political rank and social position were all-important. Wardrobes of silk commissioned for burial show that the order of the after-life duplicated the order on earth. The rank badge robe or *bufu* no. 9 was the most important court garment an official could own. The robe considered here was originally made of lustrous bright red silk damask patterned with peonies, adorned with *buzi* or rank badges at the chest and back (see no. 10), indicating the individual's rank at court *(see figs. 3 and 4)*. Like the informal robe no. 8, this garment was identical to that worn in the person's lifetime. Clothing was included in the entitlements attributed to the individual's rank and status, determining everything from the size of one's house to the furnishings of the tomb.

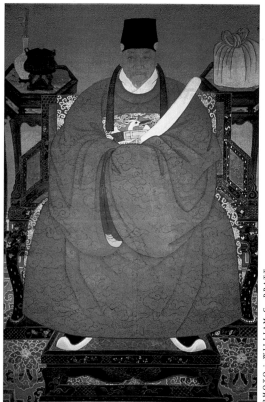

fig. 3 Posthumous portrait, sixth rank civil official late 16th century The Royal Ontario Museum (923x56.7)

PHOTO : WILLIAM C. PRATT

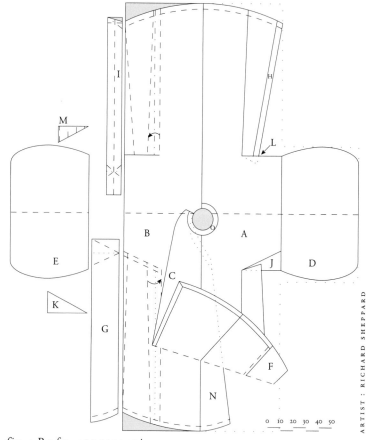

fig. 4 Bufu *construction*

ARTIST : RICHARD SHEPPARD

1 See *Yijing* 1999, p. 310 and Lauman 1984, pp. 30-31.
2 Confucius, *Lunyu* 1963, bk. XX, ch. II, 2, pp. 244-245.
3 The closest comparisons are the garments excavated from the tombs of Xu Fan (1463-1530) and his wife. See Li Yinghua 1996, pp. 28-31, fig. 6.
4 Sylwan 1937, pp. 119-126.
5 Zhao 1999, pp. 125-149.

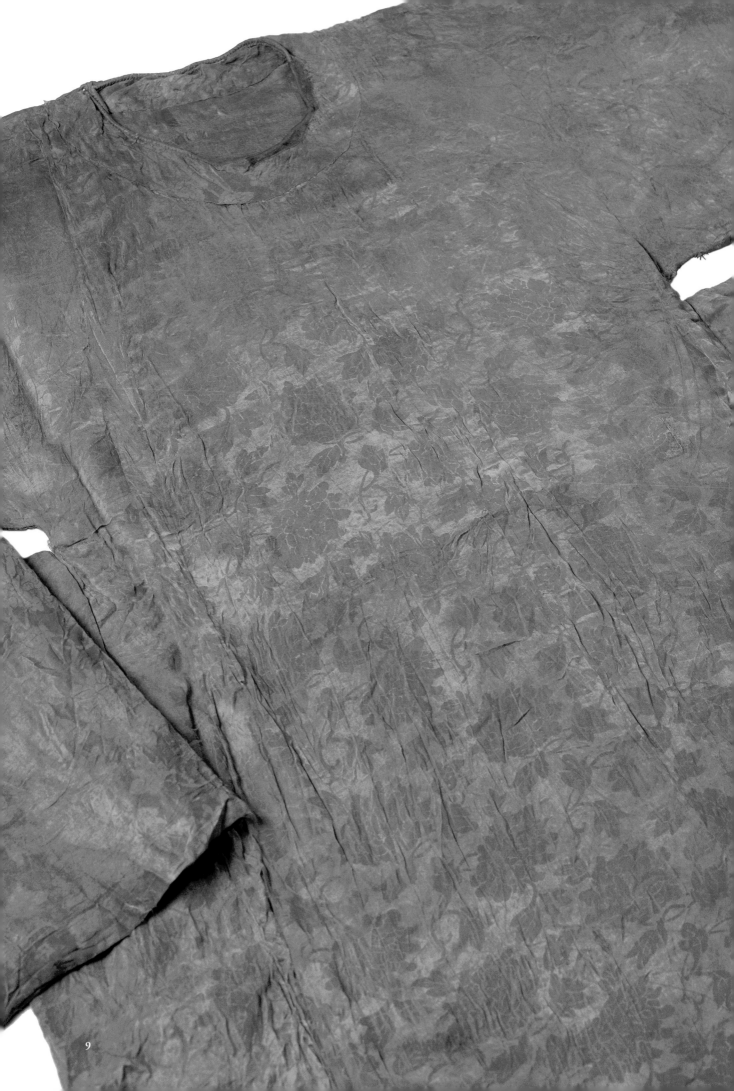

10 *Pair of buzi
or court rank badges*
embroidered gauze
Ming dynasty, 16th century
length 31.7 and 31.2 cm; width 31 and 31.5 cm

11 *Buzi or court rank badge*
embroidered tabby
Ming dynasty, 16th-17th century
length 38 cm; width 39.5 cm

12 *Buzi or court rank badge*
embroidered tabby
Ming dynasty, 16th-17th century
length 39 cm; width 38.5 cm

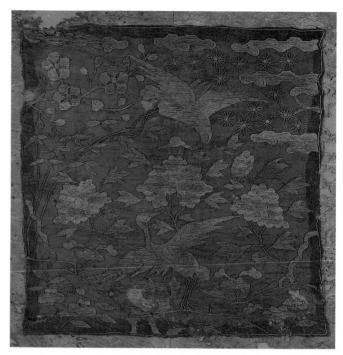

10

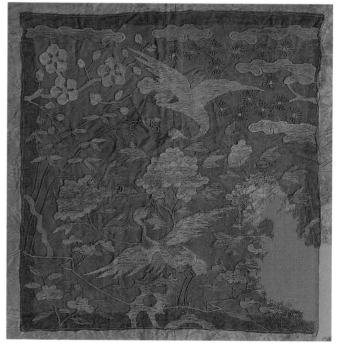

The nine grade ranking system which assigned *buzi*
or pictorial badges *(see appendix I)* to all in attendance
at the imperial court was codified in 1391.[1] Under
the Ming and Qing dynasties, badges with different
categories of beasts were assigned to distinguish
the aristocracy from the gentry, as well as to differen-
tiate status within the elaborate military and civil
bureaucracies. The Ming convention of wearing
garments with badges at court continued the practice
of the Yuan dynasty which stemmed from the custom
of nomadic peoples of the Eurasian steppe who
wore special textiles or emblems on their coats
as a means of identification and as a sign of status.

From at least the Tang dynasty, dragon insignia
had distinguished members of the imperial clan.[2]
Dragons also marked the upper ranks of the Ming
aristocracy, while other animal badges were used
for the lower ranks of nobility and military officers.
Badges with birds were assigned to civil officials.
Whereas most nomadic groups sewed badges to
a surcoat that was worn over other garments, *buzi*
for Ming civil officials were placed directly onto
a full-length robe as in no. 9.

The pair of badges no. 10 for a first rank civil official,
once attached to a *bufu,* features pairs of cranes in
a stylized landscape with peonies symbolizing wishes
for wealth and the Confucian theme known as *san
you* or "The Three Friends". These motifs and the
darned embroidery on the gauze ground are typical
of mid-Ming period badges.

The silver pheasant and lion badges nos. 11 and 12,
with their large lozenge-shaped clouds and prism-

like rocks and billows, reflect aesthetic developments
of the later Ming period. These two badges were part of
a group of similar badges reportedly from the collection
of the Palazzo Corsini in Florence.[3] Over thirty *buzi,*
mostly showing lions or paired silver pheasants, were
probably assembled in Tibet to form a large hanging or
canopy. Although the embroidery is not refined, perhaps
done in a provincial or private workshop, the materials
and style as well as the exuberant colors and large scale
motifs of these badges are typically late Ming.

1 Cammann 1944, pp. 71-130.
2 *Tang huiyao* 1968, ch. 32.2, p. 582.
3 *Hall* 1999, pp. 66-68.

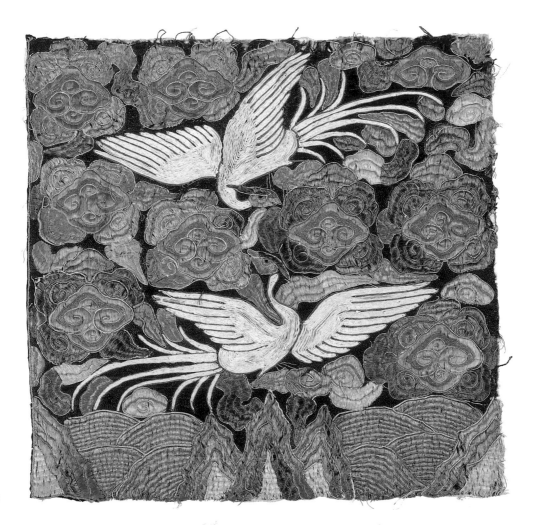

11

12

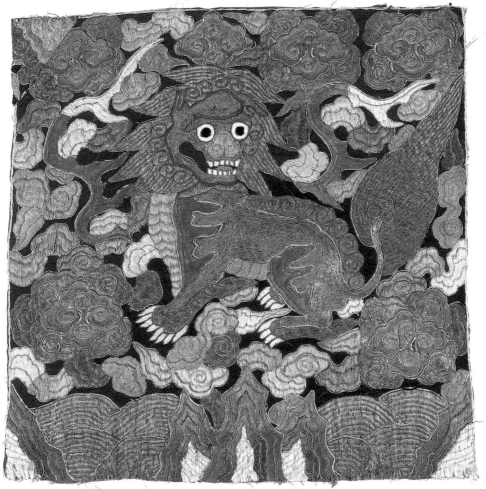

13 *Emperor's* buzi *or rank badge*

kesi, *slit tapestry weave*

Ming dynasty, 16th century
diameter 39 cm

At court the shapes of badges had particular importance. Circular shapes were reserved for the highest ranks *(see fig. 5)*, as the prestige attached to roundel patterns of the Sui and Tang dynasties persisted. Round shapes also recalled the altars for worshiping Shangdi, the supreme deity, which were set on circular terraced platforms. Lesser deities were worshipped at altars set on square platforms.[1] Superior, central and celestial were notions associated with the circle, in contrast to the earthly square (see nos. **10**, **11** and **12**). The emperor, heir apparent and the first four ranks of princes, including the emperor's sons, brothers, uncles and brothers-in-law, were entitled to use five-clawed *long* dragon roundels. Front-facing dragons ranked higher than those shown in profile (see nos. **14** and **15**). Nobles from the fifth through the eighth grade were assigned the four-clawed *mang* dragon.[2]

This *buzi* was probably part of a set of eight or ten circular badges for an emperor's robe. Each cloud, mountain and band of radiance is marked with the characters *wan* and *shou,* proclaiming 10,000 long lives, suggesting that the badge may have been made to mark the emperor's birthday, a major event in the court calendar. The rendering of the dragon, with its front legs clutching a flaming pearl over its head and the claws of the back legs grasping two prism-shaped mountains, is very unusual and can be related to designs emanating from the imperial workshops during the reign of the Wanli emperor (1573 - 1620).[3] The quality of the *kesi* weaving is also indicative of the skilled craftsmanship associated with the workshops under imperial patronage.

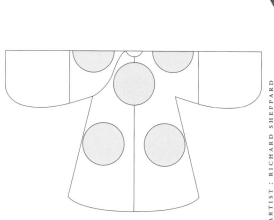

fig. 5 *Schematic diagram of Ming dynasty roundel decorated robe*

<div style="text-align:right"><small>ARTIST : RICHARD SHEPPARD</small></div>

1 The magnificent sacrificial sites of Beijing, rebuilt in the early 15th century by the Ming dynasty Yongle emperor (1403 - 1424), preserved the distinctions between altar shapes in the ritual precinct south of the Forbidden City; the Temple of Heaven with its circular terraces and structures contrasts with its counterpart, the square-shaped Altar of Agriculture. See Bredon 1931.

2 Cammann 2001, pp. 10 - 19.

3 The range of dragon patterns used to ornament the wardrobes of the Wanli emperor and his empresses are visible in the garments recovered from the Dingling tomb north of Beijing. See Dingling Museum 1990.

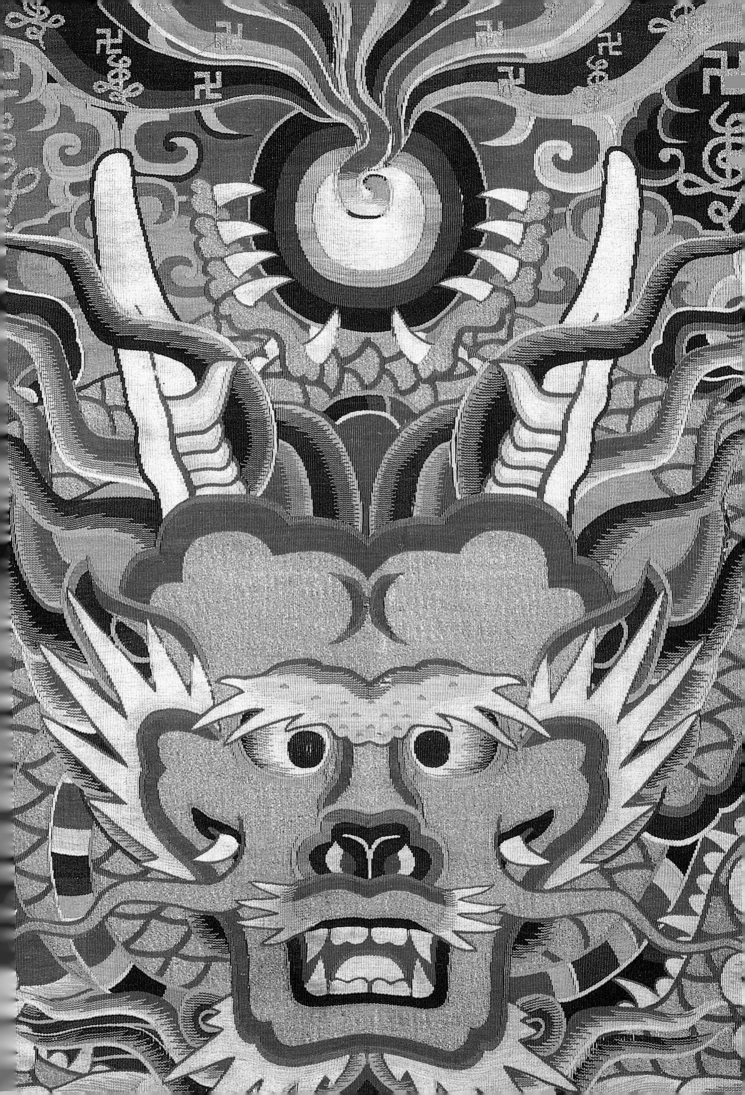

14 **Buzi** *or court rank badge*
embroidered satin

>> Qing dynasty, 17th-18th century
>> diameter 32 cm

15 **Buzi** *or court rank badge*
embroidered satin

>> Qing dynasty, mid to late 18th century
>> diameter 27 cm

>> provenance: Barbara Hutton Collection

16 *Woman's* longgua *or court surcoat (unfinished)*
kesi, *slit tapestry weave*

>> Qing dynasty, late 18th century
>> length 148 cm; width across shoulders 296 cm

The Qing court continued the Ming dynasty practice of using *buzi* in either round or square shapes on the front and back of official attire to indicate rank.[1] While Ming insignia were displayed directly on court robes, under the Qing they were sewn to a nomadic-inspired surcoat or outer garment. Depending upon the status of its wearer, these robes were variously called *bufu, longgua* or *gunfu.*

The Qing court had twelve grades of nobles and nine grades each for civil and military officials *(see appendices I and II).* Each was assigned its own badge, most of which were worn in pairs – one attached to the back of the court surcoat, while the other was divided in half vertically at the front. The first eight ranks of nobles were assigned dragon badges. Distinctions were made first by the type of dragon, then by the shape of the badge. *Long* or five-clawed dragons marked the rank badges of the emperor and his immediate family.

These were superior to *mang* or four-clawed dragons, which were assigned to courtiers from the ranks of princes of the blood of the third through the eighth rank.

The emperor and the heir apparent, as well as the first two ranks of princes of the blood, who would have included the emperor's sons, brothers and uncles, used *long* roundels. Princes of the blood of the third and fourth rank, including the emperor's brothers-in-law and ranking clansmen, used *mang* roundels. Coats with four roundels outranked those with only two. Front facing dragons outranked those shown in profile. Princes of the blood from the fifth through the eighth rank were assigned *mang* insignia displayed in squares. Nobles of imperial lineage from the ninth through the twelfth rank and all military officers were assigned animal insignia. The highest-ranking male members of the imperial family used four badges; lesser-ranking clansmen were assigned two badges.

With the exception of the empress dowager and the highest-ranking members of the emperor's harem, women were not entitled to attend the audiences and ceremonies for which *bufu* or rank badge surcoats were worn. Manchu women's insignia coats, *longgua,* differed from their male counterparts in style and decor. They were full-length and, for the highest-ranking women, bore eight roundels based on Ming dynasty court styles. The empress and empress dowager were assigned two types of surcoats: the first type was decorated only with medallions, the second had a *lishui* or standing water border at the hem with eight medallions on the field above.[2] The three degrees of imperial consorts and crown princesses were allowed to use the first type of *longgua*; the consorts of all other imperial princes and nobles wore full-length *bufu* bearing the same insignia

fig. 6 Third style jifu *(semi-formal court robe)*
Embroidered gauze
Second quarter 19th century
Musée Guimet, Paris
Former Myers Collection

PHOTO: BRUNO LEO HIR LA FALLOIS

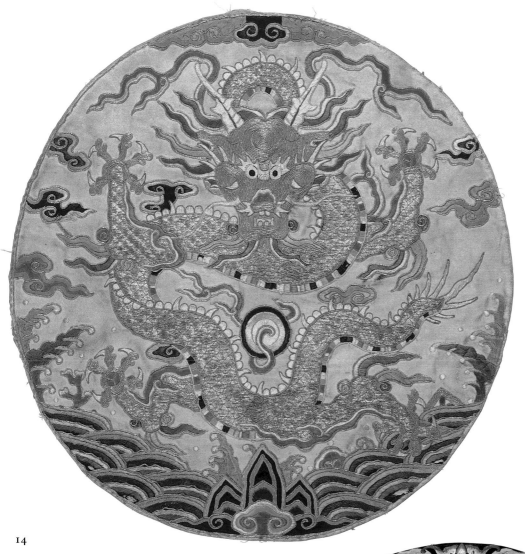

14

15

badges as their husbands. This followed a Ming dynasty custom of wives and daughters wearing garments marked with the rank of their husbands and fathers.[3]

The roundels on the shoulders of the *longgua* no. **16** bear two of the Twelve Symbols of Imperial Authority (see nos. **25** and **26**), the sun on the right shoulder and the moon on the left. The costume legislation of the mid-18th century, which added these ancient symbols of sovereignty to the ritual and ceremonial costume of the Qing emperors for the first time, did not mention the use of any of the 12 symbols for other ranks. In previous dynasties, the nobles and officials who assisted the emperor at the principal annual sacrifices wore these ancient symbols on their robes, but in lesser numbers. Several Qing court robes survive, including ones for women, which bear 2, 4, 8 or even all 12 of the symbols. Most of these apparent abuses of official privilege date from the late 19th century, when Qing power was in decline. However, a few 18th century garments, including no. **16**, suggest a more complicated story. An emperor's *jifu* in The Metropolitan Museum of Art, attributed to the early years of the Qianlong emperor's reign, bears the same two symbols only.[4] That robe predates the promulgation of the edict which specified 12 symbols for the emperor alone and it has been suggested that the robe may demonstrate the emperor's personal interest in the history of the Liao, Jin and Yuan dynasties, which had used the sun and the moon on the emperor's robes.[5] Portraits of Xiaoho, the consort of the Jiaqing emperor (1786-1820), depict her wearing robes with some or all of the restricted symbols.[6] Based on the

style of the motifs and the quality of the workmanship, it is possible that the *longgua* no. **16** which dates from the end of the 18th century was made for her or her mother-in-law.

The badge no. **15**, with its profile or running *long* dragon, has been cut from the lower skirts of a surcoat similar to no. **16** and demonstrates the very high standards of workmanship demanded in the imperial factories. Such a badge would have appeared on the surcoats of the first four ranks of imperial consorts. The embroidered badge no. **14** is more unusual because of its yellow satin ground. It was probably cut from a dragon roundel robe for the Kangxi emperor or his consort *(see fig. 6)*.

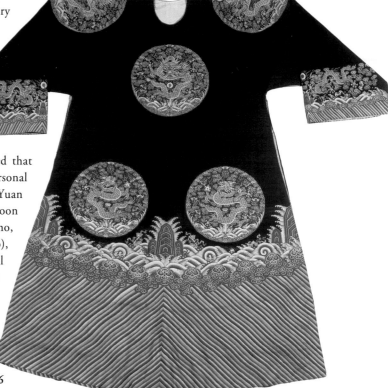

16

1 The first Qing dynasty edicts concerning rank ornament were decreed in 1652. See Cammann 1947, pp. 81-82; Cammann 2001, p. 21.
2 Dickinson and Wrigglesworth 2000, pp. 186-189.
3 Cammann *op. cit.,* p. 75.
4 Cited in Cammann *ibid.,* p. 92.
5 *Ibid.,* p. 92.
6 *Ibid.,* pp. 70-71; Stuart and Rawksi 2001, p. 176.

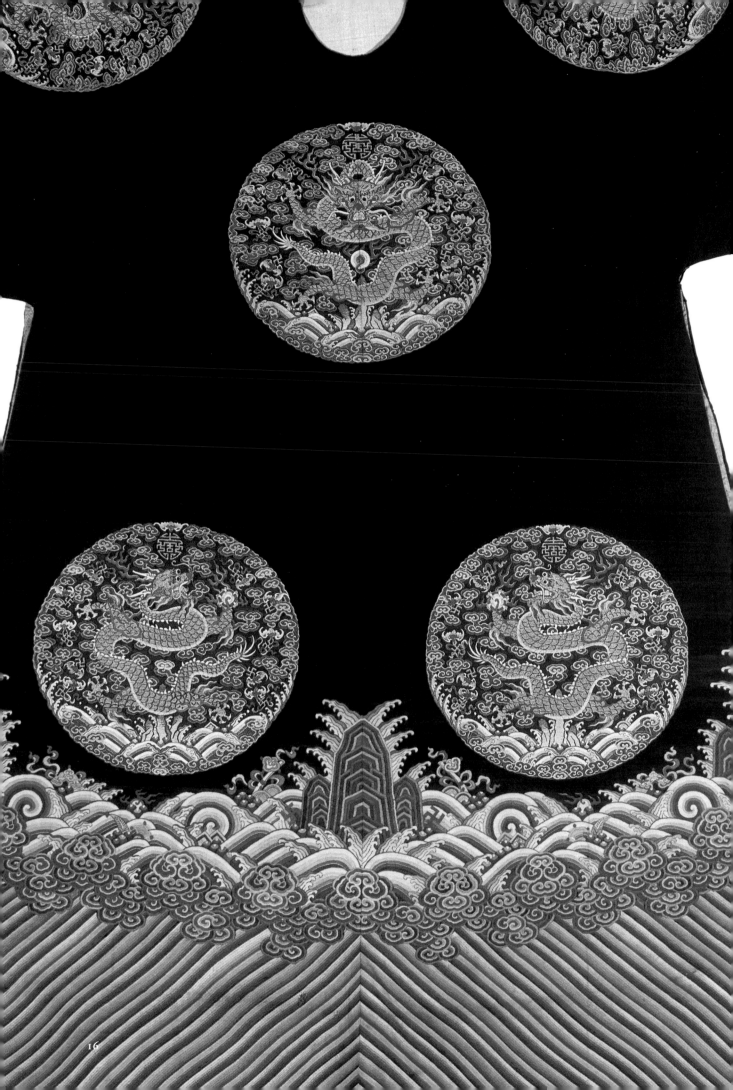

17 *Yoke from a woman's robe*
embroidered tabby

Ming dynasty, 16th–17th century
length 106 cm; width 112 cm

The quatrefoil yoke and skirt band decoration used for both court and domestic garments during the Ming dynasty was a legacy of the Jin and Yuan dynasties (see no. 7). Areas of ornament contrast with a ground that is plain or self-patterned. Dense patterns in the quatrefoil yoke and across the fold at the top of the sleeves focus attention on the wearer's head, creating a horizontal frame from which the rest of the voluminous coat flows. A band of ornament at the knees emphasized the expanse of the skirts and, during the Ming period, would have enhanced the graceful movement of the robe without cutting the sweep of the garment to the floor.[1]

The design convention of placing animals in a landscape setting dates from the 12th century (see no. 5). On this Ming dynasty robe fragment, eight pairs of phoenix fly amid a tangle of blossoming stems that grow among pierced rocks rising from the sea. These Lake Tai rocks were associated with gardens, but also recalled the Daoist theme of the Isles of the Immortals in the Eastern Ocean. Among the earliest precedents for this phoenix and blossom design on a lobed quatrefoil yoke is an embroidered late 13th or early 14th century fragment, now in a private collection.[2]

1 Four fragments of a related yoke patterned with phoenix and peonies from a brocaded damask robe are in The Metropolitan Museum of Art (62.29.1 a,b,c,d), unpublished.

2 Watt and Wardwell 1997, p.186, fig. 80.

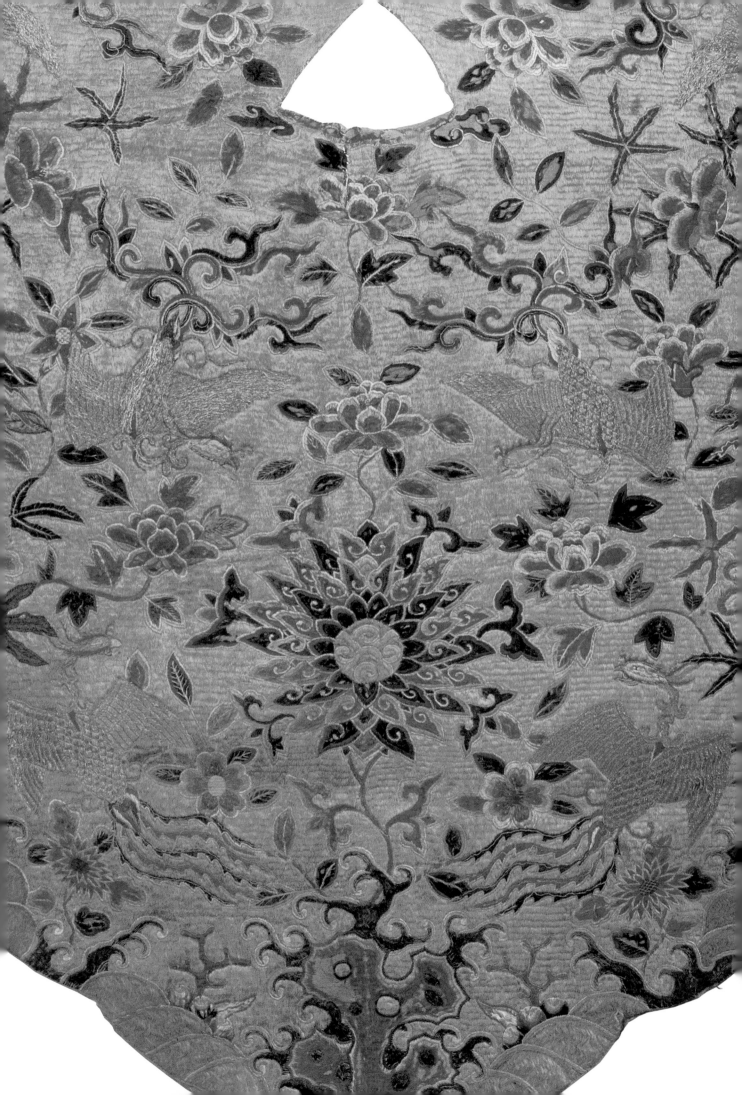

18 *Fragment of a robe band*
 embroidered solid cut velvet
 Ming dynasty, 16th-17th century
 length 27.5 cm; width 65 cm

19 *Fragment of a robe band*
 embroidered tabby
 Ming dynasty, 16th-17th century
 length 23 cm; width 30 cm

At the Ming court, dragons ornamented the yoke and band patterns of official robes of the aristocracy *(see fig. 7)*. The Mongol convention of placing the heads of dragons on the center front and back of the yoke with their sinuous bodies looping over each shoulder continued during the Ming and it was in this form that the design was transmitted to the Manchu. Ocean waves and prism shaped rock-like mountains symbolizing a cosmic landscape define the lower edge of the quatrefoil yoke and clouds fill the space above. In the skirt bands, smaller running dragons are shown against clouds with mountain and sea borders below.

The Ming emperors bestowed yardages with quatrefoil yoke and band designs as diplomatic gifts upon foreign leaders. Gifts of Ming robes and yardages to Manchu chieftains were recut to nomadic tastes, but the yoke and band decor was respected. When the Manchu became the Qing emperors, their formal robes or *chaopao* preserved this distinctive Ming pattern (see no. 20).

Both fragments shown here would once have been part of the band decor of robes with the characteristic quatrefoil yoke. Their exuberant embroidery reflects court tastes under the Wanli emperor. The fragment with the pair of four-clawed *mang* utilizes couching, padded couching and laid and couched stitches in a variety of different threads to form a richly textured surface which complements the equally rich surface of the solid cut and uncut velvet patterns of the main fabric. The other fragment uses parallel rows of overlapping satin stitch to create a yellow background in contrast with the red silk tabby fabric on which it was worked. This technique creates color and textural contrast without changing the drape of the relatively lightweight fabric (see no. 17).

ARTIST : RICHARD SHEPPARD

fig. 7 Schematic diagram of Ming dynasty yoke and band decorated robe

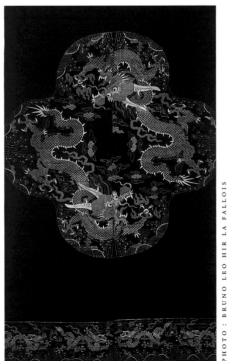

PHOTO : BRUNO LEO HIR LA FALLOIS

fig. 8 Chaopao *yardage*
17th century
Musée Guimet, Paris
Former Myers Collection

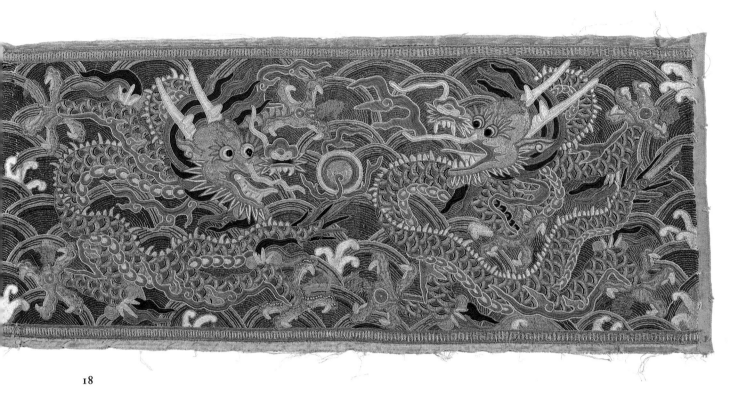

18

19

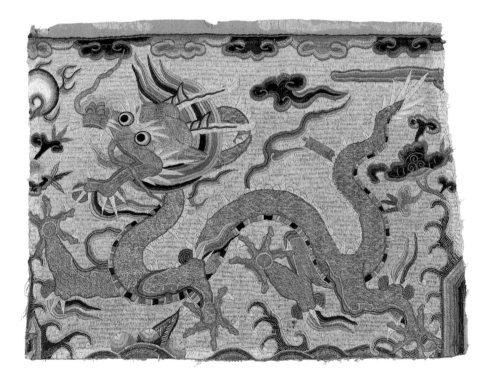

20 *Man's chaopao or formal court coat*
damask with patterned areas of figured satin
Qing dynasty, Kangxi period, early 18th century
length 134 cm; width across shoulders 218 cm

PUBLISHED John E. Vollmer. *Ruling from the Dragon Throne: Costume of the Qing dynasty (1644-1911)*. Berkeley and Hong Kong 2002, pp. 66-67.

The dragon decor of this garment follows the Yuan and Ming dynasty quatrefoil yoke and band scheme, contrasting patterned areas with the solid colored damask *(see fig. 7)*. Its use here reflects the history of the Manchu who had formerly been vassals of the Ming court. From the end of the 16th century, the leaders of the Manchu clans, having accepted Chinese suzerainty, received both bolts of silk and dragon-patterned coats from the Ming emperors.[1] Adapting fabric designed for voluminous Ming dynasty court garments to the more body-fitting forms of Manchu clothing, which derived from animal hide constructions, resulted in crowding the pattern.[2] The figured yoke design of the upper garment extended to the waist in the front and back, and to the elbow at each shoulder; a horizontal band marked the midpoint of the skirt. A second horizontal band of dragons – probably originally pieced from leftover patterned fabric – was placed between the yoke and the skirt band.

Qing male formal attire evolved into a single garment, although visually its construction preserved the three original units. The upper part was a riding coat, of which only the lower sleeves and cuffs were visible. Over the riding coat was a short sleeved, hip-length surcoat. The third component, a pair of aprons worn over trousers and boots, was arranged to overlap at the sides and gave the ensemble a bulkier,

hence more formal, appearance. By 1644, the tradition of Manchu silk *chaopao* decorated with yoke and band areas of dragon patterns was so firmly established that its form was unchangeable except for stylistic variations in the motifs. Because of its ceremonial use and ethnic significance, the formal *chaopao* was the most conservative of Manchu costumes, preserving features distinctive to Manchu native costume worn prior to the conquest. The full court regalia included a robe, a hat and accessories.

Manchu formal attire, *chaofu* or court costume, was worn for the most important court functions. These events included the Grand Audiences held in the Forbidden City on such occasions as the enthronement of the emperor, receiving felicitations from officials, imperial weddings, imperial nominations, banquets associated with the festivals of the New Year, the winter solstice, the emperor's birthday, the great ritual sacrifices held at the turn of the seasons and at other significant events that were performed outside the walls of the capital.[3] Only the highest-ranking courtiers were entitled to attend these events and wear the required wardrobe. Because these garments reflected the highest level of court status that an individual could attain, Qing period posthumous or ancestor portraits of nobles and high-ranking military and civil officials show them wearing *chaopao* and its accessories.

Compared to other types of court robes, the number of *chaopao* was small; as a result, the survival of Qing dynasty *chaopao* is rare. Of the surviving examples of *chaopao* in Western museum collections, most date from the last half of the 19th century. In addition to this garment, only the skirts of an embroidered satin *chaopao* in The Victoria and Albert Museum can be dated to the 18th century.

1 Cammann 2001, pp. 20-25.
2 Vollmer 2002, pp. 35-57.
3 Ter Molen and Uitzinger 1990, pp. 71-73.

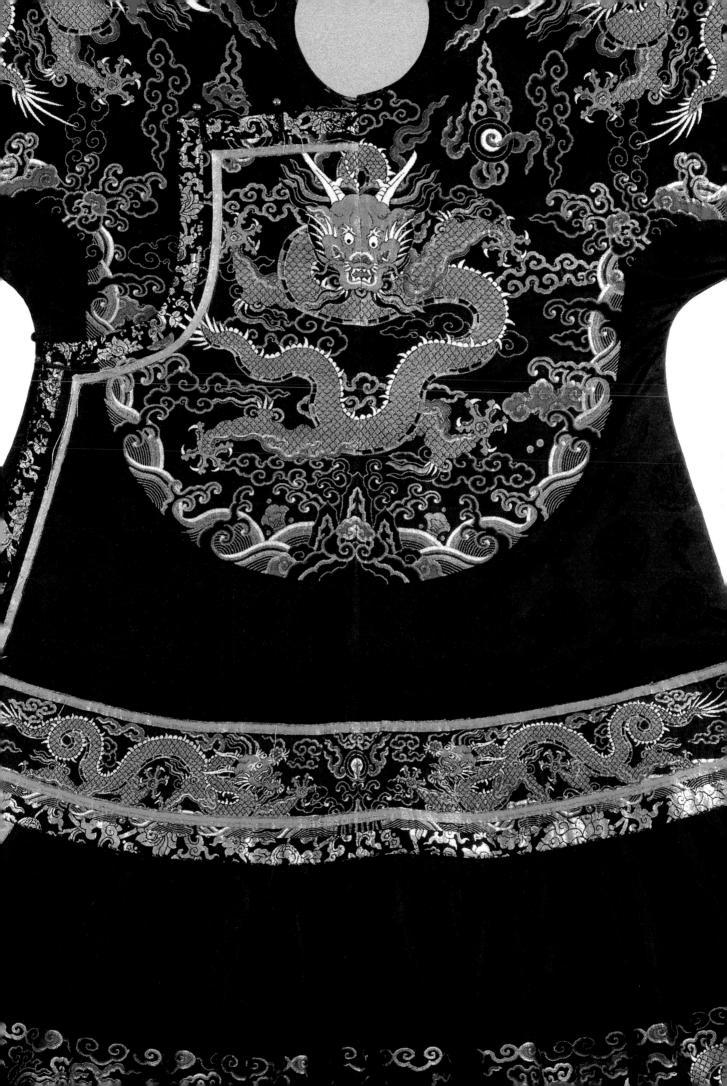

21 *Fragment of a* longpao *or dragon robe*
embroidered gauze
late Ming dynasty, mid-17th century
length 104 cm; width 72 cm

22 *Fragments of a* longpao *or dragon robe*
brocaded satin
late Ming or Qing dynasty, mid-17th century
length 113 cm; width 97.5 cm

During the Yuan dynasty, the Chinese silk industry, which had always prospered under imperial patronage, was reorganized into two offices for weaving and dyeing or *zhiranju.* One establishment was located at Xunmalin in Mongolia, the other at Besh Baliq in Central Asia. The workshops at Besh Baliq were later moved to Dadu (Beijing). New designs and technologies were introduced through trade and by relocation of foreign artisans.[1] When the Ming dynasty was established in 1368, the Ming imperial household assumed control of the Yuan imperial textile factories in Beijing and established a second imperial textile production center in Nanjing.[2] Two centuries of peace under the Ming encouraged the wider appreciation and use of luxury goods. Sericulture spread; advances in weaving technology and improved distribution systems led to increased production to meet internal needs and supply the growing international trade in silks. Trade flourished first with China's many neighboring states and South Asia, then with Europe. Under Ming court patronage, there was great creativity at the imperial silk factories and as a result the variety and range of textiles and the brilliance of their designs increased.

By the end of the 16th century, imperial silkworks had begun to experiment with dragon designs. The separation between areas of decoration and the self-patterned field was gradually eliminated. One approach amalgamated the patterned areas when the mountain and billow borders of the quatrefoil yoke moved to the top edge of the horizontal band at the knees and similar borders at the lower edge of the horizontal band moved to the hem of the coat. This was already well established at the court of the emperor Wanli, as evidenced by various garments recovered from his tomb, excavated in the 1950's.[3]

Further modifications occurred during the early 17th century when distinctions between the areas of decoration for the upper and lower portions of a robe were discarded, resulting in an integrated composition *(see fig. 9).* A single mountain and billow border at the hem marked the bottom of the coat's pattern, while the body of the garment represented the sky in which dragons were seen among clouds. Initially, the main dragons remained looped over the shoulders, while the smaller dragons, liberated from their horizontal bands, were given more prominence on the lower skirts. Later adjustments focused even more attention on the principal dragon ornament. As these two fragments demonstrate, the dragons were uncoiled from the shoulder and extended full length down the front and back of the coat, creating a striking and imposing image of cosmic order.

1 Watt and Wardwell 1997, pp. 127-141.
2 Shih 1976, p. 2.
3 Dingling Museum 1990.

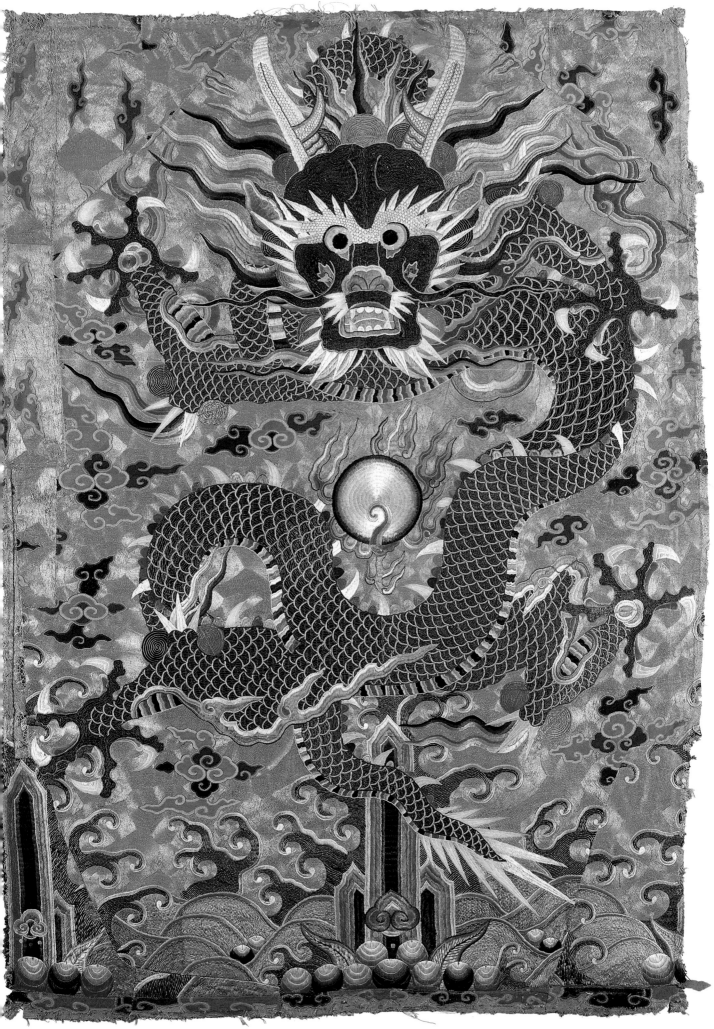

The design of the embroidered fragment of the back of a *longpao,* no. **21**, combined lavish materials – gold-wrapped threads, peacock feather filament-wrapped threads, floss silk, as well as plied silk threads – and accomplished techniques typical of late Ming imperial production.[4] Its richly textured surface contrasted highly reflective elements like the concentric patterns of couched gold thread and accents of satin stitches with less reflective areas in counted stitch work and laid and couched stitches in floss silk. The brocaded pattern from the front of a dragon robe, no. **22**, was designed without repeats and would have required a highly skilled and time-consuming loom set up and production schedule. It reflects the consummate skill of the 17th century drawloom weaving workshops.[5]

By the mid-17th century, the Qing had adopted the Ming dynasty practice of patronizing the silk industry. The number of imperial silkworks increased to four: Suzhou, Hangzhou, Nanjing and the silkworks in Beijing, which was renamed a *jiranju* or textile workshop,[6] where production continued without interruption.

ARTIST : RICHARD SHEPPARD

fig. 9 Schematic diagram of Ming dynasty integrated pattern robe

4 Although approximately 50 years later in date, a solidly embroidered dragon robe in The Royal Ontario Museum (919.6.21) uses a very similar design and mixture of embroidery stitches. See Vollmer 2002, p. 95.

5 A much altered garment, which has reversed the front and back of an almost identical fabric is in The Metropolitan Museum of Art (65.217), unpublished.

6 During Qing administration, each establishment was under an administrator appointed by the emperor and was strictly regulated as to the procurement of raw materials, shipments of finished products, the laborers, their wages, and the specific types of silk textiles each produced, as well as the prices for any excess goods which could be sold. See Shih 1976, pp. 1-2.

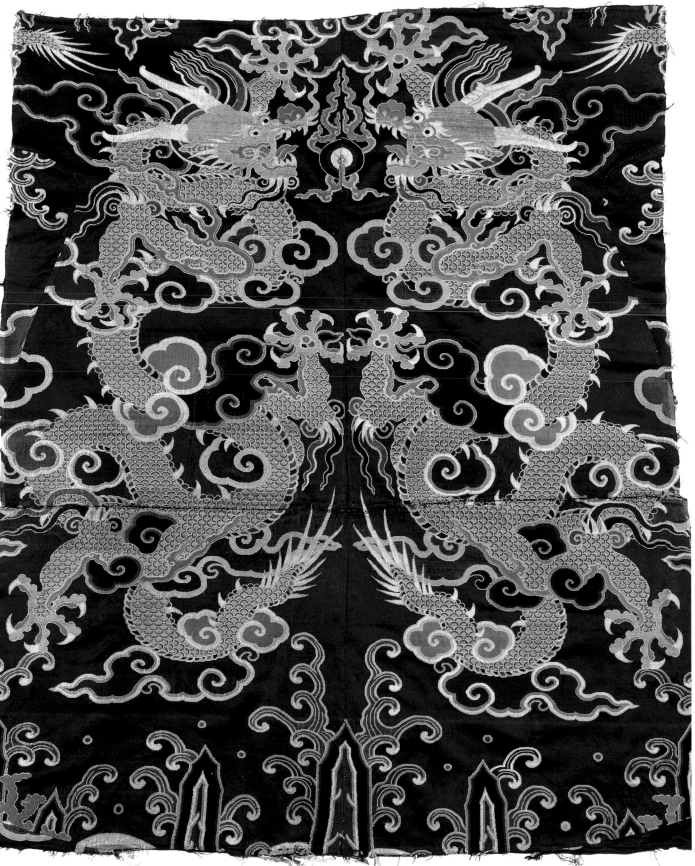

22

23 *Unfinished* gua *or surcoat*
figured twill or satin

Qing dynasty, late 17th century
a coat length 136 cm; width 137 cm
b sleeve end fragment length 41 cm; width 28 cm

PUBLISHED Christine Kontler. *Arts et Sagesses de la Chine*. Milan 2000, pl. 88 and p. 238.

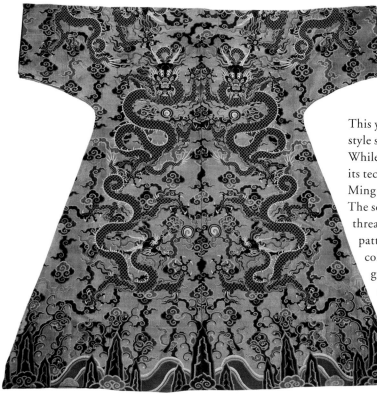

23 a

This yardage is woven to the shape of a Manchu-style surcoat with tapered sleeves and flaring skirts. While it was intended for a Qing court official, its technique and aesthetics stemmed directly from Ming dynasty silk production standards (see no. 22). The solidly figured designs in silk and gold-wrapped threads create an effect similar to the embroidered patterns of no. 21, although here the brilliantly colored motifs are set against the cloth of gold ground. The use of dark blue and green threads on the dragon's scales suggests the more costly threads of peacock tail feather filaments. The lavish use of gold also evokes the tradition of *nasij* or cloth of gold robes that were distributed at the Yuan dynasty court as a sign of imperial favor.

Of the two new dragon-pattern styles developed at the end of the Ming dynasty, the Manchu preferred the integrated version with its single wave and billow border at the hem and a field filled with dragons among clouds. The shape and styling of Manchu garments required changes in the Ming designs. Dragons were made smaller in scale and increased in number, which was set by precedent and eventually by edict (see no. 25). The decor of surcoats became more restrained; for official use, dark colored surcoats bore the insignia badges (see nos. 14, 15 and 16).

23 b

By the early 18th century, flamboyant robes like this were out of fashion, which probably accounts for the fact that this fabric was sent to Tibet unused, where it was pieced with other textiles to create an altar canopy. For these liturgical furnishings, which were suspended over an altar platform and its icons, Tibetans preferred to use larger pieces of Chinese textiles. In particular, dragon robes with their cosmic imagery provided a ready-made representation of the firmament or canopy of heaven. In this instance the entire yardage of an early Qing surcoat, none of which survive in China, has been preserved, affording us an insight into the transition of Ming style court textiles for Qing dynasty use. These transformations had previously been known only from a handful of costume depictions on ancestor portraits.

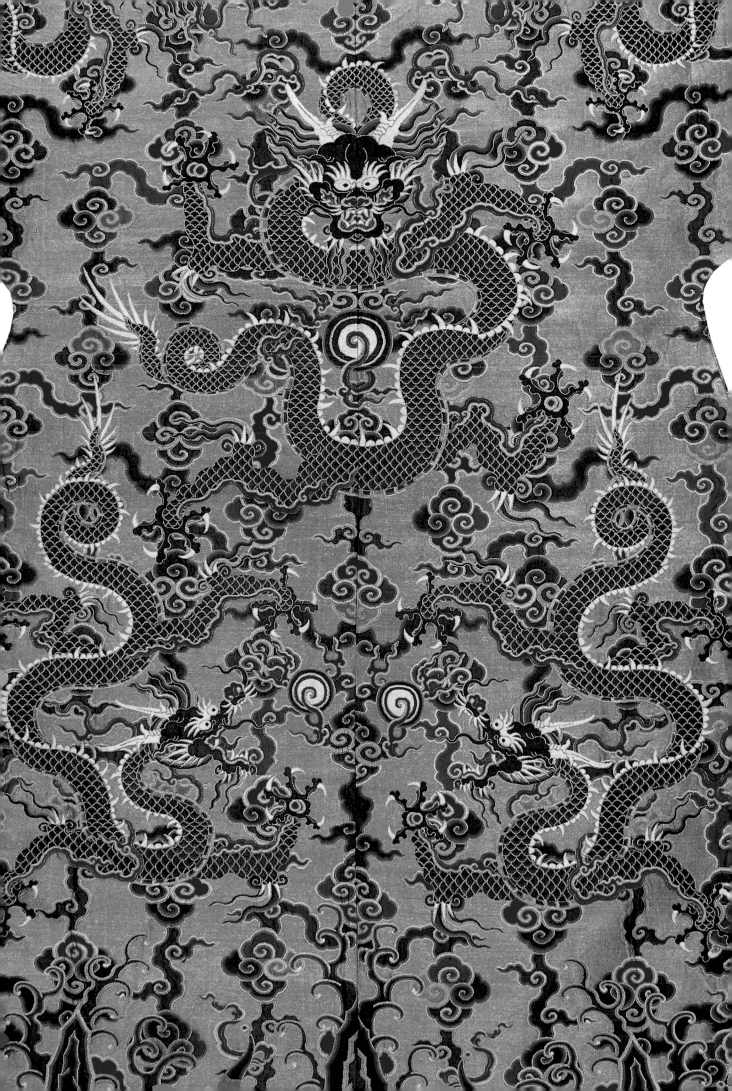

24 *Man's jifu or semiformal court robe*
embroidered satin

Qing dynasty, early 18th century
length 139 cm; width across shoulders 139 cm

Musée des Arts Asiatiques, Nice
Former Myers Collection

PUBLISHED John E. Vollmer. *Ruling from the Dragon Throne: Costume of the Qing dynasty (1644-1911).* Berkeley and Hong Kong 2002, p. 105.

During the 1st century after the Manchu conquest, Qing wardrobe requirements expanded far beyond the ritual clothing specifically mentioned in the earliest sumptuary legislation.[1] The proliferation of patterns and garment types for the Manchu nobility and Han Chinese officials resulted in a misuse of symbols originally controlled by edict or imperial prerogative. In addition, the role of the Qing emperor was revised to link the Manchu rulers more firmly to the traditional Chinese imperial model.[2]

These efforts attempted to balance Manchu and Han Chinese interests to create a new semiformal robe, which became known as *jifu* or auspicious attire.[3] Refinements instituted during the 1720's were made at the expense of the dragon decoration. First, the upper front facing or standing dragons and lower profile or walking dragons became roughly the same size. Second, increasing attention was given to secondary motifs: the wave and mountain border rose higher from the hem, reaching to midcalf. Clouds evolved from large scattered motifs to more closely spaced ribbonlike forms. Third, the costume construction began to incorporate multiple fabrics.

Although largely undocumented, the evolution in official attitudes toward dress can be observed in a small group of the surviving garments; among them, this example.[4]

By the early decades of the 18th century, Qing court clothes were deliberately redesigned to meet traditional Chinese, rather than Manchu, aesthetics. Chinese taste preferred garments with distinct, often contrasting borders at the hem, neckline and sleeve edges. Chinese valued the preservation of the integrity of pictorial images; the Manchu or Tibetan practice of piecing, patching or otherwise rearranging

pattern elements looked crude and disordered to the Chinese. Qing coats were worn tightly belted at the waist, thus cutting the large single dragon design in half, which probably accounted for the decision, during the reign of the Kangxi emperor (1662-1722), to abandon the single large dragon motif in favor of separate dragon patterns on the upper and lower parts of the garment. The four larger dragons were confined to the upper part of the coat; pairs of smaller, confronting dragons were placed on the coat skirts at the front and back; and a fifth smaller dragon was placed out of sight on the panel under the front overlap. This unseen dragon brought the total to nine, a number associated in ancient Daoist numerology with infinity and heaven.

These changes in scale and placement of the principal ornament of the robe resulted in changes elsewhere. The lower border advanced upward from the hem to fill the void, and by the early years of the 18th century the *lishui* or standing water motif rendered by parallel colored wave bands was a prominent feature of Qing dragon coat imagery. Other construction and design changes, such as the reduction of the mountain symbols to four and changes in the scale of components like the clouds, served to better integrate these secondary motifs with the dragons.

These reinterpretations of older Chinese imperial design conventions transformed Qing costume ideas from those of a conquering people into a wardrobe appropriate for the rulers of the Chinese empire.

1 Vollmer 1998, pp. 49-54.
2 *Ibid.*
3 The name *"jifu"* appeared in the *Zhouli* 1975 (Book of Rites of the Zhou), ch. 21.7; Cammann 2001, p. 22.
4 A garment of slightly earlier date and similar color and style, but without facings and with reconstructed sleeves, is in The Royal Ontario Museum (951.142). See Vollmer 1977a, pp. 50-51.

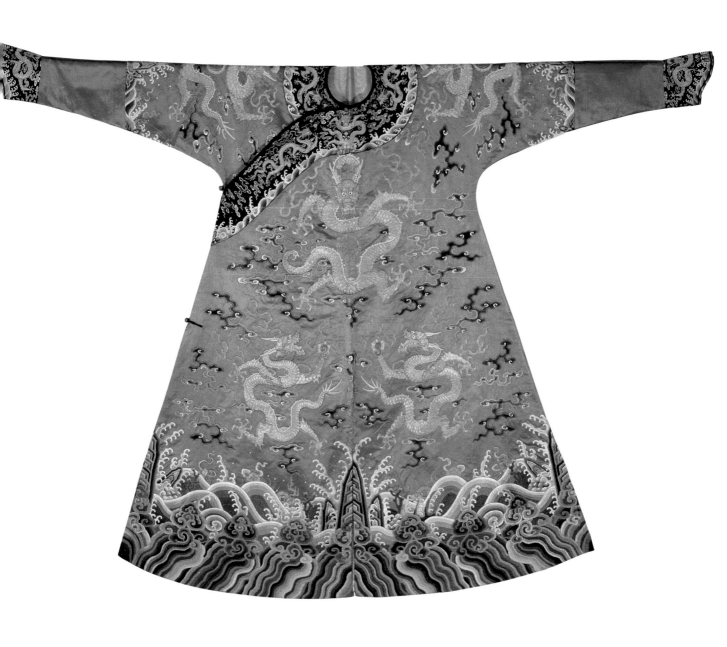

25 *Emperor's* jifu *or semiformal court robe with the Twelve Symbols of Imperial Authority*
embroidered satin and seed pearls

Qing dynasty, Qianlong period, third quarter of the 18th century
length 145 cm; width across shoulders 190 cm

provenance: Edmond Fourier Collection, Paris[1]

In 1748 the Qianlong emperor commissioned a review of all previous costume regulations enacted during the reigns of the first three Qing emperors, each of whom had modified the laws for court attire through the *neiwufu* or Office of the Imperial Household. The Qianlong review culminated in the promulgation of a comprehensive set of costume edicts in 1759. The *Huangchao liqi tushi* (Illustrated precedents for the ritual paraphernalia of the [Qing] imperial court) classified all clothing and accessories used by the court, from the emperor to the lowest functionary. It affirmed the determination of the Manchu conqueror to resist increasing pressures to restore native Chinese costume. The reasons are eloquently summarized in the 1759 Qianlong preface:

> *We, accordingly, have followed the old traditions of Our dynasty, and have not dared to change them fearing that later men would hold Us responsible for this, and criticize Us regarding the robes and hats; and thus We would offend Our ancestors. This We certainly should not do. Moreover, as for the Northern Wei, the Liao and the Jin, as well as the Yuan, all of which changed to Chinese robes and hats, they all died out within one generation [of abandoning their native dress]. Those of Our sons and grandsons who would take Our will as their will shall certainly not be deceived by idle talk. In this way the continuing Mandate of Our dynasty will receive the protections of Heaven for ten thousand years. Do not change Our traditions or reject them. Beware! Take warning!*[2]

Ostensibly the *Huangchao liqi tushi* costume edict was concerned with preserving Manchu style clothing, and with it Manchu identity. Some garment features, like the shaped overlap at the front and the sleeve extensions with horse hoof cuffs, continued Manchu forms and construction details. But in general the restyling reflected Chinese tastes and

the efforts of the Office of the Imperial Household to transform the image of the Manchu sovereign from barbarian chieftain to the emperor of a Confucian Chinese state. The semiformal coat, which had previously borne the name of *longpao* or dragon robe, was renamed *jifu* (literally, auspicious attire), undoubtedly a reference to the name appearing in the *Zhouli* (Book of Rites of the Zhou).

The sumptuousness of this magnificent embroidered robe reflects the Qing court taste for lavish silks and the quality demanded for imperial textiles. Every detail of the embroidery, from the principal dragons to the waves in the border trim, is meticulously worked despite the fact that this garment would have been worn with a surcoat, almost totally concealing the decor. This gives some idea of the perfection demanded of robes for the Son of Heaven.

In accordance with stylistic changes of the first third of the 18th century (see no. 24), this robe is constructed of multiple fabrics, standard practice for Qing court attire after the 1759 edicts. Here a yellow satin ground fabric constitutes the body of the robe. Dark blue satin patterned to complement the ground fabric is applied as facings at the neck, the top edge of the overlap and the cuffs. A third fabric, patterned with supplementary gold thread weft patterns, is used to bind the coat edges. A fourth fabric used for the sleeve extensions is missing; it would have been made of pleated silk in imitation of the creases of a pushed-up sleeve (see nos. 20, 24, 26, 27 and 28).

1 D'Ardenne de Tizac 1924, pl. 39.
2 Medley 1982, pp. 1-30.

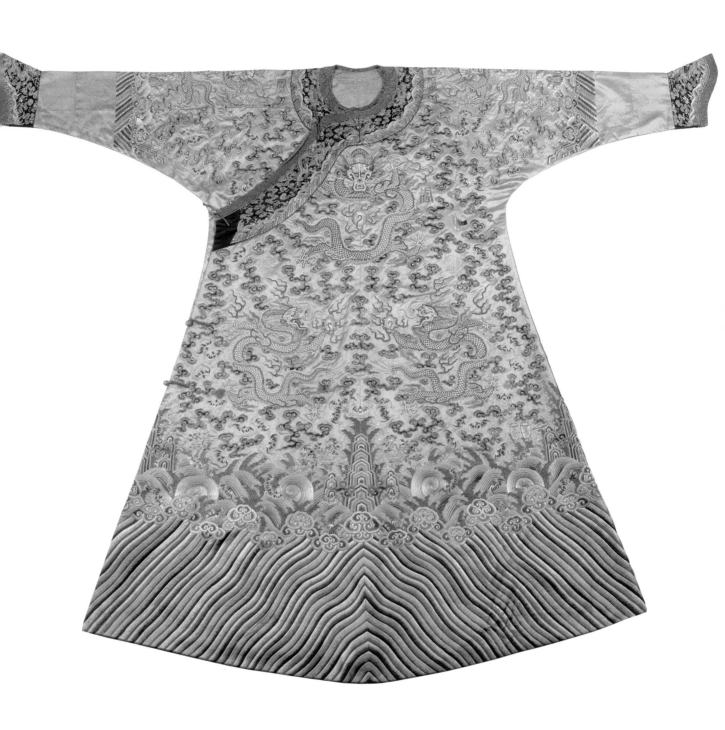

These features incorporated both Manchu garment forms and constructions and Han Chinese traditions for imperial ritual garments.[3] The resulting hybrid style, influencing our perception of late imperial Chinese aesthetics, actually imposed several north Asian ideas on Han Chinese tastes. The gold brocaded bindings reflected an innovation introduced to the imperial wardrobe during the 12th century under the Jin dynasty (see nos. 2 and 5). The combination of brocade bindings and lines of couched gold thread edgings continued the Mongol tradition of multiple borders appearing on imperial dress at the Yuan dynasty court.[4]

The lavish use of pearls in the decor of this impressive costume is one of its most striking features. All the contours of the *long* dragons were painstakingly worked in couched, spirally plied silk cord; then tens of thousands of seed pearls were sewn to fill

in the areas of the scales. Embroidery with pearls may originate in north Asian traditions, although little evidence survives to confirm this hypothesis. The Manchu particularly loved "Eastern pearls," freshwater pearls from the Sungari, Yalu and Amur rivers in Manchuria. Because of their association with the Manchu homeland, only members of the imperial clan were permitted to use them as hat ornaments. The emperor's hat finial was a tall three-tiered arrangement of fifteen pearls set in gold for the most formal occasions with a single large Eastern pearl for semiformal wear.[5] Other male members of the imperial family were entitled to fewer pearls in shorter tiered arrangements and a ruby or other red jewel for semiformal wear. The emperor also wore strands of Eastern pearls as a *chaozhu* or court necklace for rituals conducted at the Altar of the Moon. Smaller pearls decorated women's earrings and neckpieces and were used to outline borders on formal court robes.[6] The use of a myriad of seed pearls in embroidery would seem to be an extension of this Manchu taste.

Less than half a dozen pearl-embroidered court robes survive and of these only four can be associated with a particular imperial personage. A robe excavated in 1976 from the tomb of the Mongol prince, Wuergun, belonging to his wife, Rongxian, the second daughter of the Kangxi emperor, is made of yellow satin ornamented with eight roundels with five-clawed *long* dragons embroidered with pearls.[7] A robe of brown twill with couched peacock filament-wrapped threads and pearl-embroidered dragons in The Capital Museum, Beijing, like this robe, is associated with the Qianlong emperor.[8] A brown satin man's Twelve Symbol robe in the Palace Museum, Beijing, dated to the Jiaqing period, was probably intended for the emperor.[9] Lastly, a late 19th century yellow satin woman's Twelve Symbol robe in The Victoria and Albert Museum may have been made for the Dowager Empress, Cixi.[10]

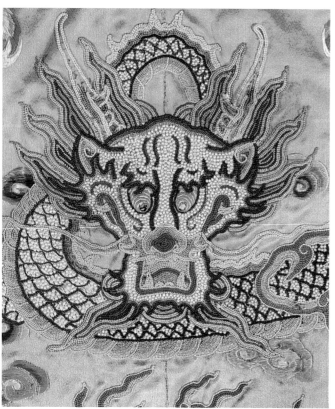

3 Vollmer 1998, pp. 52-53.
4 Watt and Wardwell 1997, pp. 130-138.
5 Dickinson and Wrigglesworth 2000, pp. 100-106.
6 The portrait of Empress Xiaoxian attributed to Castiglione illustrates the generous use of pearls on formal court attire. See Dickinson and Wrigglesworth *op. cit.*, p. 171.
7 See Zhao 2001, p. 21, pl. 4.
8 See Christie's Education and The Beijing Cultural Relics Bureau 1999, no. 99.
9 Zhao Xiuzhen 1999, p. 216, pls. 200-201.
10 The Victoria and Albert Museum (T 253-1967); see Wilson 1986, p. 41, detail, and Kerr 1991, p. 189, no. 87.

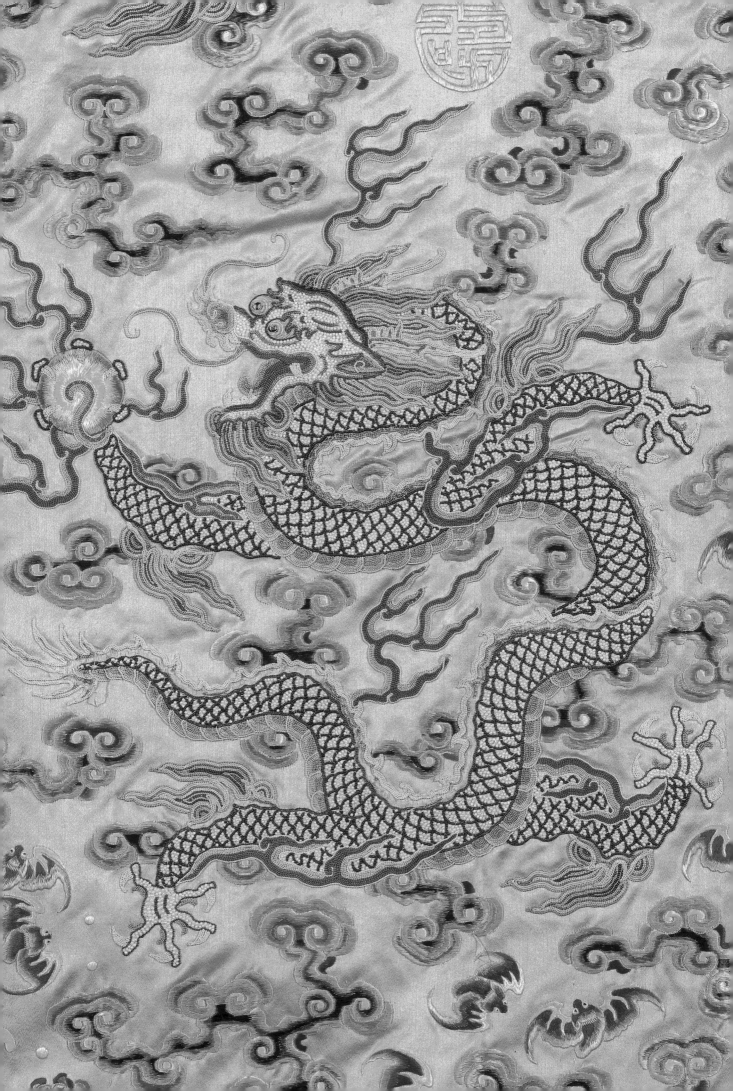

26 *Emperor's jifu or semiformal court robe with the Twelve Symbols of Imperial Authority*
embroidered satin

Qing dynasty, Qianlong period, third quarter of the 18th century
length 143 cm; width across shoulders 210 cm

PUBLISHED John E. Vollmer. *Ruling from the Dragon Throne: Costume of the Qing dynasty (1644-1911)*. Berkeley and Hong Kong 2002, pp. 109-111.

The robe shown here follows scrupulously the models illustrated in the edicts.[1] It combines four fabric types (see no. **24**) with consummate skill. The embroidery is executed with exceptional finesse; floss silk satin and long and short stitches have been placed with care, calculating the angle of the stitches so as to reflect light along the contours of individual motifs and suggest relief. The couched gold-wrapped threads worked in a pattern of overlapping scales on the dragons have been adapted to the serpentine shapes.

This robe was made for the emperor of China, the Son of Heaven, who demanded nothing short of perfection. The number of hands involved in completing the commission of this robe is now impossible to calculate. We must presume that detailed drawings with exacting iconographic

requirements were needed for the robe yardage and its trimmings. These would have been prepared and submitted for review and correction before a final presentation to the emperor himself for approval. The drawings, together with instructions for execution, would have been sent to the specific imperial workshop where fabrics for robes for the emperor were prepared. The finished needlework would have been checked against the drawings and sent to the Forbidden City, where it was certainly checked again, then placed in storage. When the emperor required a new garment, the ensemble of the robe elements would have been removed from storage, probably checked again for condition and correctness, and finally tailored into the robe we have before us, awaiting its unique appearance, worn by the emperor himself.

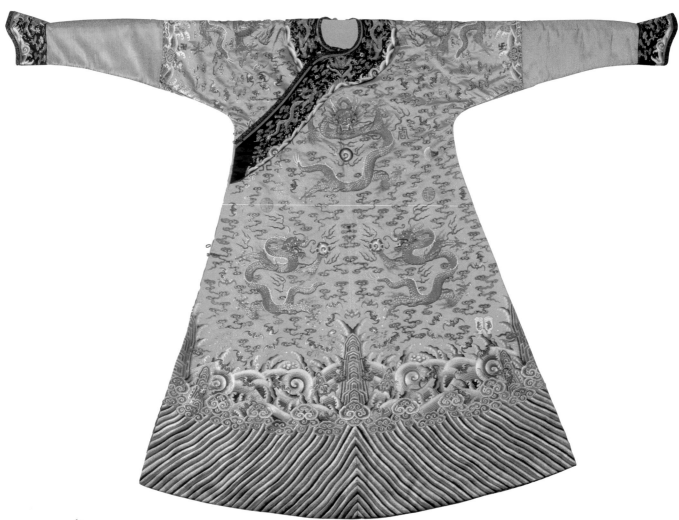

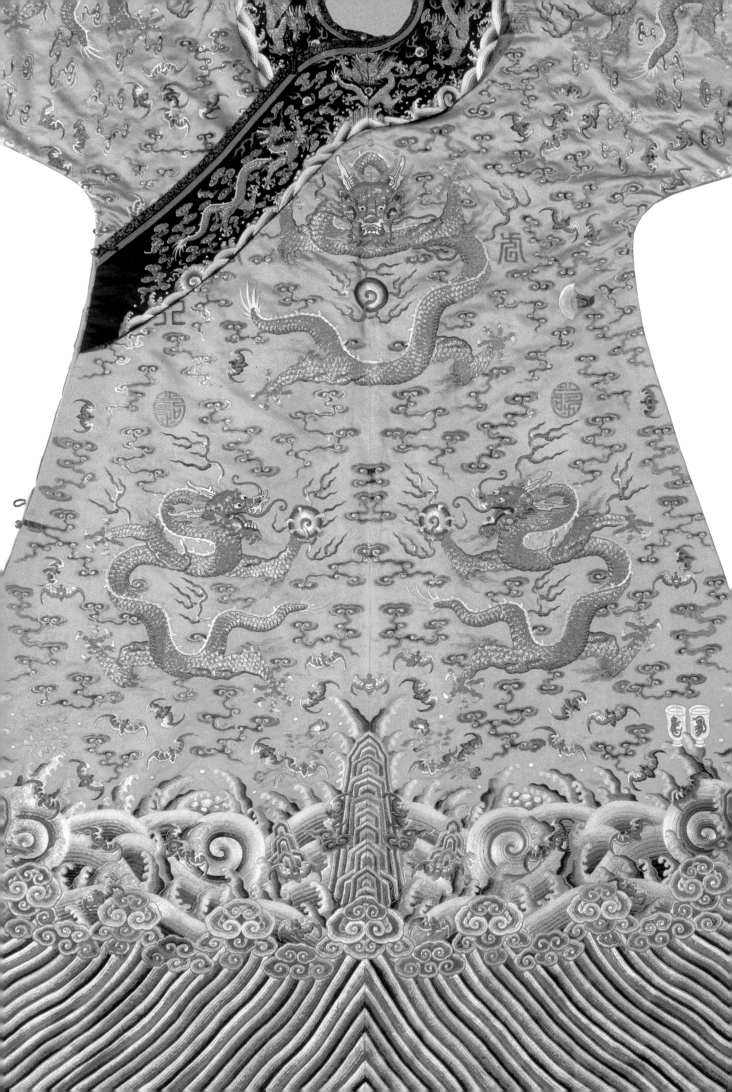

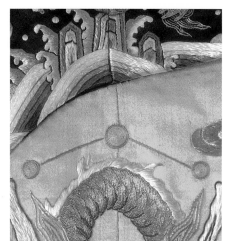

The Twelve Symbols of Imperial Authority, reserved for the emperor's use only, first appeared on the Manchu emperor's clothing after 1759, with the promulgation of the edicts.[2] This was part of a plan to legitimize Manchu power by linking it with the ancient ritual iconography associated with the Chinese emperor. The first four symbols – the sun, moon, constellation and rock – were placed respectively on the shoulders, chest and back of the coat. These emblems referred to the celestial and terrestrial powers to which the emperor made sacrifices during the year. These sacrifices were conducted at four imperial altars which were aligned with the cardinal points of the compass and located outside the walls of the capital: the sun to the east, the moon to the west, heaven (represented by the constellation of three linked stars) to the south, and earth (represented by the rock) to the north.

On the emperor's court garments, eight additional symbols were placed on the robe, four on the upper torso, four on the skirts, each aligned in accordance with astronomy and the seasons. The four symbols on the torso were: at the front, the *fu* (a pair of mirror image characters) and an ax head; in corresponding positions on the back, a pair of *long* dragons and the "flowery creature" (usually shown as a golden pheasant). These four symbols are related to the four major astronomical events of the year: the *fu* symbol, sometimes translated as the "symbol of distinction", can also be linked to the homophone character for "return", a term used in connection with the winter solstice when days begin to grow longer. The paired dragons are placed diametrically opposite the *fu* symbol. They reflect the polarity of increasing and decreasing changes in light and darkness at the summer

solstice. The ax head and the flowery creature are located equidistant from the markers of the solstices. The ax, traditionally the symbol of the emperor's power over life and death, occupies the position of the autumn equinox, when all executions took place in ancient times. The flowery creature marks the spring equinox, linked to the appearance of the Red Bird Constellation in the late spring.

Usually, another group of four symbols appear just above the *lishui* or standing water border: aquatic grass, temple cups, flames and grains of millet. These correlate with four elements included in the Daoist notion of *wuxing* (Five Phases) as water, metal, fire and wood. These symbols align with the four above: temple cups below the ax head are linked to the autumn equinox; aquatic grass represents the ascendant element during the winter solstice and relates to the *fu* symbol; grains of millet, symbolizing spring and wood, align with the flowery creature of the spring equinox; flames, representing fire, are aligned with the dragons marking the summer solstice; the rock, symbolizing earth, the fifth element, is placed at the center of the compass. Following the ideal formulated by the Confucian philosopher Mencius (370-290 BC), the Son of Heaven was to "stand at the center and stabilize the four quarters".[3]

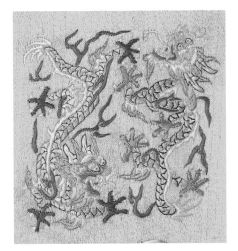
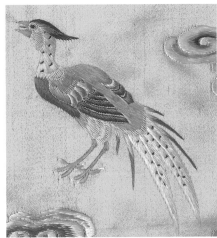

1 A similar Twelve Symbol robe is in The Royal Ontario Museum (919.6.23), unpublished.
2 Dickinson and Wrigglesworth 2000, pp. 76-98.
3 Mencius 1979, bk. VII, ch. XXV.7, p. 482.

27 *Man's* jifu *or semiformal court robe*
embroidered satin
> Qing dynasty, late 18th century
> length 143 cm; width across shoulders 204 cm

> Edwin and Rina Mok Collection, Sydney
> Former Myers Collection

28 *Boy's robe modeled on a* jifu
or semiformal court robe
embroidered figured gauze
> Qing dynasty, late 18th century
> length 90 cm; width across shoulders 134 cm

Following Chinese imperial practices, the Qing adopted a new dynastic color to legitimize their rule in accordance with the *wuxing* or Five Phases system.[1] *Wuxing* was associated with the ancient *yin-yang* philosophy. In it, the five elements of the universe – earth, fire, water, metal and wood – had a direct correspondence to seasons, directions, musical scales and colors. The sequence black, blue, red, yellow and white was viewed as the natural succession of colors. Red, the official color of the Ming dynasty (see no. 9), was replaced by yellow (see nos. 25 and 26), reflecting the belief that the element earth overcomes fire. Qing court clothing was thus harmonized with the color yellow. With the exception of rituals that required red robes, the Qing largely avoided the Ming dynastic color.

Yellow had additional significance in traditional China. Since at least the time of the Jin dynasty and possibly dating back to the time of the Gaozu emperor (618-626) of the Tang dynasty,[2] yellow robes had been the prerogative of the emperor, linking him to the mythical founder of Chinese civilization, Huangdi, the Yellow Sovereign. Some of the earliest Qing edicts reasserted this ancient imperial precedent by reserving *minghuang* or bright yellow for the emperor and his consort.[3] The heir apparent and his consort used *xinghuang* or apricot yellow, usually orange in tone; the emperor's other sons and their consorts used *jinhuang* or golden yellow; while other members of the imperial clan used *qiuxiangsi* or tawny yellow, which actually ranged from brown to plum tones (no. 27).

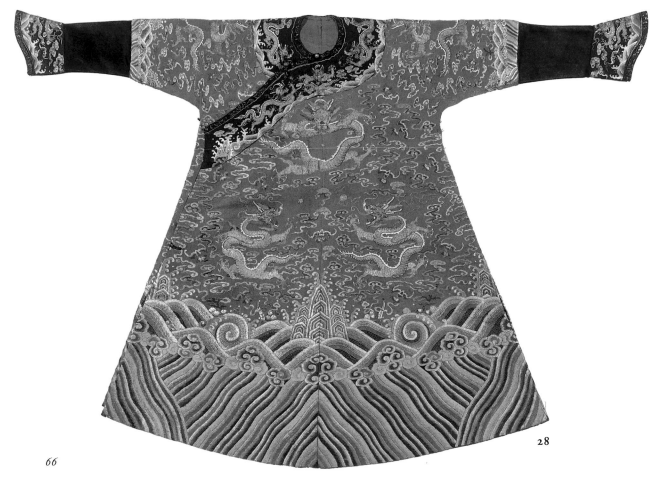

28

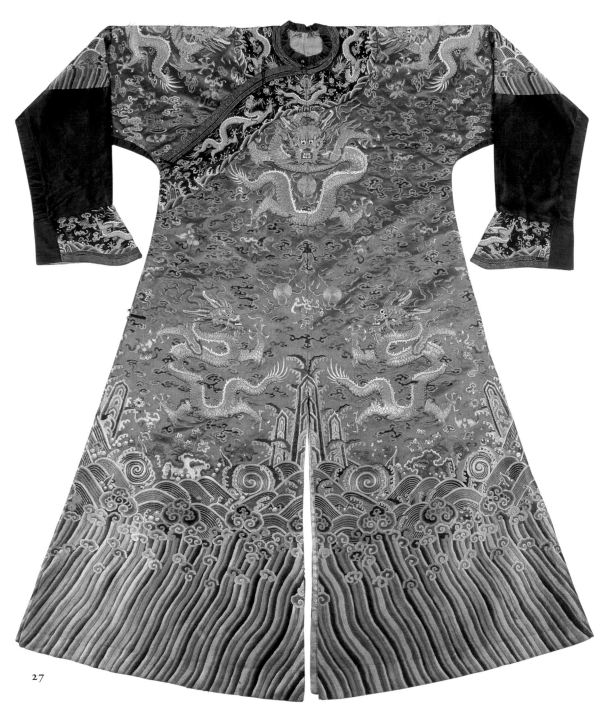

27

Manchu nobles to the rank of third degree prince used blue; all others were assigned black.

These assigned colors refer to the background of the body of the robe, restrictions which applied only to those actually worn at court. Many of the surviving Qing ceremonial and celebratory garments were undoubtedly made for purposes other than court wear. Without documentation or other evidence, it is now almost impossible to identify the rank of the owner of a garment by its color alone.

While the embroidered gauze robe no. 28 resembles court clothing, it is not an official garment as no child, except an emperor in his minority, would have attended court functions. Within the family, personal and seasonal celebrations mirrored court functions. The patriarch and matriarch were often viewed as the emperor and empress of the family; family members enjoyed status according to generation, age and kinship. Their clothes indicated their status and promoted a sense of order and harmony. For a Manchu boy, this quasi-official robe imitated the *jifu* of his father. Its purpose was to encourage the child to emulate the men in the family.[4]

1 Cammann 2001, pp. 20-49.
2 *Chun Qiu fanlu* (Spring and Autumn Annals).
 See Laumann 1984, pp. 23-26.
3 Cammann op. cit., p. 6.
4 *Ibid.*, pp. 25-26.

29 *Throne seat cushion cover*
brocaded satin
 Qing dynasty, early 18th century
 length 99 cm; width 98.5 cm

30 *Elements of an elbow cushion*
kesi, slit tapestry weave
 Qing dynasty, mid to late 18th century
 length 16.6 and 21.5 cm; width 18 and 23.5 cm

31 *Fragment of a furnishing fabric*
embroidered gauze
 Qing dynasty, late 17th century
 length 15 cm; width 56.5 cm

32 Kang *seat cushion cover*
embroidered damask
 Qing dynasty, early 19th century
 length 149 cm; width 113 cm

 provenance: Barbara Hutton Collection

33 *Fragment of a furnishing fabric*
voided cut and uncut velvet
 Qing dynasty, second quarter of the 18th century
 length 190 cm; width 62 cm

The interiors of palaces and great houses were transformed for ceremonial and social occasions by rearranging and covering furniture with appropriate silk textiles. Formal occasions at court, such as audiences and rituals, or gatherings of the family for ancestor worship, birthdays or weddings, required organizing the reception rooms. At court the setting focused on a throne or other chair flanked by tables placed on the axis of the room, facing the door. Silk textiles adorned the furniture and walls much as costume adorned the participants.

The emperor conducted affairs of state seated on an ornately carved throne; for less formal occasions, he sat on a hardwood chair. The least formal seat was a *kang,* a divan-like platform. All hardwood seats were covered with removable cushions. Thrones were always provided with a back bolster and a pair of elbow rests, while simple chairs usually had only a seat cushion and a chair cover. Either arrangement of soft furnishings would have been used for the *kang.* Any seat occupied by the emperor became the Dragon Throne, therefore most palace furnishings were made of bright yellow silk, the Qing dynastic color.

The silk furnishing fabrics used by the other occupants of the Forbidden City, like their garments, revealed their rank. The square cushion cover no. 29, while of the same superb quality as furnishings made for the emperor, has a different ground color and decor – *jinhuang* or golden yellow and five *long* dragons, identifying it as appropriate for an emperor's son or uncle. The comparable textile for use by the emperor would have had a bright yellow ground with a total of nine *long* dragons. This fabric was never made into a cushion as its rounded corners remain uncut. The *kesi* elbow cushion no. 30, composed of six panels, was part of a suite of soft furnishings, which would have included a seat cushion, back bolster and another elbow cushion. The cushion would originally have been stuffed with densely packed cotton to fill out its compressed round form.

The private chambers of the emperor and his harem were also supplied with luxurious silk fabrics. The rooms used by the emperor and his consort often had furnishings with yellow grounds and decorative images linked to the seasons. The embroidered

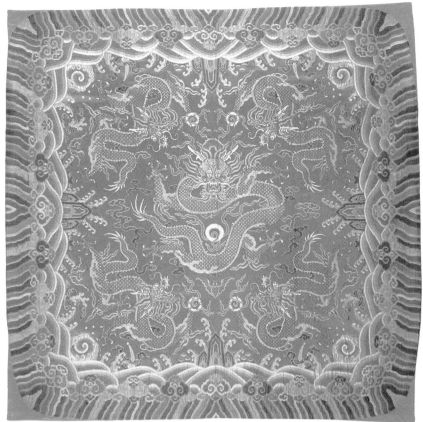

29

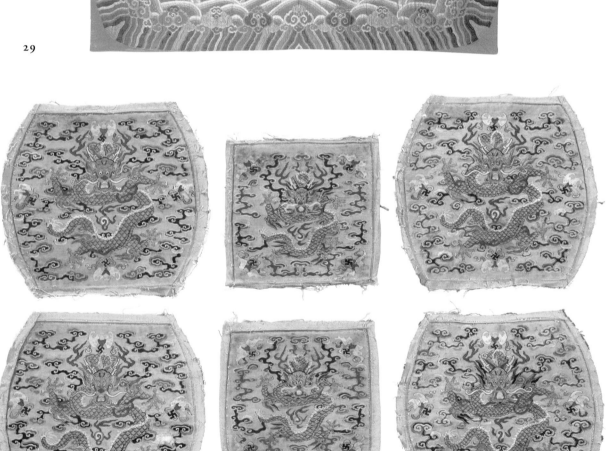

30

31

fragment no. 31 features a variety of motifs like a lotus leaf, a butterfly, a begonia and a dragonfly against a brocade-like pattern set on a diagonal grid. This complex design and its rigorous execution in counted stitch imitates a woven design. The *kang* cushion cover no. 32 presents a formal design of lotuses in satin stitch embroidery on a silk damask ground.

The panel of voided cut and uncut polychrome velvet on a yellow ground, no. 33, was probably inspired by Italian Genoese furnishing fabrics dating to the late 17th or early 18th century.[1] The Chinese weaver substituted peonies for the roses of the original fabric and probably made it especially for the exotic

architectural folly of the Yuan Ming Yuan, a favorite retreat for the Qianlong emperor. The late Ming and early Qing dynasty emperors used a succession of Jesuit priests as advisors. Western-trained artists, like Giuseppe Castiglione (1688-1766), held appointments at the Imperial Painting Academy; others maintained instruments in the astronomical observatory in the capital, repaired the various Western clocks and automata given to the Qing emperors by European heads of state, and served as architects for the series of pavilions and gardens in the rococo manner built at the Qing summer palace, Yuan Ming Yuan.

33 (detail)

1 Other examples of this textile are in The Palace Museum, Beijing (see Sezon Bijutsukan 1997, no. 43); The Art Institute of Chicago (1964.1037) (see Vollmer 2000a, p. 30, pl. XI) and The Museum of Fine Arts, Boston (41.542), unpublished.

32

34 *Woman's* changyi *or semiformal robe*
kesi, *slit tapestry weave*
Qing dynasty, late 19th century
length 143 cm; width across shoulders with sleeve folded 141 cm

Clothing worn domestically by the Manchu population was classified as *changfu* or ordinary dress. Like court attire, the domestic wardrobe was graded as formal, semiformal and informal, each category consisting of an ensemble of garments and accessories. For example, formal domestic wear included a robe and surcoat with a hat and collar. However, as domestic costume was not subject to official edicts, its ornament often expressed personal preferences.

On Manchu women's domestic garments, floral imagery was linked to the seasons to be in harmony with nature, an ideal of Chinese Daoism. Traditional Manchu features are present, such as the curved front overlap, the loop-and-toggle fastening and the multiple fabric assemblage which imitated *jifu* construction (see no. **24**). However, the primary interest in creating such clothing was aesthetic, achieving a Chinese style of harmony prized by Chinese connoisseurs. Here the theme of flying cranes in clouds is subtly orchestrated, appearing on a pale green ground for the main fabric, and on a contrasting light blue ground on the interior of the sleeves, which when turned back form decorative cuffs. The same motif appears on a white ground on the borders. This costume, like other Manchu garments, suggests the long and complex interaction between nomadic and Chinese traditions.

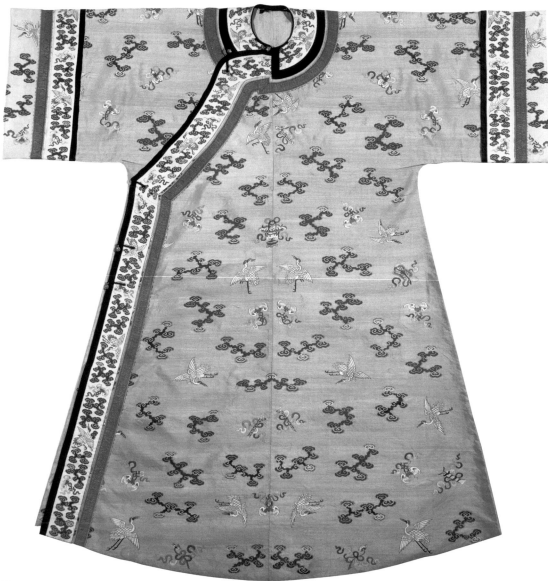

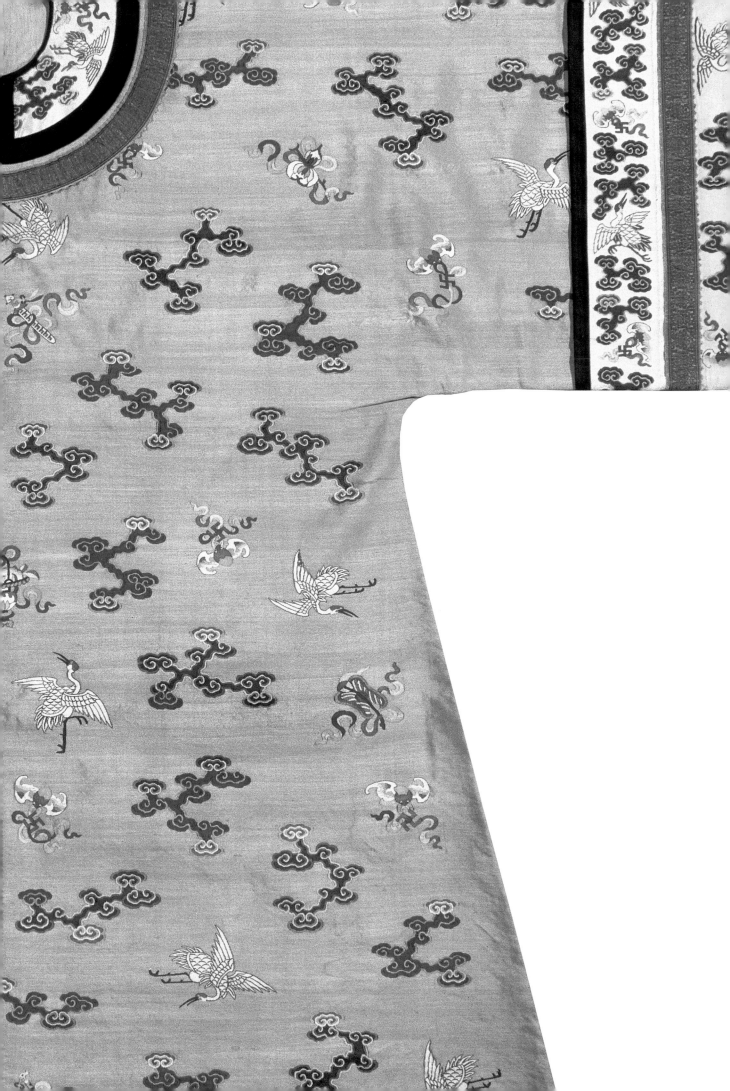

35 *Military banner*
embroidered satin

Qing dynasty, early 18th century
length 211 cm; height 162 cm

Different colored banners helped coordinate attacks on the battlefield and maintain order on the parade ground. The triangular form of this banner with dagged edges resembling flames is an old shape which can be seen in Chinese painting dating to the Tang dynasty and throughout the history of imperial China. The precise identification of this banner is elusive.[1] It may have been part of a set of five banners representing the *wuxing,* Five Phases, order of the cosmos. According to the *wuxing,* the blue-green color, *qing,* corresponds to the element wood and the east; its animal emblem is identified by the dragon. Another possibility is that this banner was associated with the Green Standard Army, *luyingbing,* which acted as the militia during the Qing dynasty.

The Green Standard Army existed outside the standing Manchu army with its Eight Banner or *baqi* divisions which conquered the Chinese empire in 1644.[2] After the conquest, banner troops and their families were settled in separate garrisons in the major cities of the empire. This segregation was an attempt to maintain the Manchu fighting spirit, to prevent assimilation and to intimidate the much larger Han Chinese population. In effect it created a population of professional warriors which over time became less efficient and more corrupt as discipline waned and there were few opportunities for advancement. However the task of enforcing the laws throughout the empire fell to the Green Standard Army, which was almost exclusively recruited from the Han Chinese population and led by officers from the Banners.

Stylistically the embroidery on this banner can be dated to the first third of the 18th century and may have identified a company of the Green Standard Army within the capital where, among other duties, it was responsible for maintaining the city gates.

1 A pair of very similar banners with a white satin ground, possibly for the White Banner regiment, are in The Minneapolis Institute of Art (42.8.282 and 283). See Jacobsen 2000, vol. II, pp. 994-997.

2 In 1601 the Manchu leader Nurgaci (1559-1626) grouped all of the Manchu population into four large units called *gusa* or banners which were distinguished by their yellow, white, red or blue flags. As the banner ranks increased during the first decades of the 17th century, Nurgaci continued to develop new companies and attach them to various banners. In 1615, he created four more banners, making a total of eight. To distinguish the new banners, flags of the original yellow, blue and white banners were given contrasting red borders, while the original red banner was bordered with white. Manchu ranks were also increased by Chinese who switched loyalties and by alliances with various Mongol tribes. By 1634, eight separate Mongol banners had been created, followed in 1642 by eight Chinese banners. See Elliott 2001.

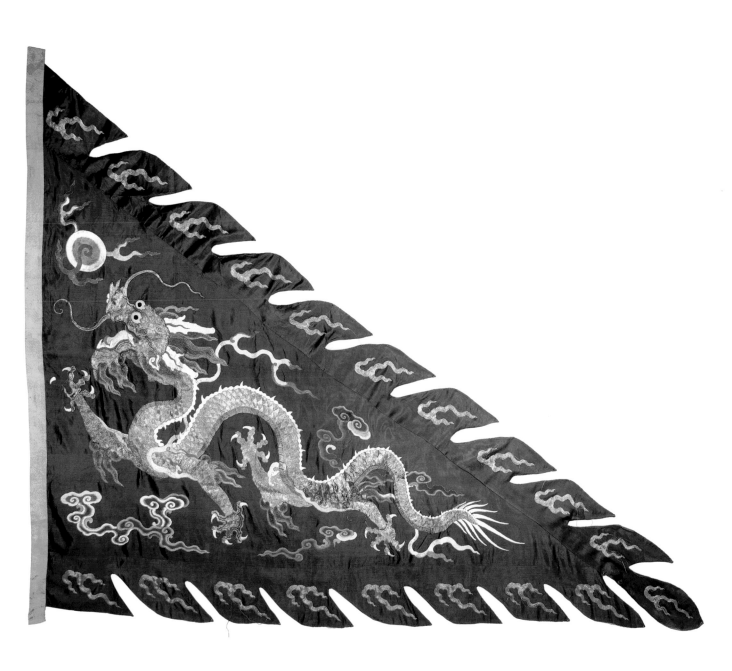

36 *Suit of parade armor*
kesi, *slit tapestry weave over metal plates*
Qing dynasty, mid-18th century
jacket length 78 cm; width across shoulders 42 cm; length of chaps 88 cm

provenance: Georges Papazoff (1894-1972) Collection, Paris
Alfred Forgeron Collection, sold in Paris in 1910

37 *Suit of parade armor*
figured satin over metal plates
Qing dynasty, early 18th century
jacket length 69 cm; width across shoulders 38 cm;
length of chaps 79 cm

38 *Suit of parade armor*
figured satin
Qing dynasty, late 19th century
jacket length 73 cm; width across shoulders 200 cm;
length of chaps 102 cm

published John E. Vollmer. *Ruling from the Dragon Throne: Costume of the Qing dynasty (1644-1911).* Berkeley and Hong Kong 2002, pp. 87-88.

The Qing conquerors were particularly sensitive to their martial heritage. During the early years of the dynasty when power was being consolidated, the emperor was present in person on the battlefield. Until the mid-18th century, the Eight Banner troops gathered in the capital for military exercises and review every three years. By extension, hunts in the hills north of the Great Wall were viewed as a means of maintaining military preparedness. Surviving evidence suggests that Manchu military uniforms were identical to their riding costumes with added coats of chain mail. Dress or parade armor did not appear until after the conquest.

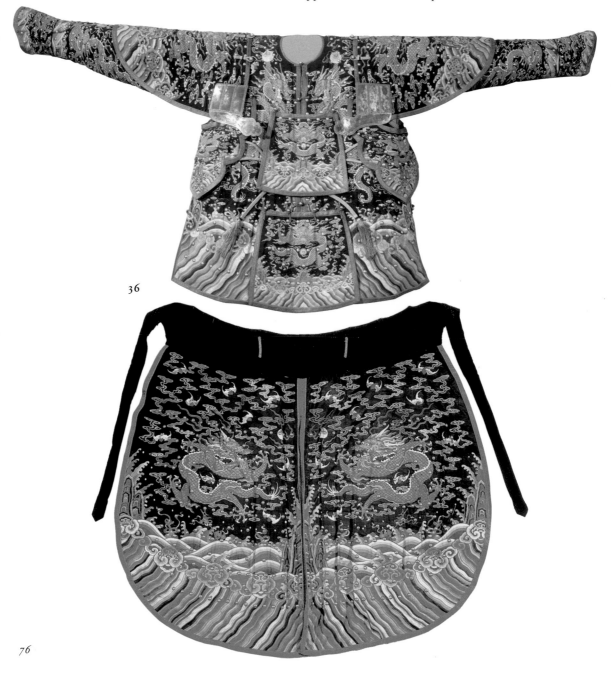

36

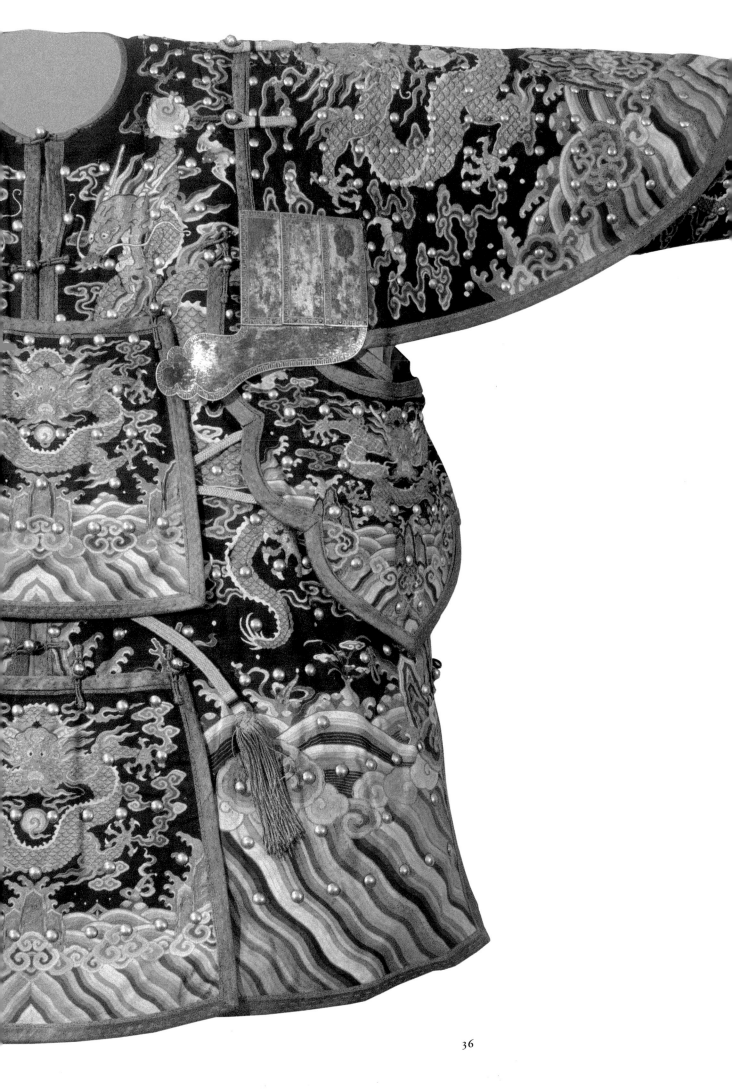

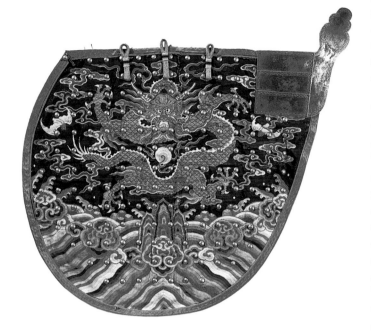

At that time, the Manchu adopted Chinese-style armor of metal plates covered with padded textiles which had been used by Han infantry since the 3rd century BC. Overlapping metal plates afforded protection from arrows, particularly those shot from powerful crossbows. Ceremonial armor worn by guards at the Forbidden City and high-ranking members of the imperial household, including the emperor, was derived from Ming dynasty prototypes and featured metal plates covered with luxury silks and gilt brass fittings.

The suits of armor shown here can be related to the *wuxing*, in which the colors black or dark blue correspond to the element water and to the north. The mid-18th century *kesi* armor no. **36** has five-clawed *long* dragons reflecting Qing innovations in displaying the imperial iconography. Each armor component, whether major like the chaps and jacket or minor like the underarm pieces, is marked with a dragon amid clouds above mountains and waves, each a miniature cosmic pattern familiar from court costumes of the period (see nos. **24**, **25**, **26**, **27** and **28**). The quality of the workmanship of the *kesi* and the extravagance of using such a delicate fabric over metal plates tempts one to associate this armor with the Qianlong emperor himself in his role as commander in chief. No other suit of 18th century armor in *kesi* of this quality has survived.

36

37

The early 18th century armor no. 37 of brocaded satin fabric over a suit of metal plates is patterned with four-clawed *mang* dragons in roundels, following one of the oldest formal decorative arrangements for court attire (see nos. 2, 3, 13, 14, 15 and 16). It would have been appropriate for a prince of the blood of the third or fourth rank *(see appendix II)*.

The suits of armor of palace guards were often elaborately decorated as befitting the protectors of the imperial person and his residence. The brocaded satin cloth of gold textile used in no. 38 has been woven with a pattern imitating a variety of chain mail. It has embroidered elements and is trimmed with silk velvet borders. The sleeves and vest of this suit were made in one piece. While the epaulets still strap onto the jacket, other components simply button onto it.

38

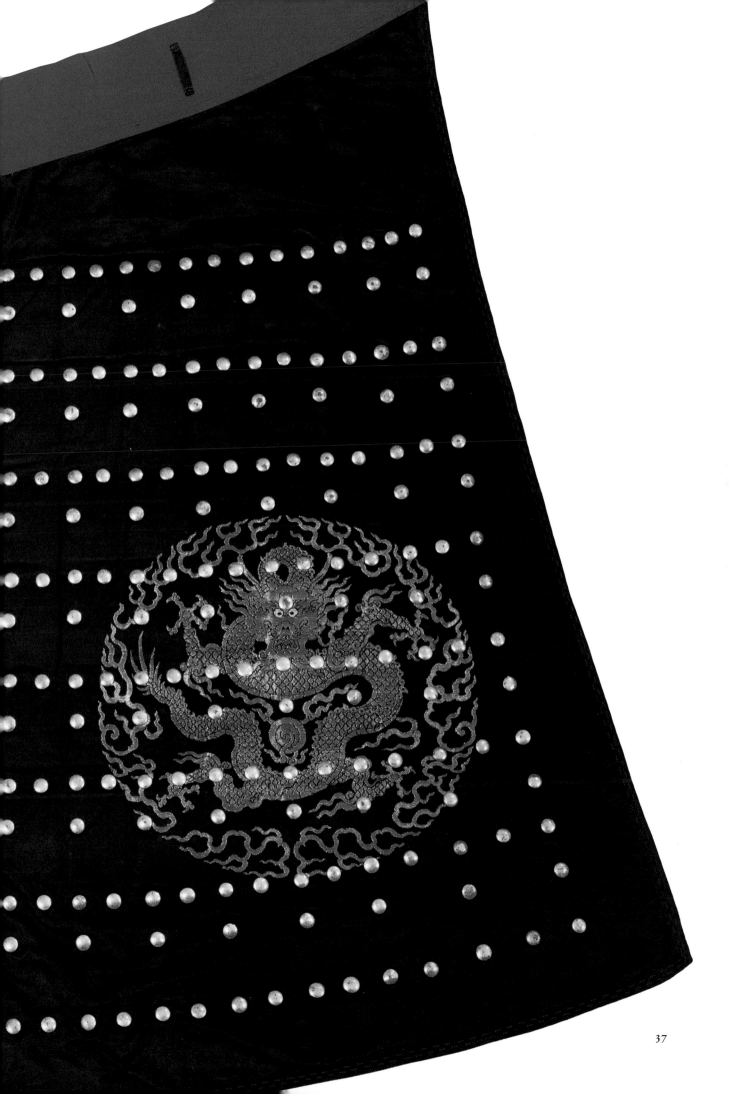

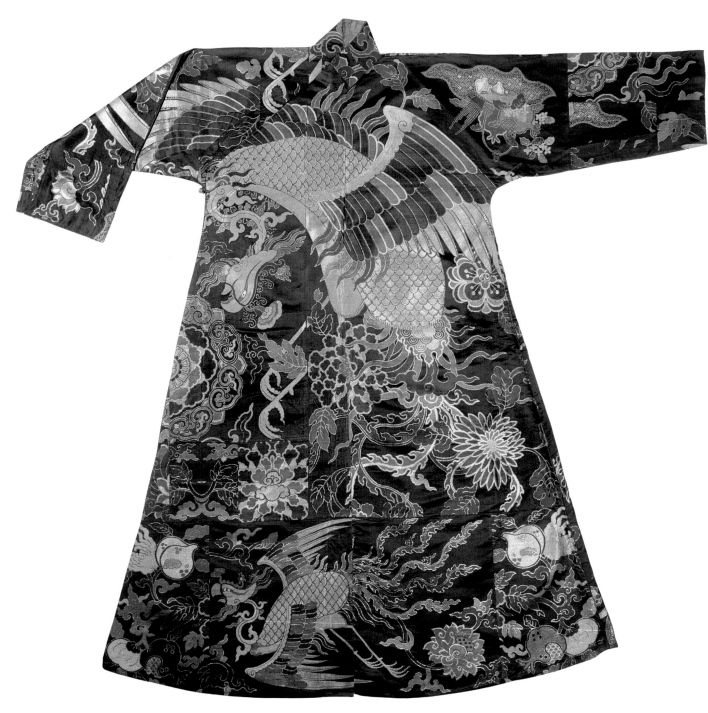

Chuba
late 17th century

Silks in Trade and Diplomacy

From the end of the Neolithic period, around 2500 BC until the 4th century AD, sericulture was a monopoly of the Chinese state. Early rulers encouraged sericulture by making taxes payable in silk cocoons or yarn. By controlling production of the finished fabrics, the use of silk was protected as a prerogative of the aristocracy. For the ruling elite, silk contributed to notions of image and status and furthered political and economic ambitions. To protect its interests, early Chinese governments prohibited the export of silkworm eggs; those caught divulging the secrets of sericulture faced execution.[1]

Because of its exclusivity, Chinese silk was highly prized by foreigners and, as a coveted commodity, an instrument of diplomacy. Traces of silk cloth recovered from the early 2nd millennium BC site of Sapallitepe in northwestern Afghanistan[2] and the mid-1st millennium BC Halberstadt site of Hochdos near Stuttgart[3] suggest that Chinese textiles were already traded over great distances during the late Bronze Age. While no written record exists to explain the presence of Chinese silk so far away, it is likely these goods moved overland to China's nearest neighbors, and then westward, changing hands as they moved from one sphere of influence to another. These fabrics may have been gifts or bribes from China's rulers to nomadic chieftains threatening the security of Chinese territory in the North and West – a chronic condition in Chinese history.

Chinese diplomacy was essentially centered on the person of its ruler. Efforts to secure the loyalty of subordinates as well as the support of foreign allies often involved distributing lavish gifts. Chinese emperors presented court garments to the highest-ranking nobles as entitlements, but they also awarded these garments to especially worthy courtiers and military officers. Gifts to foreign leaders fostered links to the Chinese imperial court. Tributary relationships were developed with peoples living on China's frontiers as a strategy to keep the empire at the center of the civilized universe. In exchange for Chinese suzerainty, the emperor awarded titles and aristocratic trappings to vassal rulers. In addition to prestigious gifts of garments and bolts of silk, the emperor might authorize limited and carefully controlled commerce between foreigners and Han Chinese.

Chuba
17th century

CAT. 44

Interaction with Tibet, which began in the 10th century, underscores the complexities of China's diplomacy and trade. After the collapse of the Tang dynasty, the Tibetans established a rival dynasty, the Xia, which controlled the Gansu corridor and trade with Central Asia and the West. Although Tibetan imperial ambitions were crushed by the Yuan dynasty in the 13th century, its leaders continued to enjoy special prominence due to the strong attachment of the Mongol court to Tantric Buddhism.[4] A century later, the Ming toppled Yuan political authority, but Tibetan

Tantric Buddhism continued to be influential in the Mongol populations on the frontiers of the Chinese empire. In efforts to control the political situation in the North and West, the Ming court renewed the Yuan practice of bestowing gifts and titles on Tibetan religious leaders and of sanctioning trade in luxury goods. Religious power politics involving Tibet and Mongolia lasted into the 17th century and imperial patronage of Tibetan Buddhism continued throughout the Qing dynasty.

Although some silks were manufactured specifically for the Tibetan market (see

Prime minister's coat CAT. 42
17th century

nos. 47, 48 and 49), many of the textiles sent to Tibet had originally been produced for the Chinese court (see nos. 43, 44 and 45). They were often drawn from textiles amassed by the imperial household and held in reserve for such purposes. Although highly prized, garments and furnishing fabrics were frequently recut to fit Tibetan costume styles or to serve new functions, which were often at variance from their original decorative schemes and symbolic meanings (see nos. 42 and 43). This practice was widespread among China's neighbors: 16th century Manchu chieftains also recut Ming robes and yardages received as diplomatic gifts to fit their local traditions, a

practice that was preserved in the decoration of the most formal Qing court robes[5] (see nos. 20 and 45).

However, diplomacy was often not sufficient to pacify border populations. During the 2nd century BC, Chinese diplomacy failed to subdue the nomadic Xiongnu, also known as the Huns, who harassed China's northern frontier, threatening the security of Chinese settlements and disrupting the lucrative trade with the West. The Han dynasty emperor Wudi (141-87 BC) sent military expeditions which crushed Xiongnu power south of the Gobi Desert, but his initiatives in seeking alliances with other Central Asian groups to contain the nomadic threat were unsuccessful.[6] Ultimately the emperor established a Chinese military presence in Central Asia, settled Han Chinese along the Gansu corridor, and extended the Great Wall to the edge of the Tarim Basin, thus securing the eastern end of what would become the Silk Road.

Control of the trade routes resulted in such dramatic increases in the volume of Chinese silks in the West that 1st century moralists complained that the fashion for silk clothing among Roman nobles was causing a constant drain of gold and silver bullion eastward.[7] Historians inform us that most of the silk seen throughout the Roman empire was imported as skeins of silk thread or unpicked from Chinese fabrics and rewoven in Syria.[8] While Silk Road trade fluctuated over the centuries, it contributed enormously to the wealth of the Chinese imperial court and the economy of the empire. Trade also stimulated significant exchanges, which encouraged the cosmopolitan culture that flourished in China, especially during the Sui and Tang dynasties.

Exotic goods expressive of Tang international tastes moved freely along the trade routes, ultimately reaching Japan. Although trade with China was intermittent and conducted largely by privateers and Buddhist

pilgrims, the influence of Chinese culture was profound. Some sense of the magnificence of the Japanese imperial court, imitating that of Tang China, can be deduced from the personal effects of the Emperor Shômu (724-749), which were donated by his widow upon his death to the Tôdaiji Temple in Nara, where they have been preserved to this day in the Shôsôin repository.[9] Emperor Shômu's prestige was reflected in the amassed luxury goods, both foreign and domestic, which number over one hundred thousand items. Among the most prized possessions were the celebrated silk textiles of China, Iran and the Byzantine world.

The imperial court and the feudal lords who came to dominate Japanese politics continued to admire imported Chinese silks throughout the centuries. Song and Ming dynasty silks even played a role in the tea ceremony, *chanoyu*. Tea drinking, originally practiced in the Buddhist context in China, was brought to Japan and transformed into a ceremony imbued with philosophic and aesthetic ideas by monks acting as spiritual and aesthetic advisors to Japanese feudal warlords. In time, the cult of tea spread to all classes of Japanese society (see nos. 50, 51 and 52).

When 17th century Japanese feudal leaders attempted to curb foreign influence and the threat of invasion, they closed the island nation to international trade. An indigenous silk weaving industry began near the old imperial capital of Kyoto which produced Chinese-style patterns to compensate for the restricted quantities of these desirable imported goods. Nevertheless, even the smallest fragments of old imported Chinese silks were treasured and collected for use for scroll and screen mounting or for creating the special pouches and wrappers used to hold revered objects such as tea ceremony utensils.

During the 13th century under the Yuan empire, which stretched from the Pacific to the Black Sea, trade expanded dramatically.

Chinese traders and their silk suppliers rose to the challenge of meeting the increased demands for silks and adapting designs to a wide range of foreign tastes. A major factor in the expansion of the silk trade was the shift from overland routes, which were limited by the burden-bearing capacity of camels – never more than a few hundred pounds – to ocean-faring ships. Under the early Ming dynasty emperors, maritime trade expanded rapidly on the peripheries of the South China Sea and

Shifuku (detail)
13th or 14th century
CAT. 50

the Indian Ocean, but by the end of the 15th century, as Chinese political power was declining, the Ming court returned to the traditional pattern of land-centered self-sufficiency. Although trade continued, largely in the hands of private merchants, the Ming emperors preferred to regard it as tribute from vassal states.

The arrival of Portuguese traders off the southern coast of China in 1517 began a period of European domination of international trade routes. Persistence and naval superiority eventually convinced the Ming government to

allow the Portuguese to build a trading station at Macao near the port city of Guangzhou in 1557, thereby extending Portugal's control of its Indian Ocean trade network and its monopoly for supplying Asian goods to the European markets. Spain and the Netherlands challenged Portugal's advantage by establishing outposts in the Philippines and Taiwan, respectively. Private Chinese, Malaysian and Japanese merchants readily supplied them with goods, including Chinese silks.

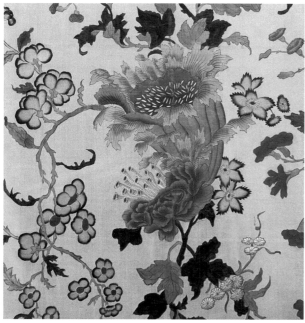

Painted tabby panel (detail) CAT. 57
18th century

In the early 17th century, the Dutch, Danish and English founded chartered trading companies to compete in the lucrative Asian trade. These enterprises were followed by French, Swedish and Prussian companies. By the end of the 18th century, American traders were also active in Chinese ports. Western trade was organized on a truly global basis, moving goods from every continent to markets everywhere. Trade followed the "three corner" pattern established by the Portuguese, who had learned it from Eastern merchants. European bullion was taken to India where it was exchanged for cottons and silks, which in turn were traded for spices in Malacca, Sumatra and the Moluccas. The spices were taken to Europe for sale, and the cycle began again. Variations on this pattern included porcelains, silks and lacquers from China and, to a lesser extent, Japan. In the 19th century, British trade interests began to use opium in dealing with China, reversing the traditional outflow of bullion from the West. Like the South Asian merchants before them, Westerners freely intervened in Chinese textile production to ensure the commercial success of Asian-produced goods for European markets. Traders supplied patterns and instructions to Asian craftsmen to meet the ever-changing fashions and tastes of the West.

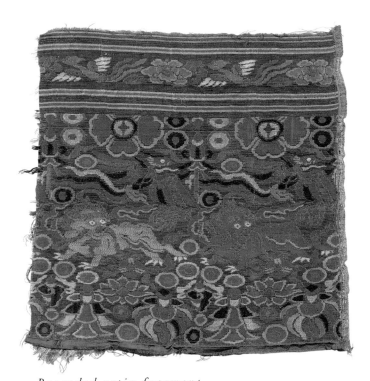

Brocaded satin fragment
16th century

1　Kuhn 1988; Liu 1941; Xia 1972, pp. 12-27.

2　Barber 1991, pp. 30-31.

3　Wild 1984.

4　Franke 1981, pp. 296-328; Hessig 1980; Reynolds 1997;
Rossabi in Watt and Wardwell 1997, pp. 7-19;
and Snellgrove and Richardson 1968.

5　Cammann 2001, pp. 20-25.

6　In 139 BC the Han emperor Wudi dispatched the officer
Zhangqian to negotiate a treaty with the Yuezhi who
had been pushed westward by the Xiongnu. The negotiation
was unsuccessful, as was another mission in 115 BC. While
in the West, Zhangqian observed Chinese products in the
markets of Bactria and discovered the source of the famed
"heavenly horses" of Ferghana, which were so coveted
by the Chinese aristocracy. See Watson 1961.

7　The effect of silk clothes may be judged by Lucius Annaeus
Seneca the Younger's (4 BC? - 65 AD) oft-quoted outrage:
"There I see silken clothes, if they can be called clothes,
which protect neither a woman's body nor her modesty,
and in which she cannot truthfully declare that she is not
naked. These are bought for huge sums of money… so that
our women may show as much of themselves to the world
at large as they show to their lovers in the bedroom."
See Seneca, *Epistulae Morales and de Beneficiis,* John
Basore (trans.), vol. 3, New York 1935.

8　Pliny the Younger (62? - 114) complained that the fashions
for silk clothing among Roman nobles caused a constant
drain of gold and silver bullion eastward. Textile fragments
recovered from the Iraqi site of Dura Europos at the head-
waters of the Euphrates River or at Palmyra in Syria are
testimony to this early Western silk industry. Designs
reflected Near Eastern tapestry weave influences and
were executed in weft-faced compound weave structures
unknown in China at that time. See Andrews 1920.

9　Matsumoto 1984.

Silks in Trade and Diplomacy

39 *Fragment,*
possibly a sutra *cover*
brocaded satin
> Ming dynasty, 15th-16th century
> length 23.5 cm; width 63.5 cm

40 *Fragment,*
possibly a pleated valance
kesi, slit tapestry weave
> Ming dynasty, circa 1500
> length 14.5 cm; width 39.7 cm

41 *Liturgical banner head*
embroidered satin
and embroidered damask
> silk: Qing dynasty, late 17th-early 18th century
> construction: Tibet
> length 77.5 cm; width 70.5 cm

During the last twenty years, silk fabrics from Tibet in the art market gave some sense of Tibet as a repository of important Chinese textiles from the 8th to the early 20th century. These include diplomatic gifts and specially ordered textiles for Tantric Buddhist liturgical needs, as well as secular textiles which were indistinguishable from those designed for and used in China. Many of these textiles were used by Tibetan aristocrats before being donated as acts of devotion to Tibetan monasteries and temples (see the next section), where Chinese silk textiles were often totally transformed to create pious patchworks for use as altar cloths, *sutra* covers and *mandalas*.

The mid-Ming dynasty brocade satin fragment decorated with boys and lanterns no. **39** was originally intended as a Chinese household furnishing fabric. It would been appropriate for cushions or hangings used to mark the Lantern Festival, which concluded the two weeks of New Year's festivities. These celebrations involved the extended family and its departed ancestors.[1] On the fifteenth day of the first month, lanterns were lit to guide the souls of ancestors back to the realm of the dead. This fabric with its

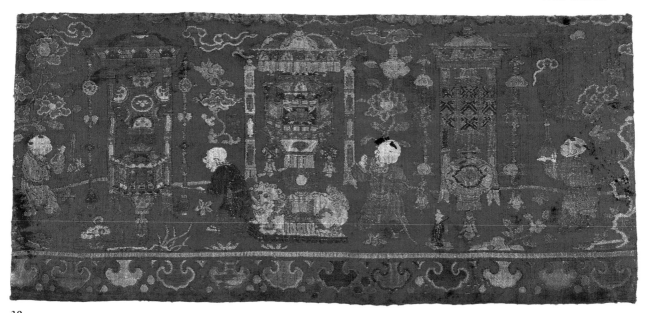

39

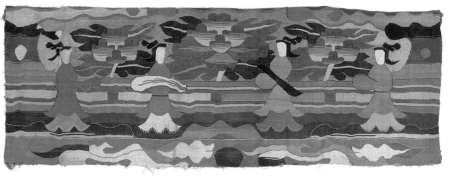

40

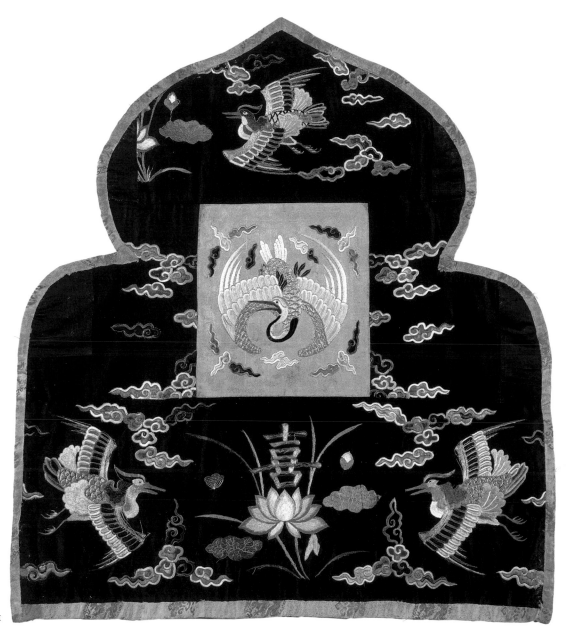

41

dense polychrome brocaded pattern is typical of a group of textiles which bear images associated with the annual cycle of Ming festivals.[2] It has been cut to size for a wooden cover used to protect the leaves of a religious text or *sutra*.

The *kesi* tapestry-woven silk band with its design of female musicians and peonies no. 40 was originally intended to be the border of a larger textile as traces of heavy blue cotton weft remain where the top edge was cut. Several other examples of this textile survive[3] and there are related *kesi* borders with other patterns.[4] The theme of women musicians can be traced in Chinese art to the Six Dynasties period (220-589), but appears in literature of the Han dynasty, where it evoked the eroticism of the emperor's private court. Vertical fold marks on this and other fragments of the group suggest that it was once pleated, largely concealing the figures, and that in Tibet this set of borders may have formed the valance of a canopy.

The ogee-shaped liturgical banner head no. **41** was pieced from two textiles. The navy blue satin embroidered with a pattern of pairs of Mandarin ducks and lotus flanking *xi* or joy characters was originally intended as a wedding furnishing fabric. In China Mandarin ducks were believed to mate for life and were therefore used as symbols of marital fidelity. The word for lotus, pronounced *lian,* has the same sound as the word meaning "to bind" or "to connect", hence here it carries a specific meaning, "to connect" like a pair of Mandarin ducks. Lotus symbolism was even more layered: a bloom with a leaf and bud indicated "a complete union" while the lotus pod with its many seeds symbolized fertility. The other embroidered fragment features a crane in roundel form that is reminiscent of insignia badges or *buzi* (see nos. **10** and **11**).

1 Bodde 1975; Cammann 1953 b.
2 Zhao 1999, nos. 8.02 and 8.09.
3 Other pieces of the same valance are in the collections of The AEDTA, published in Myers 1996, pl. 20.
4 A related design from a *kesi* band is in The Museum of International Folk Arts, Santa Fe, New Mexico, published in Kahlenberg 1998, p. 102, pl. 106.

42 Gyu-lu che *or prime minister's coat*

kesi, *slit tapestry weave*

silk: Qing dynasty, mid to late 17th century
construction: Tibet
length 63 cm; width across shoulders 185.5 cm

This short coat was part of a *gyu-lu che,* literally
a "garment of royalty" costume, worn by a Tibetan
official for ceremonial occasions such as the New
Year's festival. According to tradition, the costume
represented the dress of ancient Tibetan kings
who ruled northwestern China under the dynastic
name Xia (1032-1227).[1] To adapt to traditional
Tibetan costume forms, Chinese silk textiles
were often cut and resewn, completely altering
the original pattern and creating another vision
of luxury and prestige.[2]

This *kesi* fabric, which had been used at least twice
before this construction, was originally made for
a Manchu-style court robe. To create this coat, the
fabric was cut and reassembled: a section from one
shoulder with a frontal *long* dragon has been rotated
180 degrees and used for the back of the short coat;
the heads of the *long* once positioned at the center
chest and back have been used on the front of the
long sleeves. This *kesi* is related to a small group of
semiformal court robes[3] originally woven in a double-
width piece which eliminated the traditional center
front and back seam. Although patterns with large-
scale dragons first appear on garments during the
reign of the Wanli emperor (1573-1620), construction
details, such as the garment's profile with narrow
sleeves (seen in two other nearly complete garments)
and the fact that paired warps are used at the center
front and back to form the selvages for front and
back skirt vents, are firmly in the Manchu tradition
of the second half of the 17th century.

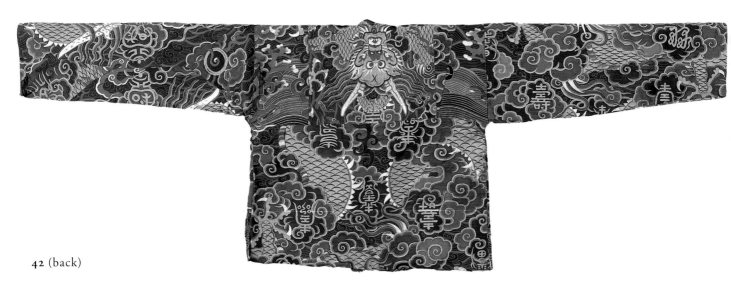

42 (back)

1 Reynolds 1981, p. 7.
2 *Ibid.,* pp. 11-13.
3 Related pieces include a man's *chuba* with three-eyed dragons
 in The Royal Ontario Museum (974.368), published in Vollmer
 2002, p. 96; and another nearly identical robe in The Museum
 of Fine Arts, Boston (2001.145). A similar *kesi* dragon robe
 in Manchu style with altered sleeves is in The Metropolitan
 Museum of Art (30.75.5); see Priest 1945, pl. 16.

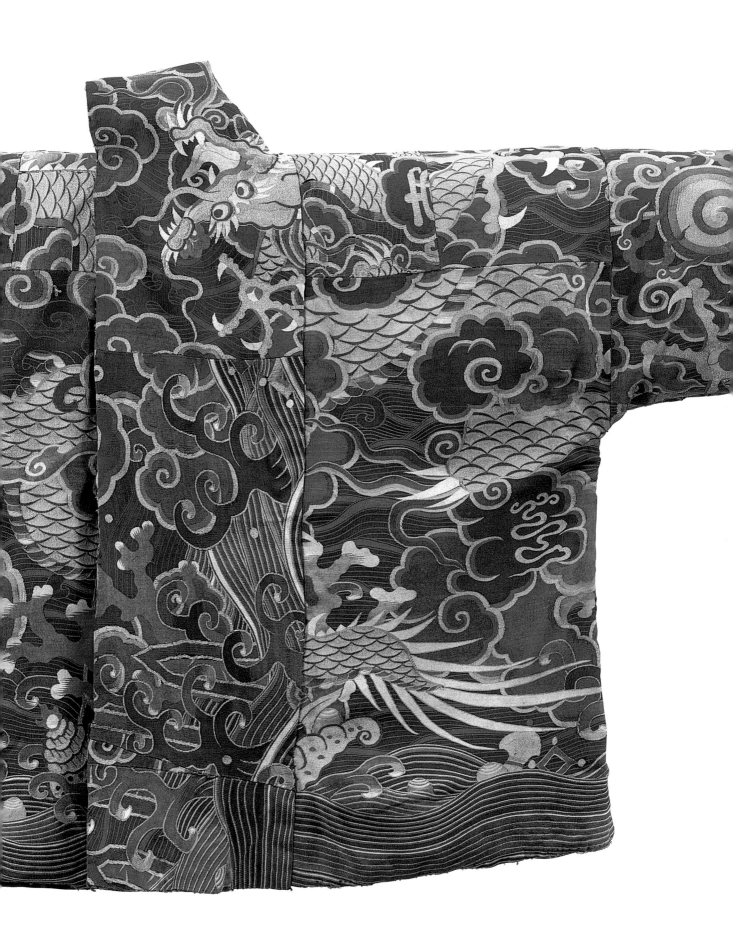

42 (front)

43 C h u b a *or man's robe*
figured satin

silk: Qing dynasty, late 17th century
construction: Tibet
length 129 cm; width across shoulders 184 cm

44 C h u b a *or man's robe*
figured satin

silk: Qing dynasty, mid to late 17th century
construction: Tibet
length 135 cm; width across shoulders 187 cm

Brilliantly colored, boldly patterned Chinese silks of the late Ming and early Qing dynasties appealed to Tibetan aristocratic tastes. However, in adapting these silk textiles to Tibetan-style dress, patterns were freely rearranged. While many Tibetan garments show how Chinese costume fabrics were used and reused, these two aristocratic coats, *chuba,* demonstrate how a Tibetan tailor approached an unused Chinese textile and attempted to use the bold designs to maximum advantage. The original Chinese patterns were radically rearranged in Tibet, losing much of their coherence, but gaining in boldness and visual impact as a result of their often surprising juxtapositions.

The phoenix material of no. **43** was originally woven for a curtain *(see fig. II)*. The main field featured a pair of birds in flight circling a rosette below a wide border containing smaller phoenix. Narrow guard stripes edged the border and framed the field at the bottom. A Tibetan robe has long, wide sleeves, an angled front overlap and long skirts tucked and held by a belt at the waist, requiring careful thought in arranging the main decorative patterns. With barely enough fabric, the construction of this robe was largely determined by positioning key decorative elements then filling in

43

fig 10 Cutting layout for
chuba *no. 43*

ARTIST: RICHARD SHEPPARD

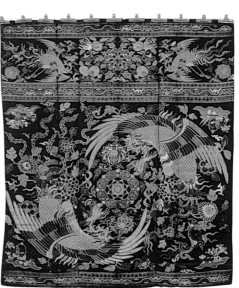

fig 11 Brocaded satin curtain
17th century
Mactaggart Collection, Canada

PHOTO: GARTH RANKIN

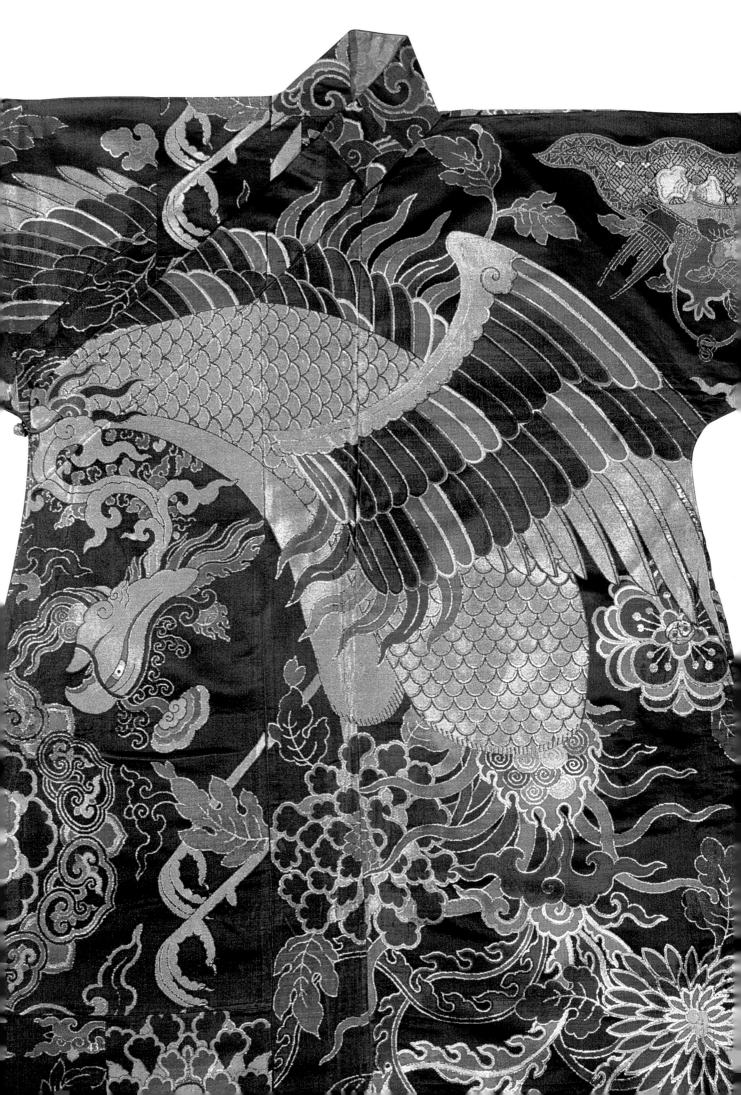

the empty spaces with parts that had been cut away *(see fig. 10)*. The guard borders, for example, were stitched together to form the front underflap. While such crossover use of furnishing fabrics for costume would have been unthinkable in China, in Tibet it occurred regularly, but rarely is the visual impact of the rearranged design so spectacular as this robe.

The dragon patterned satin no. 44 was originally woven for a Chinese robe. Designs with large *long* dragons date from the late Ming or early Qing dynasty (see nos. 21 and 22), but the presence of

a single profile *long* on the front and back of the robe suggests that it is more likely yardage for a Manchu-style garment. In Tibet, the yardage was partially sewn together, then cut to the traditional shape of a Tibetan coat resulting in the dragons switching positions. The dragon originally on the front of the Manchu coat is now at the back. Dragons on the sleeves now face the wearer's back. The width of the coat is increased with a set-in strip at each side; the dragon on the back is lengthened with an inset, which would have been covered by the sash always worn with this type of coat.

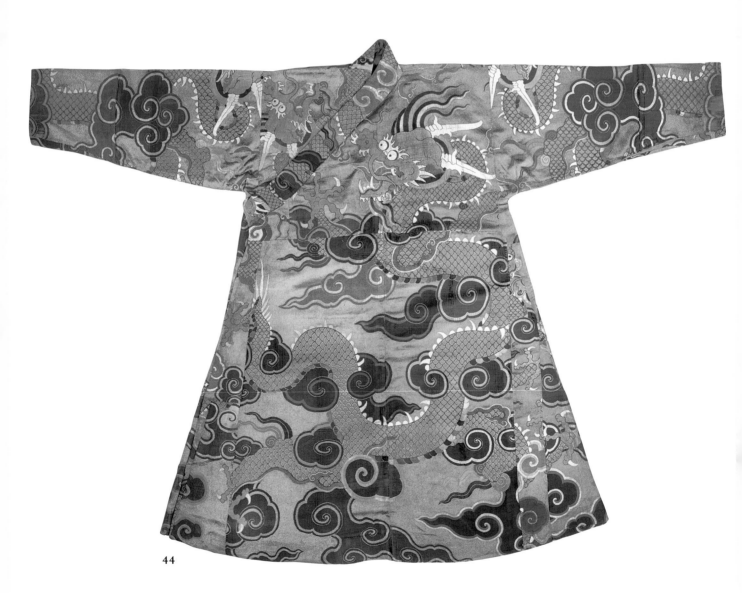

44

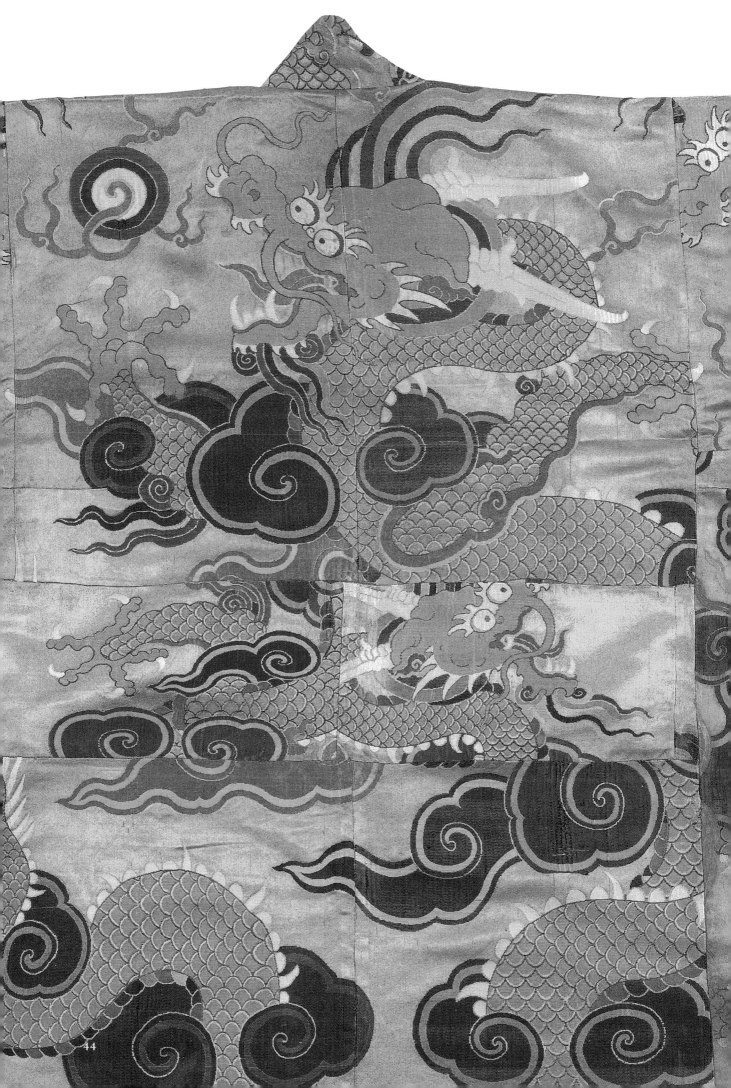

44

45 Chuba *or man's robe*

brocaded satin

silk: Qing dynasty, early 18th century
construction: Tibet
length 150 cm; width across shoulders 198 cm

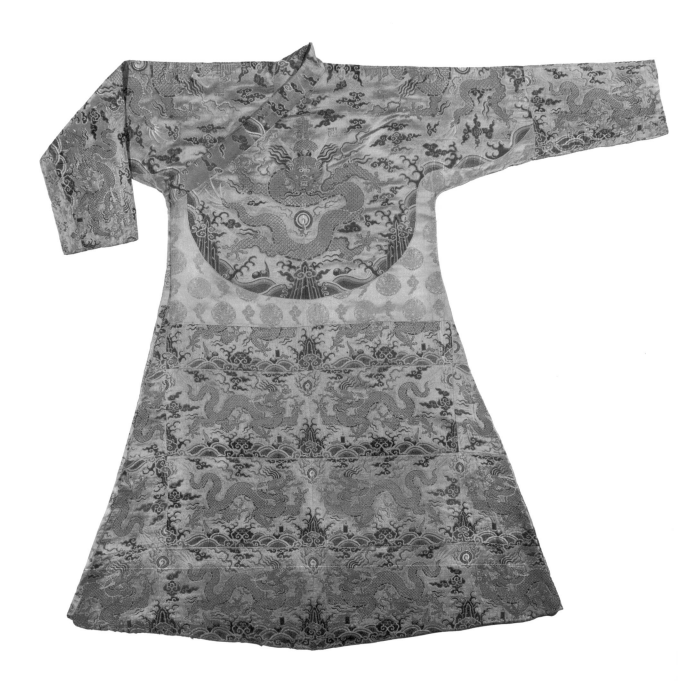

This brocaded textile was designed for the most prestigious garment worn at the Qing dynasty court. The fabric is nearly identical to that used for the *chaopao* no. **20** and may have been produced in the same workshop. The ground color is a shade of yellow known in China as *xiangse* or "incense color", and at the Qing court was most frequently used for clothing of lower-ranking imperial consorts.[1] However, this color was conferred by the emperor as a mark of special distinction and strongly suggests this fabric was sent to Tibet as a diplomatic gift. The quatrefoil yoke of the Manchu robe has been retained, but large areas of the self-patterned damask sections have been eliminated in favor of the more colorful brocaded dragon bands from the original skirts, underflap and waist sections. The dragons at the sleeves appear to have been taken from a second textile.

1 Cammann 2001, p. 72.

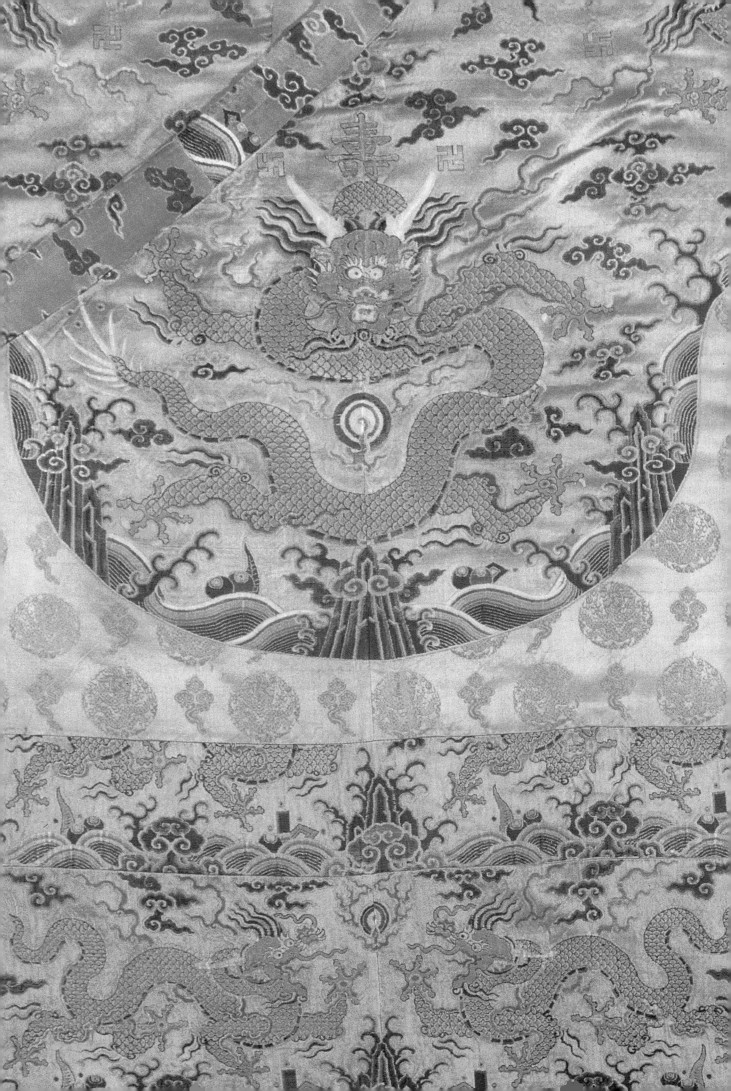

46 Chuba *or man's robe*
figured twill

Qing dynasty, mid to late 19th century, made for Tibet
length 146 cm; width across shoulders 200 cm

provenance: Rudolf Nureyev Collection

47

Dais cover
figured satin

Ming dynasty, late 16th-early 17th century, made for Tibet
length 204 cm; width 218 cm

In response to market demands, Chinese silk work-shops produced textiles for Tibet with late Ming dynasty designs like the fabric with scrolling clouds, no. 46, two hundred years after the pattern was first designed. These fabrics with their repeating patterns required fewer adjustments when sewn into Tibetan-style robes than those with dragons or other large-scale designs (see nos. 43 and 44).

The lotus paired with the ritual implement called *dorje* in Tibetan and *vajra* in Sanskrit, literally "thunderbolt", had particular significance in Tibetan Buddhism. The *dorje* was thought of as

the "means" and masculine; the lotus, as "wisdom" and feminine. Their union symbolized the supreme truth, an appropriate pattern for a dais cover on which a Buddhist dignitary would sit to teach.

These beautifully drawn, large-scale patterns were typical of late Ming dynasty textile designs that were sent to Tibet during the 17th century. A fabric like the lotus dais cover, no. 47, was probably specially manufactured as a prestige gift for a Tibetan religious leader of a specific monastery. Although these boldly patterned textiles went out of fashion in China by the early 18th century, Tibetans continued to favor them.

46

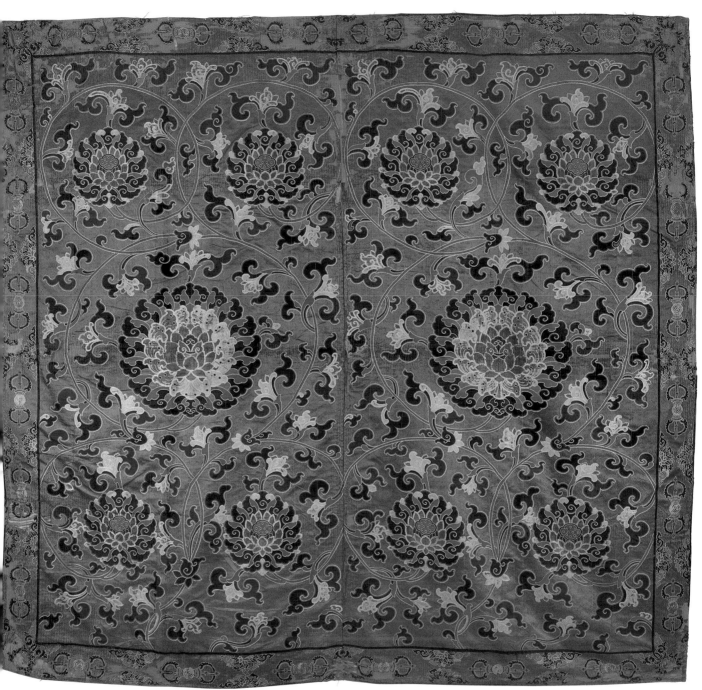

47

48 *Fragments of a furnishing fabric*

embroidered satin

> Yuan or Ming dynasty, 14th or early 15th century
>
> *a* length 26.5 cm; width 13.5 cm
>
> *b* length 18 cm; width 24.5 cm

49 *Sash*

figured satin

> Ming dynasty, mid 16th century, made for Tibet
> length with fringe 550 cm; width 14.8 cm

Chinese textiles made for the Tibetan market often included specifically Tibetan Buddhist iconography. Monster masks, known as *chibar* in Tibetan and *kirtimukha* in Sanskrit, literally "glory face", combine features of various ferocious beasts to depict a god of the skies. The mouth devours or expels sprays of vegetation symbolizing the dual powers of creator and destroyer. Characteristically the *chibar* was accompanied by dragons. Masks were often connected by festoons of jewels and occurred frequently as decorations on Buddhist altars. The two fragments from a hanging or altar cover were embroidered through two layers of fabric – silk satin and cotton tabby – using stem stitches worked in concentric rows, in a manner similar to other liturgical textiles such as nos. **61** and **64**. This time-consuming technique, which probably had devotional significance, became popular during the Yuan dynasty. Embroiderers of liturgical textiles continued to use this technique until the late 18th century.

The sash no. **49**, an integral part of Tibetan costume, is also patterned with *chibar*. The Chinese silk weaver took into account the manner in which this accessory would be worn when organizing the decoration: at each fringed end two rows of masks are stacked and read vertically; the sixth mask from the end is rotated 90 degrees as are the rest of the masks in the center section so that when worn around the waist they would be properly oriented.

48 a

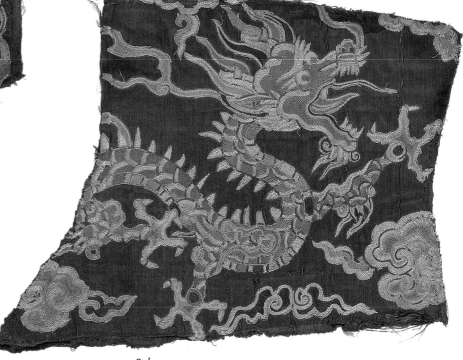

48 b

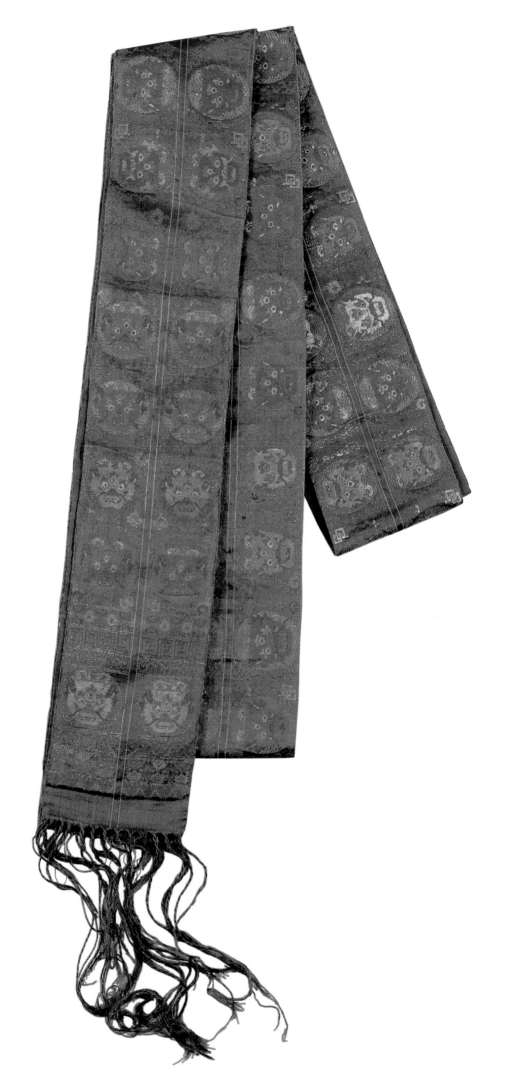

49

50 **Shifuku** *or*
pouch for a tea caddy
brocaded satin

> silk: Yuan dynasty, 13th or 14th century
> construction: Japan
> height 11 cm; circumference 22 cm

51 **Shifuku** *or*
pouch for a tea caddy
damask

> silk: Ming dynasty, 15th-16th century
> construction: Japan
> height 11 cm; circumference 22 cm

52 **Shifuku** *or*
pouch for a tea caddy
damask

> silk: Ming dynasty, 16th century
> construction: Japan
> height 11.5 cm; circumference 20 cm

> provenance of nos. 50 to 52: Louis Gonse Collection

53 *Length of fabric*
damask

> Ming dynasty, 16th century
> length 107 cm; width 71 cm

Tea drinking was introduced to Japan from China by Buddhist missionaries in the 8th century; the beverage was used as a medicine or stimulant to help monks stay awake during meditation. Initially its secular use was restricted to the Japanese court where, in imitation of Tang literati traditions, tea was the pretext for extravagant parties at which the merits of tea were discussed, poems celebrating tea were written and games about the names of tea were devised. However, monks also introduced the beverage to their more modest communities and tea drinking in informal gatherings spread among the lower classes.

The introduction of Zen Buddhism in the late 12th and 13th centuries provoked a profound shift in aesthetic taste among Japan's ruling warlords. Japanese monks and pilgrims returning from China, influenced by the severity of Chan practice and the refined tastes of the Southern Song court, introduced new ideas during a period of great social upheaval. In the 14th century, Zen monks blended the humble Japanese tea drinking practices with the more elegant traditions of the aristocracy to produce a new social ritual called *chanoyu,* literally "hot water for tea", imbued with philosophic and aesthetic ideals.[1] Over the next two centuries *chanoyu* evolved and developed into a profoundly Japanese art form.

53 (detail)

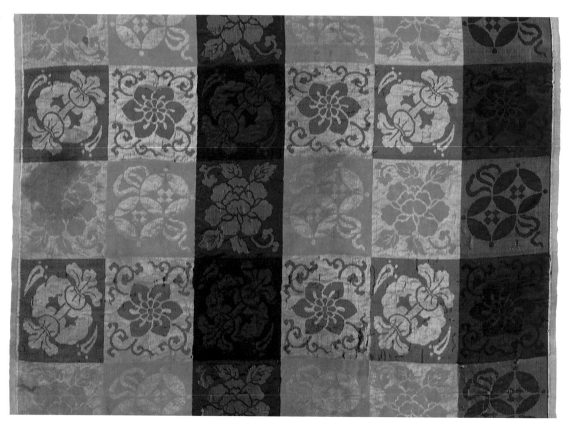

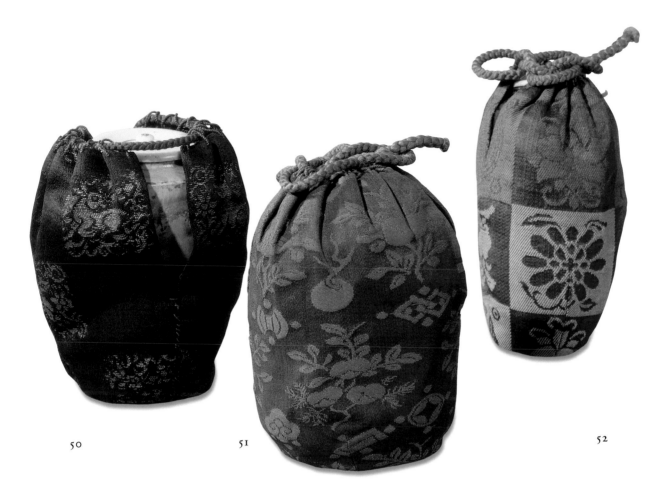

50 51 52

The gestures and implements involved in serving tea to guests evoked serenity. The atmosphere and surroundings for *chanoyu* expressed ideals of *wabi* or simplicity and *sabi* or naturalness; the utensils were carefully chosen as embodiments of these tea ideals. As a result, the vessels used in the ceremony – antique Chinese stonewares and porcelains, peasant ceramics from Japan and Korea, as well as custom-made containers and jars – were revered. When not in use, they were carefully wrapped in fine fabrics and stored in individual wooden boxes. The padded cloth drawstring bags, called *shifuku,* used to protect tea caddies *(chaire),* tea bowls *(chawan)* and other tea utensils when stored, became the focus of intense connoisseurship. The most desirable textiles for making *shifuku* were imported Chinese silks, especially those dating from the Song dynasty whose subdued colors and exquisitely soft textures were in particular harmony with tea ceremony aesthetics. These included self-patterned damasks and compound weft-faced twills patterned with small-scale motifs in muted colors or satins figured with discretely placed strips of gold filament.

Over time, pattern types were classified and noted tea masters designated individual textiles as *meibutsu-gire* or celebrated fabrics.[2] The gold brocade no. 50 is classified as *kinran* of the Yuan dynasty; it features the flower and rabbit pattern known as *hanasagi,* one of the oldest and most renowned *meibutsugire.* The two-color damask no. 51 with sprays of peaches and persimmons and scattered good luck symbols is classified as *donsu.* This type was particularly favored for its softness and uniform surface texture. The tricolor damasks nos. 52 and 53 are also classified as *donsu.* The checkerboard design with flowers and jewels is known as *Enshu donsu,*[3] named for the tea master Kobori Enshu (1579-1647). Antique fabrics with small scale patterns were sought for making *shifuku*; the larger scale patterns like no. 53 would have been more appropriate for *fukusa* or wrapping cloths.

1 For a survey of Japanese tea ceremony *(chanoyu)* history and aesthetics, see Varley and Kumakura 1989.
2 Best 1996, pp. 136-145.
3 *Ibid.,* p.144.

54 *Border panels from a bedcover*

kesi, *slit tapestry weave*

 Ming dynasty, 17th century, probably made for Spain or Portugal
a length 38.5 cm; width 167.5 cm
b length 42 cm; width 170 cm

55 *Bedcover or carpet*

embroidered cotton tabby

 Ming or Qing dynasty, 17th century, probably made for Portugal
 length including fringe 374 cm; width 232 cm

The domination of Asian maritime trade by Western powers in the 17th century put intense pressure on the Chinese imperial government. Traditionally China handled international trade within the framework of tribute paid to the imperial court, managed by the Office of the Imperial Household. Unlike the Ming imperial court, the Qing court deflected the problems of dealing directly with foreign traders. Through its appointed officials in southern China, the imperial government licensed private Chinese merchant firms to act as brokers in the southeast Asian region. Western traders were obliged to use these brokers to secure the goods they required. As Chinese manufactured goods were heavily taxed, Western merchants made every effort to obtain merchandise to their clients' tastes and intervened in the production of goods, ranging from porcelains to silks and lacquers, by specifying sizes, types, qualities, materials and colors. In time they would even supply designs.

Among the most impressive luxury textiles for export to the West were bed hangings and bedcovers. Whereas Chinese beds fit into a framing niche and were seen from the side, Western beds had a headboard and were seen from the foot. The dimensions of Western bedcovers were much larger, as bed frames were bigger and mattresses were lifted higher off the ground. Borders therefore tended to be doubled and tripled. While traditional Chinese patterns might have included dragons and other mythical beasts and auspicious symbols, export textiles were adapted to Western tastes by omitting these motifs in favor of more universally comprehensible flower and bird themes.

The *kesi* borders no. 54 were part of a very large bedcover probably with a central medallion in the field and quarter medallions in the corners. *Kesi* produced an inherently weak fabric because the weaving technique left slits in the textile between

54 a

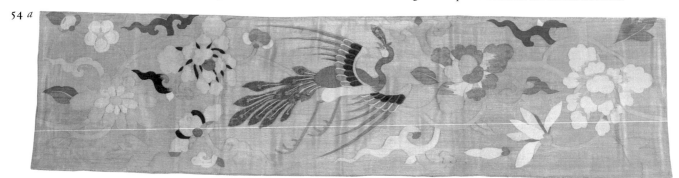

54 b

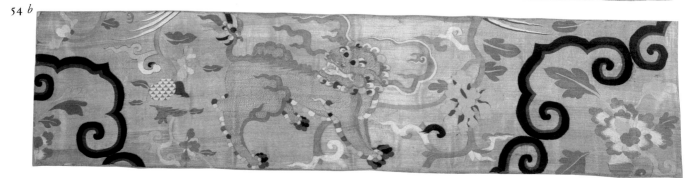

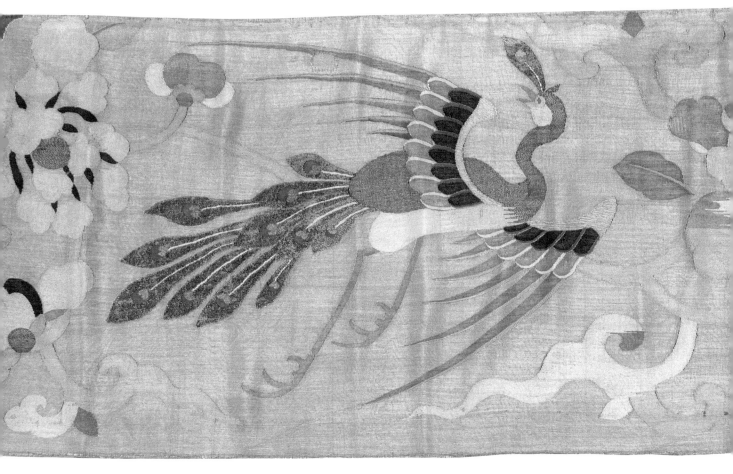

54 *a* (detail)

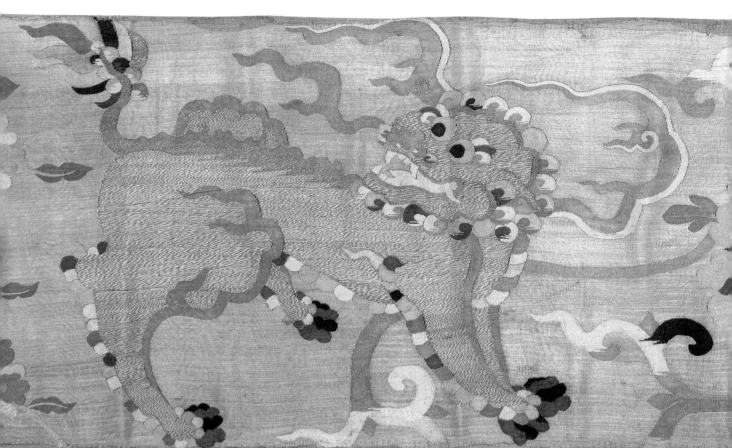

54 *b* (detail)

color areas and did not stand up to wear. It was therefore rarely used for practical items like bedcovers, except for a group of early 17th century bedcovers surviving in Western museum collections, all with light blue backgrounds.[1] These *kesi* pieces appear to have been produced by the same workshop and were probably ordered by Spanish traders based in Manila. The Spanish utilized trade routes east across the Pacific Ocean to Acapulco, then overland to Veracruz where goods were transferred to ships and carried across the Atlantic to Cadiz. Some of these *kesi* export textiles must have been traded in the New World, as Peruvian weaving workshops

produced wool tapestry panels which closely follow Chinese models including their motifs of mythological beasts and peonies.[2]

The large bedcover or carpet no. 55 is the only Chinese textile in this catalogue which is worked on a cotton ground. It is completely covered by floss silk embroidery in a variety of surface satin, long, short, laid and couched stitches. The materials – cotton with floss silk – were probably specified by the purchaser and strongly suggest it was made to resemble contemporary coverlets made in India for the Western market.[3]

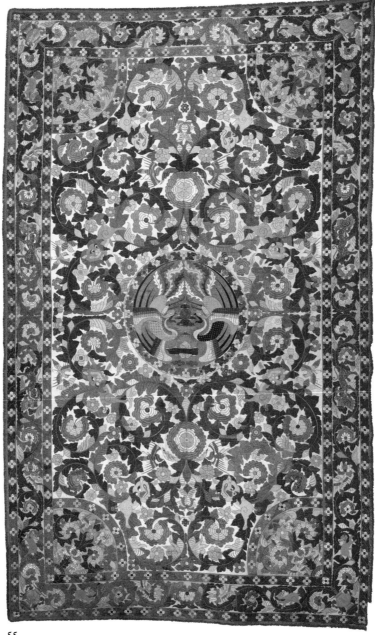

55

1 A complete coverlet, in a private collection, is illustrated in Vollmer 1982, p. 42; another is in The Ruth Chandler Williamson Gallery, Scripps College, Claremont, California, unpublished.
2 Cammann 1964 (offprint, no pagination).
3 International Exhibitions Foundation 1981.

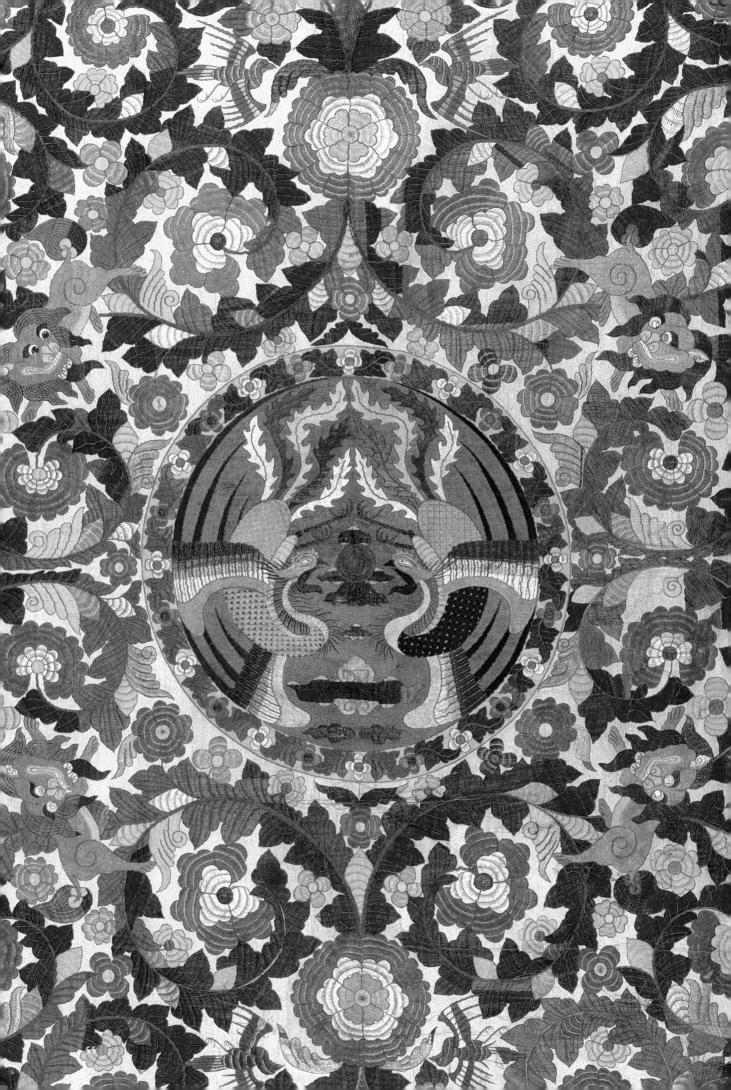

56 *Cape for a religious statue*
embroidered tabby

Ming or Qing dynasty, 17th century, probably made for Spain or Portugal
length 102 cm; width 207 cm

Although this textile must have been specially ordered, probably for use as a cape to clothe a religious statue, its decor reveals the complications of trade between China and the West. With government-appointed brokers as intermediaries between Western clients and Chinese producers, artisans were often obliged to improvise in the absence of specific instructions. While the shape, the dimensions, the border with bunches of grapes and the use of polychrome silk floss embroidery on white silk were undoubtedly ordered at variance with Chinese tastes, the motifs which fill the field were probably not specified. The workshop must have turned to house patterns for the bird and flower designs and the animals including deer, rabbits and a charming foreshortened calico cat, resulting in a surprising menagerie for a religious object.

European imports of colorful embroideries and painted silks with white or pastel grounds fed the craze for all things Chinese that swept through European society during the second half of the 17th century. In turn, the European taste for decorative arts "in the China manner" was based on works like this export embroidery, which was in fact a mixture of diverse origins suggesting an exotic fantasy world.[1] By the end of the 17th century, European pattern books with a variety of motifs drawn from Chinese, Japanese, Indian and Iranian sources, as well as from the imaginations of Western craftsmen, were widely circulated. European traders even used these models to "assist" Asian workshops in producing goods with the right exotic appeal.[2]

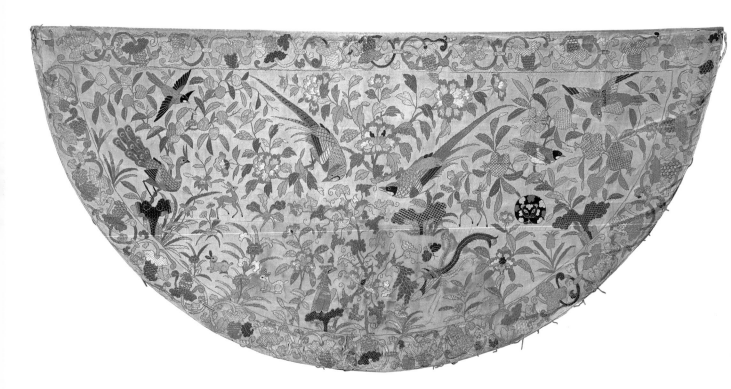

1 Honour 1961.
2 During the 17th century Chinese and other Asian motifs were included in European pattern books intended for amateur and professional decorators to create "authentic" imitations. Asian embroiderers and textile painters also used these patterns. There are instances of textiles with identical designs made in different regions of Asia. For example, a mordant painted and resist-dyed cotton bedcover from the east coast of India, a silk chain stitch embroidered cotton plain weave bedcover made in Gujarat, on India's west coast, and a linen bed curtain with wool needlework from England are published in Irwin 1949, pp. 51-56.

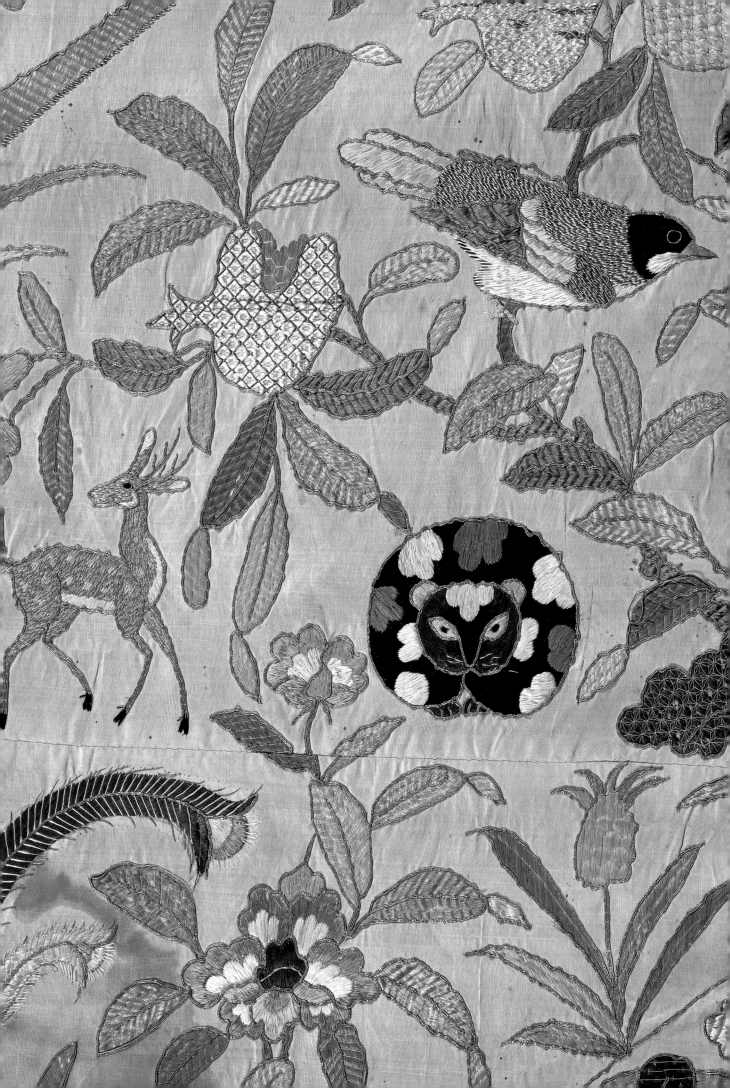

57 *Panel*

painted tabby

Qing dynasty, early to mid 18th century, probably made for France
length 225 cm; width 117 cm

When mordant and resist-dyed cotton textiles or chintz from India first arrived in Europe in the 17th century, they created a sensation. These brilliantly colored, lightweight colorfast fabrics were unlike any textiles manufactured in contemporary Europe. Despite their Indian origin, they contributed to the fashion for things "in the China manner". European traders even persuaded Indian artisans to alter the colors on painted cottons, modifying the traditional red and blue palette of India to imitate Chinese export fabrics with their gleaming white or pastel satin grounds and brilliantly colored silk embroidery (see no. **56**).[1] By the 1640's, European trading companies were sending patterns for a wide variety of goods to be made by Asian workshops. Such patterns were widely distributed.[2] There are examples of the same design used by chintz painters working along India's east coast, by Indian embroiderers in Gujarat, and by embroidery and painted silk workshops in southern China.[3]

Painted silk yardage, like this length with its exuberant, fanciful floral imagery, was probably made for a wall covering or bed hanging. Smaller motifs were preferred for making women's dresses. The large scale repeating design of an exotic Tree of Life is very similar to Indian chintz patterns made for export during the first quarter of the 18th century. The fashion for chintz swept through France and England, causing sales of European silks to suffer. As a consequence, at times during the 18th century the importation of Indian fabrics was banned because of protests by the local silk weaving industry. Some of the floral elements in this panel are similar to French "bizarre silks", which could suggest this yardage might have been intended for the French market. Imported from China, it would have avoided the ban on Indian chintz.

1 Irwin and Brett 1971; Standen 1954, pp. 24-27.
2 For the most recent general survey of the Dutch Vereenigde Oostindische Compagnie, see Stevens 1998. The English East India Company was founded in 1600. See Kaey 1991; Wild 1999.
3 See note 2 to entry no. **56** above.

Embroidered thanka
18th century

CAT. 66

Silks for Temples and Altars

From ancient times, Chinese silk was used in rituals, distinguishing celebrants from participants, imbuing ceremonies with beauty and reflecting the values of order, solemnity and harmony. During the 3rd century BC, Confucian philosophers transformed the annual cycle of rituals conducted by Western Zhou rulers (1050-771 BC) into the moral actions of the emperor, who through the *tienming*, the "Mandate of Heaven", was charged with maintaining social order on earth and balancing the forces of nature and heaven for the benefit of his people. Silk played a significant role in manifesting this image of universal harmony, which depended on the person of the sovereign in his secular and political dimensions, a theme examined in the first section of this catalogue.

Vestiges of the ritual significance of the even older bast fiber textile tradition based on hemp and ramie are preserved in the Daoist practice of using those humble textiles as linings for elaborate silk vestments.[1] Nonetheless, Buddhism, introduced to China from India, had the greatest impact on the use of silks for religious purposes in China.[2]

Buddhism was sustained by a community of disciples who entered monastic orders and a laity whose generosity supported the religious institutions. Monks accepted a strict ascetic code, vowing to lead a life of self-discipline and renunciation of earthly attachments and to devote themselves to study and meditation. Their needs were met by donations from the faithful of food, clothing and other necessities, considered acts of piety which accrued spiritual merit to their donors. In return, monks taught the secular community the ways of salvation.

Silk textiles as offerings served ritual, decorative and practical purposes, supplying cloth for creating sacred images for worship, hangings for prayer halls, covers for altars and scripture, and clothing for celebrants of the rituals.

In Buddhism, cloth and clothing were often used to express the ideal of renunciation of worldly attachment. According to the earliest teachings, monastic clothing was to be made from cast-off or rejected cloth found in a monk's wanderings, recovered from burial grounds, or received as donations. It was to be salvaged from the soiled state, cleaned and purified and given a new purpose.

The principal monastic garment, a patched or pieced together mantle, was called *kasaya* in Sanskrit,[3] *jiasha* in Chinese, and *kesa* in Japanese. The name originally meant

Kesa
17th century

CAT. 77

"impure colored". This term denoted a sharp contrast to the bleached white cotton clothing common in the India of Buddhism's origins. Thus, this garment signified a monk's vow of poverty and his acceptance of an ascetic life modeled after the historic Buddha. Once the special organization of the patchwork was codified as a composition of rectangular and square pieces worked in columns within a framework, the cutting, assemblage and careful stitching of the garment assumed the solemnity of ritual. Wearing the mantle transferred Buddha's teaching symbolically onto the shoulders of the monk (see nos. 76

and 77). The symmetrical, axial composition of the *kesa* has been compared to a *mandala* or sacred diagram.[4] Other ritual textiles used in Buddhism, like altar covers, canopies and banners, were also made from donated silks originally intended for secular use; these were cut, reassembled and transformed into sacred silks (see nos. 72, 73, 74 and 75). Despite their origins as symbols of humility and renunciation, Buddhist textiles became sumptuous pious ornaments for the faith.

Patchwork mandala (detail) CAT. 73
18th and 19th century

Historically, foreign dynasties reigning in China found Buddhism more helpful than the Han Chinese state cult of Confucianism or the indigenous religion, Daoism, in strengthening their prestige and control over the Chinese population. In the 13th century, the Mongol Yuan dynasty embraced Tantric Buddhism, forging links with the Tibetan clergy that influenced politics in East Asia for the next 500 years.[5] Imperial patronage, first by the Yuan rulers, and later by the Ming and Qing emperors, was manifested not only by construction of temples and monasteries but

also by lavish gifts and specially commissioned silk textiles offered to the Buddhist church in China and Tibet (see nos. 60, 64, 65, 66 and 67). These luxurious textiles showed that no expense was spared for materials or time-consuming techniques to create magnificent religious works reflecting the splendor of the court. Frequently imperial gifts were inscribed with the emperor's name.[6] Privately commissioned silk textiles produced for aristocratic donors at special workshops often reveal a similar pleasure in being identified with a rich gift. A dated inscription on a Daoist vestment with the same cartoon decor as no. 59 not only includes the name of the temple to which it was offered, but the names of both the master embroiderer and the donor.[7]

Liturgical textiles, particularly devotional icons, like *thankas* and *mandalas,* required artists and workshop supervisors who were trained in the subtleties of an immensely complex and rich iconography to ensure that these objects of worship and meditation met exacting ritual criteria. Under the Yuan and early Ming emperors, these ateliers were under the supervision of foreign clergy.[8]

Chinese silks for temples and altars include both specifically commissioned sacred fabrics or icons and secular fabrics used for decorative purposes in the religious context. Works were bestowed upon religious foundations in prodigious quantities by donors from every social level, from the mightiest to the most modest. These offerings to Buddha were kept in temple treasuries and in storehouses within the temple precincts and were brought out as needed for replacement, decoration or special ceremonies.

1 Vollmer 1985.

2 Myers 1996.

3 Kennedy 1991.

4 Myers *op. cit.,* p. xviii.

5 Pal 1990, pp. 30-32.

6 Reynolds 1995, pp. 146-153; Reynolds 1997, pp. 188-199.

7 The Art Institute of Chicago (1907.322). See Vollmer 2000a, cat. no. 47, pp. 41-43 and 69, pl. XXV.

8 Pal 1990, pp. 50-51, 60-61; Reynolds 1995, pp. 151-153.

Appliquéd thanka
18th century

Silks for Temples and Altars

58 Hanging
kesi, slit tapestry weave
Qing dynasty, late 17th century
length 225.5 cm; width 165 cm

This hanging depicts *Yaochi* or the Turquoise Pond in the Daoist Paradise on Mount Kunlun. At the top, Xiwangmu, the Queen Mother of the West, riding a phoenix and accompanied by her Jade Maidens, arrives greeted by the Three Stars – the Gods of Longevity, Emolument and Good Fortune. On the path descending from the cave at the upper left, crossing the pond and ascending at the right, are various divinities and their attendants, including the famed *baxian* or Eight Immortals.

This monumental textile is woven in a single piece using the tapestry weave technique in which colored silk and gold-wrapped weft threads are manipulated back and forth only in those areas required by the pattern. The weavers' skill is evident in the beautifully rendered minute details of facial expressions, textile patterns on silk robes, and the textures of animal skins, yet the whole composition retains an immediacy and liveliness that belie the very time-consuming nature of the technique used to produce it. While individual groups of Immortals and their attendants pause along the path for a game, an archery match, or even a nap, the grandiose mountainous landscape and the dramatic appearance of the Queen Mother of the West unify the scene. Its general message would have been interpreted as an elegant wish for longevity.

Although the preparatory work for this hanging was a painting which reflected a concern with naturalistic illusion, the weavers have used several flat textile-patterning strategies, such as the black and white checked coat of the attendant in the center of the work, where arbitrary squares of color ignore the contours of the garment. Similarly, gold threads have been used to dazzling decorative effect to produce a supernatural glow in this heavenly scene, at the same time obliterating any spatial differences between sky, mist and water.

The four character inscription in large seal script reads: *"Huafeng sanzhu"*, which can be translated as "Three blessings at the frontier [of China]" and ostensibly describes the events in the picture.[1] However, the inscription resonates within the historical period of its manufacture and the context of international diplomacy.

Russian incursions into the Amur River region near the Manchu homeland led to conflicts with the Qing dynasty, which were settled by the Treaty of Nerchinsk in 1690. In recognition of this agreement, the Kangxi emperor (1662-1722) sent gifts including textiles to the Russian Tsar, Peter the Great (1672-1725). Among them were a group of *kesi* hangings, which can be related to this piece. Peter the Great requested a second group of textiles in 1719 when the embassy of L. Izmailov arrived in Beijing.[2] The Tsar bestowed seven *kesi* pieces on Cosimo III de Medici (1642-1723) which are now in the Museo degli Argenti at the Palazzo Pitti in Florence.[3]

As diplomatic gifts from the Chinese state, the *kesi* textiles were made in Chinese styles and to Chinese tastes. They included chair and table coverings and large-scale decorative works like this one for which there would have been no comparable use in the West.

1 Arnold Chang, New York, personal correspondence, January 2003.
2 Maria Menshikova, personal correspondence, February 2003 concerning a paper read at The Percival David Foundation for Chinese Art, University of London, Colloquies on Art & Archaeology in Asia, June 1996 (unpublished).
3 Filippo Salviati, *Asia Arts Newsletter*, December 2000, p. 9.

59 *Daoist* jiangyi *or vestment for a first degree priest*
embroidered satin and damask
Qing dynasty, late 18th century
length with collar 138.5 cm; width across shoulders 204 cm

PUBLISHED Zhao Feng. "The Chronological Development of Needleloop Embroidery." *Orientations,* vol. 31, no. 2, Feb. 2000, p. 52, fig. 15.

The astral symbols on a Daoist vestment, *jiangyi* or "robe of descent", link the priest to the cosmos.[1] The principal emblems adorning these vestments were among the most ancient images developed by the Chinese. Symbols for the sun, moon and stars surround heaven, which is depicted here as a multi-storied tower encircled with gold discs representing stars. These motifs were often displayed against a field of clouds suggesting the firmament. Five character-like forms, arranged in an arc below the tower, represent the mythical peaks guarding the five conceptual directions of the universe. Below, four gate-like structures symbolize the cardinal points of the compass, the physical directions of the world. This view of the heavenly realm through symbols contrasts sharply with the mountain landscape setting of no. **58** where the divinities themselves are depicted gathering to welcome the Queen Mother of the West.

Fabulous creatures cavort in the waves of the border across the hem. Flanking the front opening are the Dragon of the East (see no. **35**) and the Tiger of the West. This pair of the Animals of the Four Directions has been used as a protective device in tomb decoration since the early Han dynasty and probably refers to a harmonious balance of nature. Symbolically, the priest wearing the *jiangyi* became the animator of ritual and was imagined to promote celestial order, contributing to stability on earth.

This sumptuous garment is decorated with appliquéd units of needleloop embroidery. Sheets of gold and silver leaf on lacquered paper were placed between the ground fabric and the embroidery to reflect light through the lace-like structure of needleloop stitches. This garment and another embroidered on a red satin ground in The Art Institute of Chicago share the same preparatory design, suggesting they were produced by the same workshop.[2] The Chicago piece bears two embroidered inscriptions on the front dating the commission to 1793, demonstrating the continuation of the needlelooping technique which may have originated during the Southern Song dynasty (1127-1279) and flourished during the 13th through 15th centuries (see no. **6**).

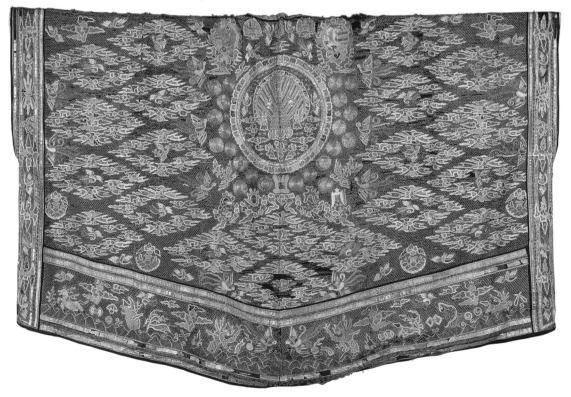

1 Wilson 1995, pp. 138–145.
2 The Art Institute of Chicago (1907.322). See Vollmer 2000a, cat. no. 47, pp. 41-43 and 69, pl. XXV. The inscriptions identify the embroidery designer as Zhang Wenda of Haichan and the donor as Ji Benli. The name of a Daoist temple, Wuhang maio, and a monastery, Xuanzhen guan, probably refer to two components of a large religious establishment.

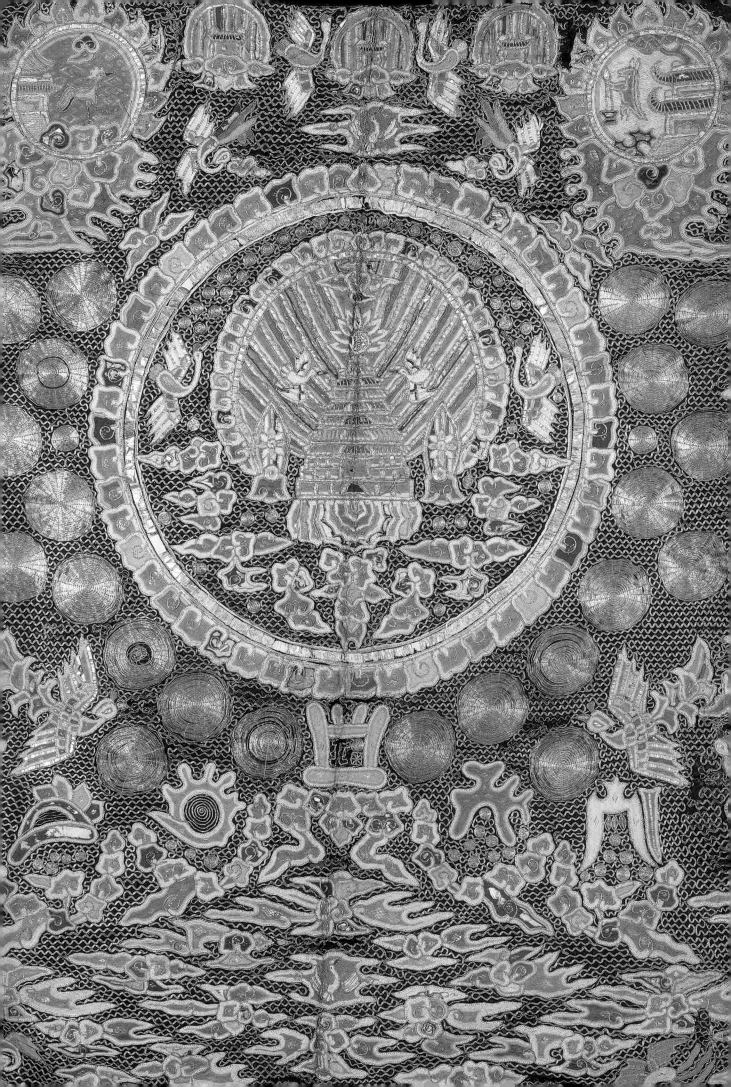

60 *Valance and banners*

embroidered tabby, gilt brass mounts

Qing dynasty, late 18th century

a valance length 155 cm; width 171 cm
b banner length 241 cm; width 46 cm

Chinese palace and temple architecture shared many features. Set on stone platforms with terraces, buildings were of post and lintel construction with heavy tiled roofs supported by elaborate systems of brackets. A valance, hung across the bay of a façade or between two interior columns, marked the space set aside for ritual. The spandrel form cut into the valance created a shrine niche. The stylized, inverted "U" shape suggested a pair of curtain panels tied to a door frame. Banners hung from the pillars at each side of the valance completed the ensemble; their long streamers fluttering in the wind signaled that the air in the space was sacred. Mats arranged on carpets created seating for participants in rituals, and tables draped with special cloths to receive offerings further established sacred areas.

The imagery executed in glorious gold-wrapped thread and silk embroidery on this set of furnishings indicate they were created for Tantric Buddhist liturgical use. Three lotus flowers and the *bajixiang,* Eight Buddhist Symbols, decorate the top panel of the valance. The Buddhist symbols, originally brought from India by Buddhist missionaries, include four royal symbols associated with Prince Siddhartha, the historic Buddha, and four emblems signifying religious tenets. Here the four royal emblems – the umbrella, conch shell, canopy of state and vase – are arranged in a row across the top; the Wheel of the Law, endless knot, pair of fish and lotus appear below. The intermediate space shows the *vajra* (the thunderbolt emblem), the *cintamani* (the Wish-granting Jewel) and the *torma* (the butter offerings). The spandrels are decorated with clouds and bats above a border of *ruyi* cloud heads.

The banners are also decorated with two large lotus blossoms. In the vertical panels between the blossoms are the *panca kamaguna* or the Offerings of the Five Senses: a cloth over a frame (touch), a bowl of fruit (taste), a conch with incense (smell), cymbals (sound) and a mirror (sight). The sixth symbol that balances the composition is the *triratna* or Three Jewels, which represents the refuge of the devotee: Buddha, *Dharma* (the law) and *Sangha* (the church).

The scale of the pieces, their elaborate gilt metal fittings and the quality of the embroidery indicate that this ensemble comes from an imperial workshop. These furnishings reflect 17th century styles (see nos. **21** and **23**) and would have suggested the celestial realm glowing in the dark interior of the worship hall.

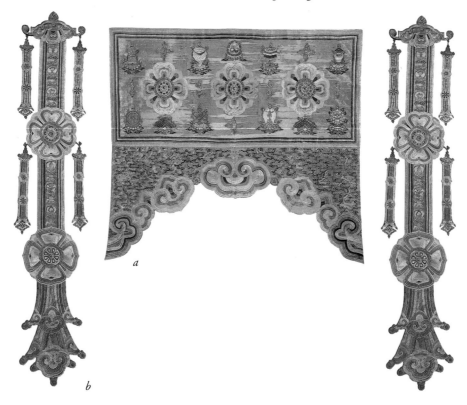

a

b

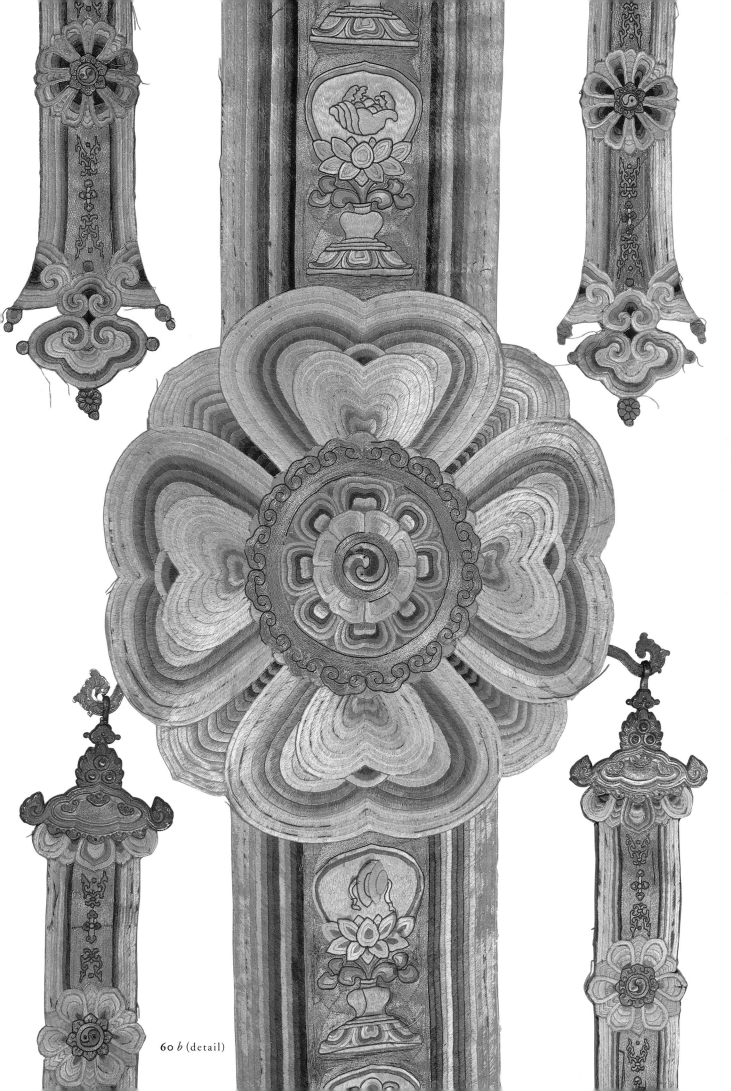

60 *b* (detail)

61 *Element of a ritual diadem*
embroidered damask
> Ming dynasty, 14th-15th century
> length 22 cm; width 13.7 cm

62 *Unused fragment*
embroidered satin
> Ming dynasty, 16th-17th century
> length 21.3 cm; width 34 cm

63 *Fragment*
lampas
> Qing dynasty, 18th century
> length 19.4 cm; width 11 cm

64 *Pendant or banner head*
embroidered satin
> Ming dynasty, probably 16th-17th century
> length 63 cm; width 32 cm

In contrast to Theravada Buddhism which focused on personal enlightenment through monastic practice, the Mahayana school developed the idea of collective salvation for all sentient beings. In India during the 1st and 2nd centuries, veneration of Shakyamuni as the historic Buddha was transformed by increasingly complex theories of the existence of successive Buddhas in time and space, in which Shakyamuni was only one of myriad manifestations. This fostered the belief that attaining Buddhahood could be a universal goal.

Five Buddhas representing the Five Families and the Five Directions were identified as the Transcendent Buddhas. At the center was Vairochana (Resplendent); to the east, Akshobhya (Imperturbable); to the south, Rathasambhava (Jewel Born); to the west, Amitabha (Boundless Light); and Amogasiddha (Infallible Success) to the north.

The element from a five-petal ritual crown no. **61** depicts Amitabha as a red divinity with his hands in the *dhyana mudra* or meditation gesture with a begging bowl. Above his head is the *bija,* the sacred or seed syllable for *"me"* in *lantsa,* a script derived from Sanskrit, suggesting that the other petals of the crown bore mystic syllables completing the mantra *"om mani padme hum"*, which was recited in homage to the Bodhisattva Avalokitesvara. The damask ground has been almost entirely covered with stem stitch embroidery worked in concentric rows similar to no. **64**. Monks or clerics wore diadems during initiation and other ceremonies. It was thought that the priest, as a receptacle for cosmic forces, became one with the divine essence embodied in the crown.[1]

Nos. **62** and **63** represent the Buddha Amitayus (Infinite Life). He is typically shown as red or white and holds the *kulasa* or vase which contains the Elixir of Life, symbolized by a flowering branch. The embroidery is from a set of five unused panels. The lampas fragment was cut from a devotional hanging with seven rows of figures, each containing five Buddhas. In three other known panels, the pattern for the Buddha remains the same, but the colors vary from figure to figure, suggesting they were to be read as the Five Transcendent Buddhas.[2]

Tantric Buddhist practice used chants and spoken prayers evoking the sacred realm of pure sound.

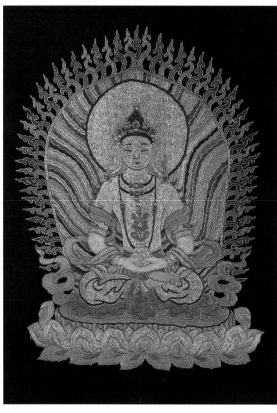

62

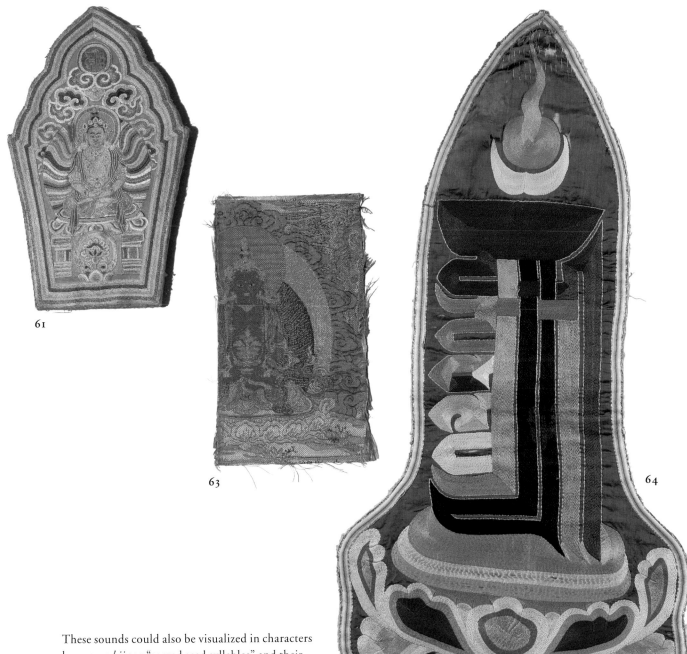

61

63

64

These sounds could also be visualized in characters known as *bija* or "sacred seed syllables" and their presence on a variety of objects was an aid to meditation, as is the case of the embroidery no. 64. Here they are worked entirely in concentric rows of stem stitch (see no. 61); a single couched gold-wrapped thread outlines the sacred syllables which may have been designed as the head of a liturgical banner.[3] The *dasakara vasi* or All-Powerful Ten was a mystic monogram composed of ten Sanskrit syllables *(om, ham, ma, la, va, ra, ya, hum, phat)* surmounted by the sun, moon and flame symbols. The ten syllables represent the elements of the cosmos.

1 Related pieces include an embroidered diadem with the Transcendent Buddhas including a red Amitabha in the Chris Hall Collection, published in Hall 1995, pp. 192-193, no. 51; a diadem bearing the five-syllable mantra in enamel on metal is in The Minneapolis Institute of Arts (L96.20.1), published in Jacobsen 2000, vol. II, p. 717.
2 For an identical panel in The Art Institute of Chicago (1931.9), see Vollmer 2000a, p. 59, no. 21. Other panels, without frames, are now in the collections of Woon Wee Tong, Singapore and The Los Angeles County Museum of Art (M39.2.61).
3 For a liturgical banner with the mystic monogram and the mantra formerly in the collection of The A E D T A, Paris, (3249), see Myers 1996.

65 Thanka *of Maitreya*
brocaded tabby or lampas

Yuan or Ming dynasty, 14th or early 15th century
length 78 cm; width 56 cm

The image of Maitreya, the Buddha of the Future, dressed in monastic robes, seated in meditation, his hands in the *dharmachakra mudra* or teaching gesture, dominates the composition of this *thanka*. In front of the throne platform are wealth-bestowing deities: Vaisravana seated on a lion flanked by the Yellow Jambhala and wrathful Black Jambhala. At the left and right, respectively, the Bodhisattvas Avalokitesvara and Padmapani stand on lotus pedestals, while in the clouds above, wearing a red robe is the *tathagata* or Buddha form of Visvabhu, the white robed *tathagata* of Kasyapa, as well as the White and Green Tara.

Created for private meditation, this brocaded image would have been completed by a textile frame and mounted as a scroll for mobility and storage. What appear to be the inner borders of the original mounting are in fact part of the original brocade.

While the prototypes for such images were wall paintings or painted cloth *thankas,* the tradition of embroidering and weaving sacred images is very ancient in Buddhist practice.[1] During the Yuan and early Ming dynasties, Chinese imperial silk factories produced costly textile *thankas* for local use and as gifts to individual lamas and temples in Tibet.

These sacred images ranged in dimension from a monumental Mahakala *thanka* of the Yongle period,[2] measuring over two by three meters, which could be hung on the façade of the Potala Palace in Lhasa, to works like this superbly woven *thanka* of more modest proportions. These *thankas* exhibit the extraordinary skills of the painter and weaver.

On stylistic grounds, this image could be attributed to the Yuan dynasty. However, technical similarities with the Mahakala *thanka* and other contemporary *thanka* fragments, which can be dated to or associated with the Yongle emperor, might suggest an early Ming dynasty date. At least two other Maitreya *thankas* from the same workshop have survived,[3] perhaps part of a series of five.

1 Rawson 1995, pp. 170–173; Clunas 1997, p. 108.
2 The Mahakala *mandala*, although much damaged, bears a woven Yongle mark as an inscription on the field, published in Hall 1995, pp. 132-133, no. 26.
3 A very similar *thanka* is in The Chris Hall Collection, published in Hall, *op. cit.,* pp. 126-127, no. 23.

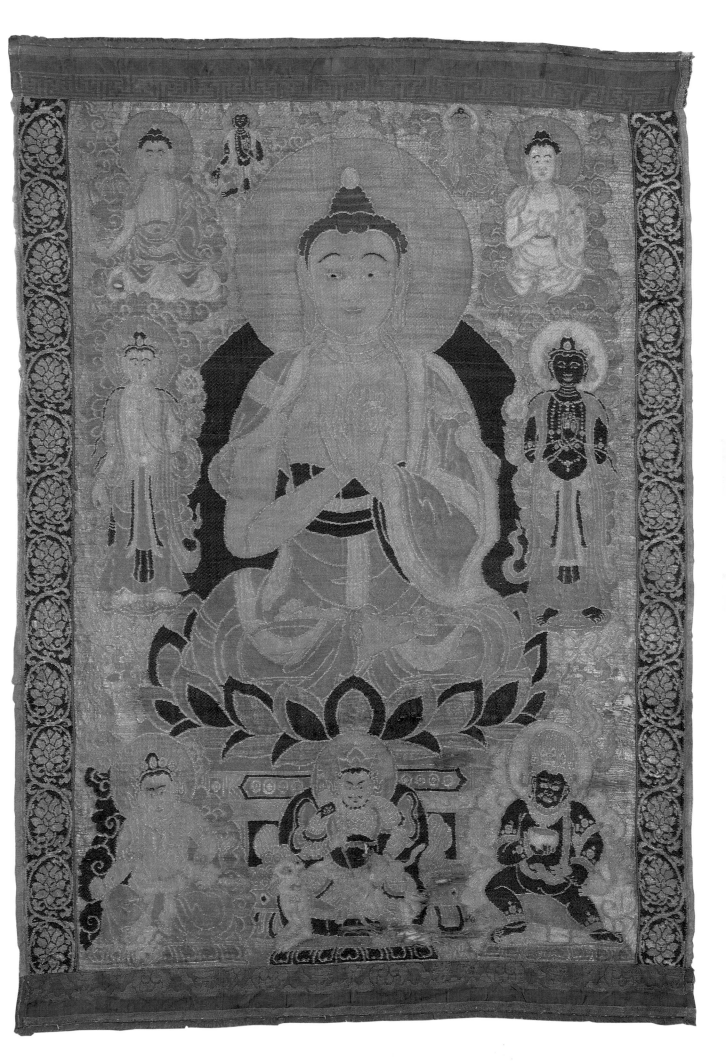

66 Thanka *of Vajrabhairava*
embroidered satin with seed pearls and coral beads

Qing dynasty, mid-18th century
image length 61.8 cm; width 47.5 cm

Yamantaka Vajrabhairava, the buffalo-headed Conqueror of Death, is the wrathful form of the Bodhisattva Manjushri and symbolizes the triumph of Buddhist wisdom over death. The head of Manjushri appears above two tiers of eight ferocious heads. Yamantaka Vajrabhairava embraces his consort Vajravetali in his principal arms, which also hold the *kartrika* or ritual chopper and the *kapala* or skull cup. Vajravetali feeds him from another skull cup and also holds a chopper. Yamantaka's thirty-two other arms hold weapons and the severed body parts of humans and animals; his sixteen legs trample the prostrate figures of gods, humans and beasts.

Across the bottom, from left to right, are: Yama, the Lord of Hell and his consort Yami riding a bull; Mahakala the Great Black One trampling a corpse and Palden Renati also called Palden Lhamo, the protector of Lhasa, riding an ass. These deities, as well as Yamantaka, are important protectors of the Gelugpa Order of Tibetan Buddhism, which was founded by Tsongkhapa (1357-1419).[1]

In the clouds above the main icon are three seated monks wearing monastic robes and yellow hoods. Based on stylistic comparisons, which would date this embroidery to the mid-18th century, it is likely the center figure is a portrait of Tsongkhapa flanked by the seventh and eighth incarnations of the Dalai Lama, Kelzang Gyatso (1708-1757) and Jamphel Gyatso (1758-1804) whose reigns overlapped the interventions of the Qing dynasty in the politics of Tibet and Mongolia.[2]

This embroidery reflects the highest standards of Qianlong period imperial workmanship.[3] The precision of the satin, long, short and encroaching satin stitches emphasizes contours and subtly creates the illusion of three-dimensional forms. Minute fresh water pearls and tiny coral beads accent the jewelry of the divine pair. Although now darkened, couched silver-wrapped threads defining the jewelry and haloes represent the radiance of the divinities. The attention to detail and the meticulous execution as well as the power of the image suggest this work may have been among important diplomatic gifts sent by the Qing court to Lhasa.

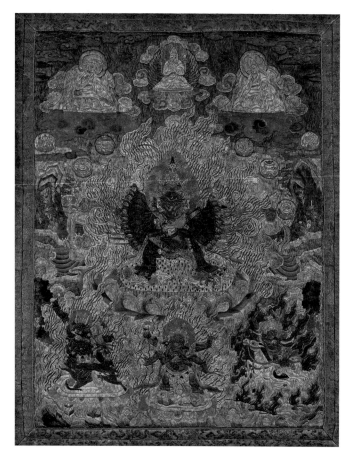

1 The distinctive yellow headwear of the clergy of this order gave it the popular name Yellow Hats. By the end of the 15th century, Gelugpa had become the dominant school of Tibetan Buddhism and its leader, the Dalai Lama, assumed religious and political power.
2 In 1720 the Kangxi emperor sent an army into Tibet to thwart Mongol advances into the region; a violent Tibetan civil war in 1727-28 brought in a second Qing army. By 1750 the Qing government established the Dalai Lama as temporal leader under a Qing protectorate which included a Chinese resident official called *amban* and a garrison of 1,500.
3 A monumental appliqué Maitreya *thanka* in The Norton Simon Museum, Pasadena, California (M 1975.1.T) bears portraits of Kelzang Gyatso and Jamphel Gyatso and has been dated to 1793/4; see Pal 2000, p. 69.

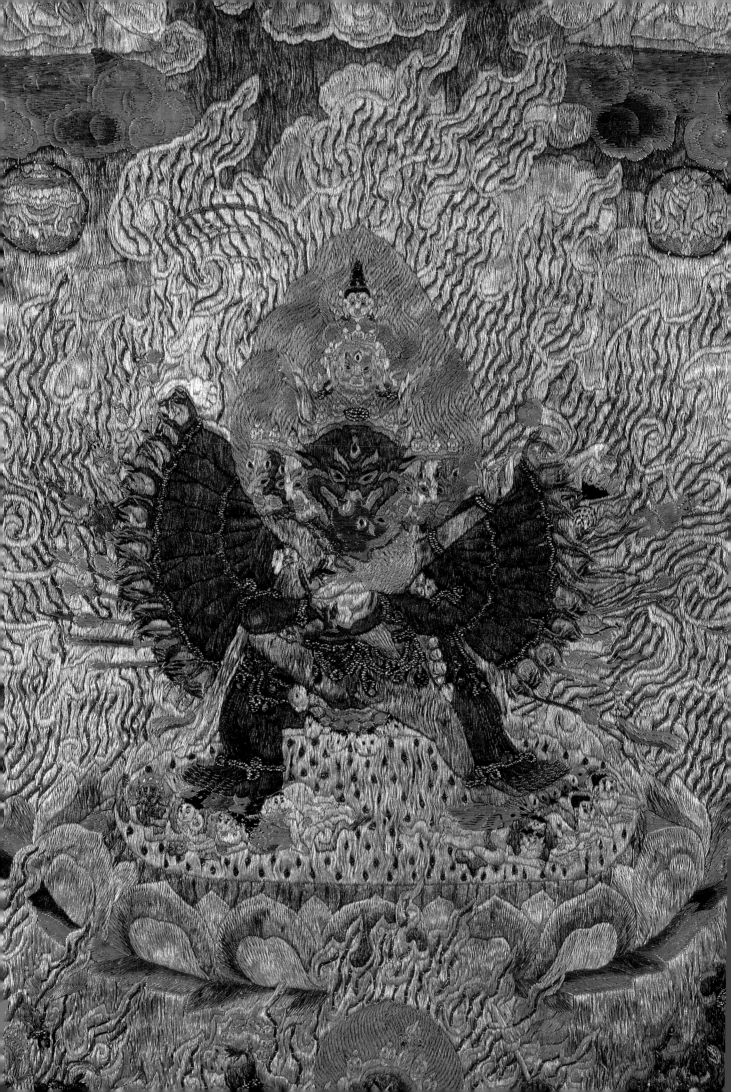

67 Thanka *of offerings*
embroidered satin
Qing dynasty, 18th century
image length 90 cm; width 57 cm

This panel of offering images called *rygan tshong,* Sets of Ornaments, or *bskang rdas,* Materials for the Banquet, was part of an ensemble of *thankas* of which at least seven survive.[1] These would have been hung in special chapels dedicated to the Dharmapalas or Protectors of the Faith. Of the eight major Dharmapalas, Mahakala, Yama and Lhamo were the most popular (see no. **66**). Every monastery would have had a shrine dedicated to Mahakala.[2]

Thankas of offerings were displayed permanently to represent the more ephemeral offerings of rice, barley, flowers and incense which were traditionally placed on altars. These *thankas* were designed to appease and propitiate the Dharmapalas and may have been used in the periodic rituals that were performed to renew the oaths of submission of local deities to the Buddhist faith under the control of the Dharmapala.[3]

Deities are never represented in these works, except by their attributes and accessories, such as the sword and the trident in the center of this panel associated with Mahakala. This type of *thanka* always has a landscape composition. Below a festoon of skulls and jeweled garlands is a scene of animals devouring corpses and skeletons on a burial ground. Between the earthly and heavenly realms are depictions of gifts offered to the deity, which include the Seven Treasures of Royalty: the Wheel of the Law, the Wish-granting Jewel, the queen, the elephant, the general, the minister and the horse.

1 Pieces from the original set include: four in The Chris Hall Collection, see Hall 1995, pp. 152-153, no. 35; one in the collection of Mr. and Mrs. John Gilmore Ford, see Rhie and Thurman 1996, p. 447; one in the collection of August Franz and Ingrid Sailer, see *Hali,* no. 58, p. 163 and a seventh in a private Hong Kong collection (unpublished).
2 Pal 1990, pp. 166-168.
3 Rhie and Thurman *op. cit.,* pp. 380-381.

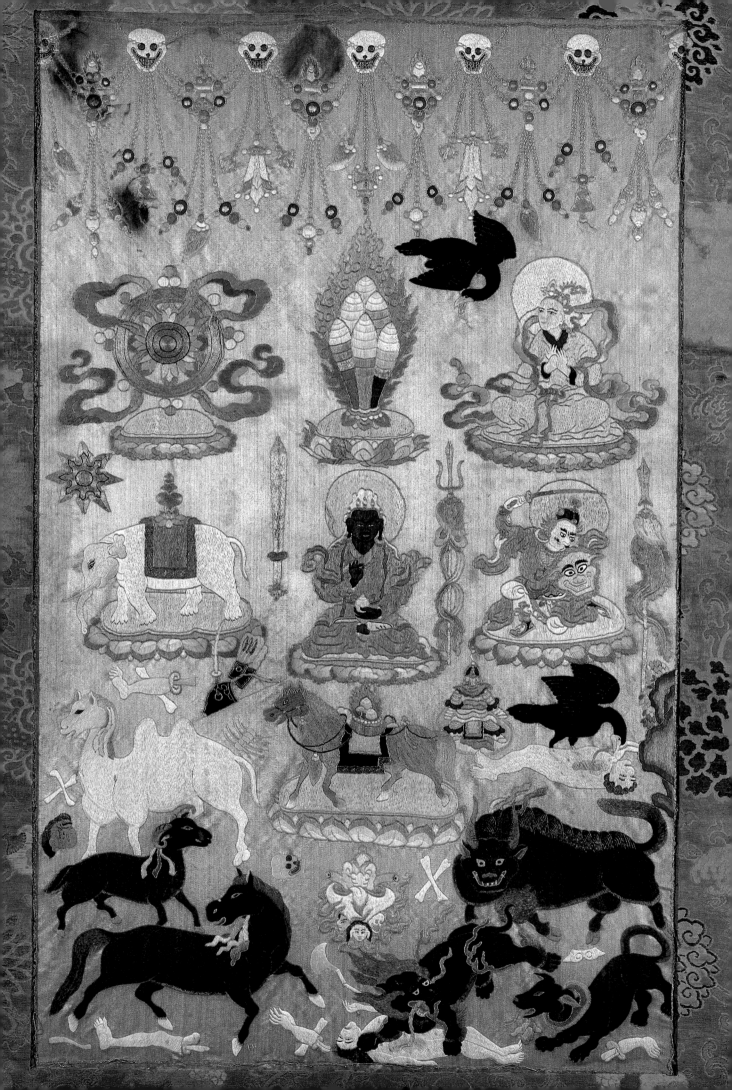

68 Thanka *of Abheda*
various appliquéd, embroidered and figured fabrics
silks: Qing dynasty, 18th and 19th century; construction: Tibet
image length 84.5 cm; width 56.5 cm

69 Thanka *of Ratnasambhava*
various appliquéd, embroidered and figured fabrics
silks: Qing dynasty, late 17th and early 18th century; construction: Tibet
original mounting: length 90 cm; width 53.5 cm
image length 42 cm; width 32 cm

70 Thanka *of Shakyamuni*
various appliquéd, embroidered and figured fabrics
silks: Qing dynasty, 18th and 19th century and Russia, early 19th century; construction: Mongolia
image length 64 cm; width 47 cm

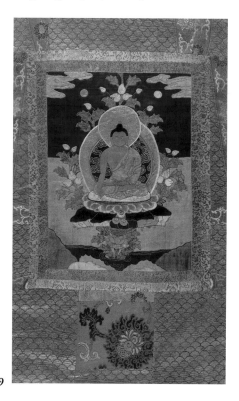

69

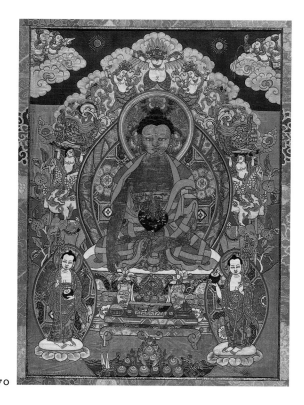

70

In Buddhist practice the donation of fine silks was
a pious act that accrued merit and contributed to
the salvation of the benefactor. Buddhist tenets
originally required disciples to renounce worldly
things, wearing only rags or donated garments in
recognition of the vow of poverty. As gifts to monks
and monasteries became more costly and precious,
deconstructing the silks of the secular world and
reassembling them as garments for monks and
decorations for altars and worship halls transformed
them. Monks who fashioned with mastery devotional
images from the tiniest scraps of cloth practiced
a form of piety through patchwork.

Abheda depicted in no. **68** is one of the sixteen *arhats*
or disciples of Shakyamuni, the historic Buddha.
He wears monastic robes and is identified by the
chorten or small stupa which was given to him by

the Buddha as protection against the evil spirits in
the northern countries where he was sent to preach.
To his left is an unidentified prince wearing a turquoise
earring, holding a flywhisk and a water pot, from
which emanates a vision of Shakyamuni. Below are
the Guardian Kings: at the north, Vaisravana with
a banner and mongoose, and at the south, Virupaksha
holding a small stupa. The appliqué work is extremely
accomplished, using very finely cut pieces of cloth
and outlining them with couched floss silk-wrapped
horsehair cord. Some details have been embroidered
and pigment enhances the atmospheric effects of
the clouds. The image has been trimmed losing part
of the top and right hand side.

Ratnasambhava, no. **69**, is one of the Five Transcendent
Buddhas (see no. **61**) who overcomes pride and avarice
and is associated with the south. Dressed in monastic

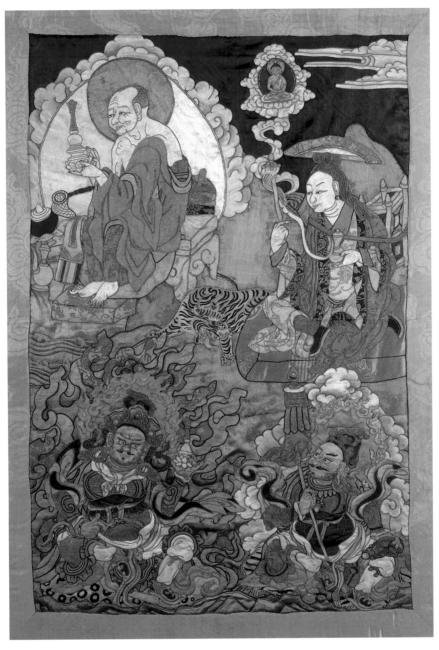

68

robes he is seated in meditation on a lotus throne, his hand in the *varada mudra* or gift-bestowing gesture. The throne on a flat rock is supported by a lotus rising from a pond. The divinity is surrounded by a landscape in the blue and green Chinese style. The artist has used mainly satins and damasks, some enhanced with applied paint, reserving gold-enriched brocades for the Buddha's robes and halo. Floss silk-wrapped horsehair has been used to outline the elements. This *thanka* survives with its original mounting inner borders of red and yellow floral brocade and a frame pieced from a brocaded green satin fabric of gold scale patterns with scrolling lotus borders that may have been made for a suit of parade armor (see no. **38**). At the bottom of this green "universe" frame is a red brocade patch "eye" marking the sacred space in Buddhist liturgy.[1]

The historic Buddha Shakyamuni is depicted in no. **70** sitting in meditation pose. He holds a begging bowl in his left hand and with the right makes the *bhumispharsha mudra,* the gesture of calling the earth to witness. Flanking him are his principal disciples, Maudgalyayana and Sariputra. This exuberant appliqué uses a wide range of gold-enriched fabrics, including a Russian brocade for the halo behind the Buddha's head. Floss-wrapped horsehair cords in the Tibetan manner outline all the elements of the composition enhancing its definition and clarity, but the narrow bias bands of colored satins which edge all the halos, as well as the palette, are typical of Mongolian work.

1 For a piece with technical similarities, see the *thanka* of Avalokitesvara in The Newark Museum of Art (57.55), Reynolds 1999, pp. 222-223.

71 *Fragment*
 figured tabby

 Ming dynasty, 16th or 17th century
 length 32 cm; width 41 cm

72 *Patchwork panel*
 *lampas, brocaded satin, satin
 and damask*

 silks: late Ming and Qing dynasties, 17th and 18th century
 construction: Tibet
 length 148 cm; width 63 cm

73 *Patchwork* mandala
 *satin, tabby, lampas, brocaded satin
 and figured damask*

 silks: Qing dynasty, late 18th or early 19th century
 construction: Tibet
 length 73 cm; width 74 cm

74 *Patchwork* mandala
 figured satins and damask

 silks: Ming dynasty, 16th and 17th century
 construction: Tibet
 length 123 cm; width 119 cm

The Ming fragment no. 71 features a pattern imitating a patchwork of different colored triangles. On this visual patchwork are tigers and the *wudu* or Five Poisonous Creatures. This furnishing fabric may have been intended for the Dragon Boat Festival, held on the fifth day of the fifth month of the lunar calendar. On this occasion sprays of artemisia were placed at the entrances of households, children wore tiger head bonnets and adults drank yellow wine to ward off evil influences represented by the Five Poisonous Creatures: the viper, centipede, scorpion, toad and lizard.[1]

In Tibet imported silks were always in short supply; the practice of making patchworks of luxury silks became a pious act born of necessity. Geometric patchworks were often made of tiny triangles seamed to form squares with contrasting halves, assembled to form larger cloths as *mandalas* used as an aid to meditation. The number of pieces, their colors and arrangements were linked to numerology and

71

1 Related pieces are published in Galloway and Simcox 1989, p. 43, no. 51; Frances 1998 and Zhao 1999, pp. 246-247, no. 9.03.

73

divination used by Tibetans in daily and religious
life. These practices included ancient Chinese forms
of astrology, numerology and geomancy. In Tibet
the *wuxing* or Five Phases and *loshu* or numerological
diagrams were important systems for calculating
horoscopes and forecasting the future. In the context
of Tantric Buddhism, geometric patchworks evoked
the matrix of time and space in which the soul was
caught in the web of existence. Patchwork like a
mandala served as a plan of the cosmos and a chart
for freeing the soul from entanglement and suffering.

No. 73, with its composition of 8 by 8 squares, each
of two triangles to equal 128 pieces, and no. 74,
with 10 by 10 squares, each divided in half equalling
200 pieces, have been carefully arranged in a design
of concentric lozenges which could have served
as sacred diagrams and the focus of meditation.

Geometric patchworks were also used as temple
or monastery furnishings. Panels like no. 72 were
probably used to cover the tables on which sacred
texts were placed or may have been used on altars
to receive ritual objects precisely placed to evoke
the cosmos.

These geometric patchworks incorporate a variety
of secular Chinese traditional silks. Nos. 72 and 73
also include textiles with dragon patterns originally
manufactured for Chinese court use. However,
in all cases those who pieced together the silks were
more interested in the color balance and overall
pattern than the motifs on individual elements.

72

74

75 *Altar frontal or hanging*
lampas and brocaded satin

silks: Ming and Qing dynasties, 17th to early 19th century
construction: Tibet
length 98 cm; width 115 cm

Although this textile is in the tradition of Tibetan patchworks of Chinese silks, it is conceptually different from the geometric patchworks previously discussed in nos. 72-74. The maker of this altar table frontal selected five fabrics with specific colors to comply with notions of *wuxing,* although the composition is typical of Chinese-style table frontals consisting of a main panel with a smaller valance across the top. Certain of the fabrics included have been used intact with minimal seaming. Three of the fabrics were made for the Qing dynasty court. The brocaded yellow satin textile with vertical running dragons, now on their sides, was originally a strip from a banner. The brocaded red satin with repeating patterns was originally a backing fabric for cushions. The main fabric was originally part of a semiformal court robe dating from the early 18th century. The triangular pieces filled in at each side suggest the coat had been made up as a garment, either in China and/or Tibet, before it was utilized here. In this unusual assemblage, the Tibetan maker has opted to retain much of the original cosmic symbolism of the Chinese dragon patterns.

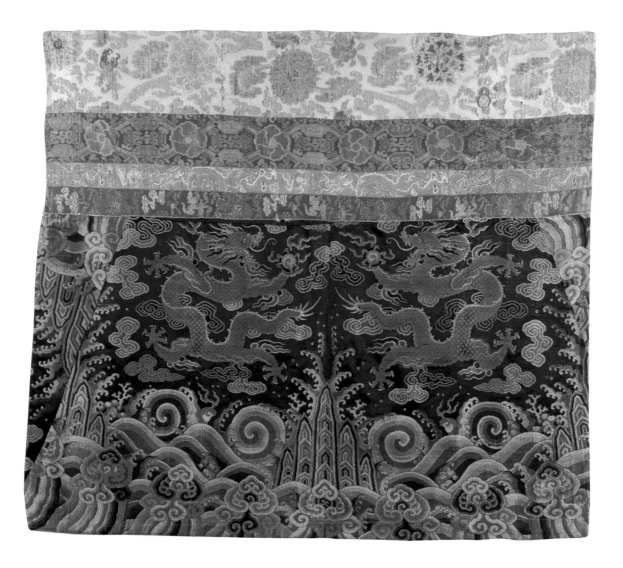

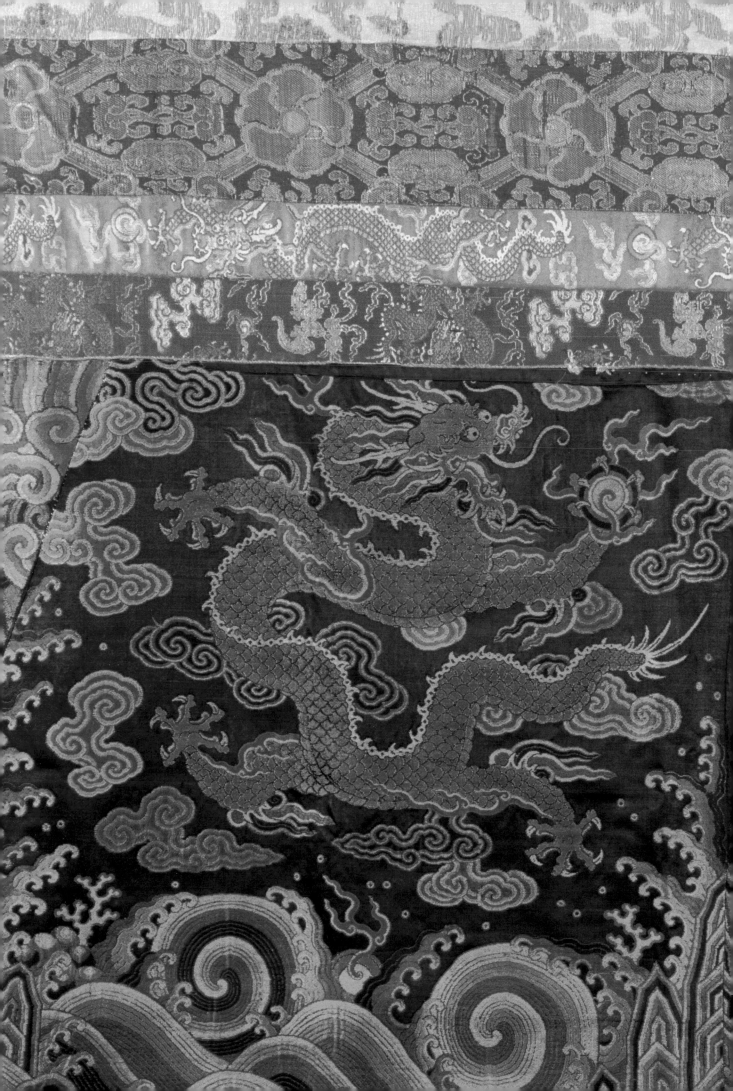

76 Kesa *or mantle for a Buddhist monk*

brocaded tabby with gauze

silk: Qing dynasty, early 18th century; construction: Japan
length 115 cm; width 206 cm

77 Kesa *or mantle for a Buddhist monk*

figured satin and lampas

silk: Qing dynasty, late 17th century; construction: Japan
length 115 cm; width 204 cm

As Mahayana Buddhism spread from India across Central Asia in the 3rd and 2nd centuries BC, then to China around the 4th century AD, and on to Japan in the 6th and 7th centuries, the doctrines and practices of the faith changed profoundly. As the theology developed into one of promising salvation for all, monastic rituals evolved into public ceremonies. On these occasions, worship halls of shrines and temples were profusely decorated with special textiles (see no. **60**) and priests celebrating the rituals were clothed in beautiful vestments made of the refined fabrics offered to temples by wealthy devotees. These vestments preserved the form of the traditional patchwork mantles worn by Indian monks to symbolize the vow of poverty and rejection of material possessions. According to legend, while gazing over newly planted rice fields, Buddha told his disciple that monks' garments should resemble the pattern formed by the rectangular rice fields within their earthen walls.

The name in Japanese, *kesa,* was derived from the Sanskrit *kasaya* meaning impure, referring to garments of unbleached cotton pieced together from worn or discarded fabrics. Throughout East Asia, the mantle was worn over other robes, draped over the left shoulder and under the right arm with a loop and cord, sewn along the upper edge of the garment, for fastening.[1]

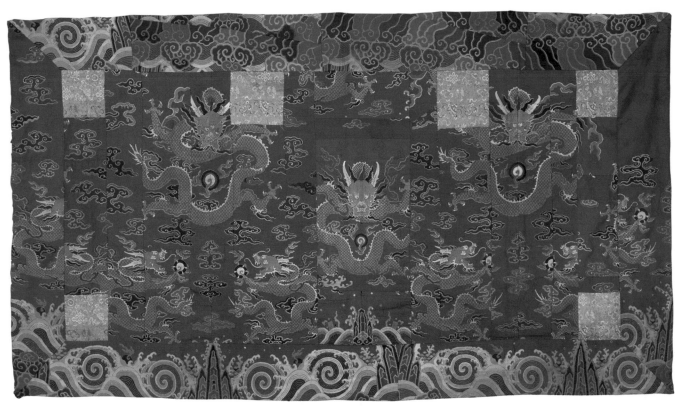

76

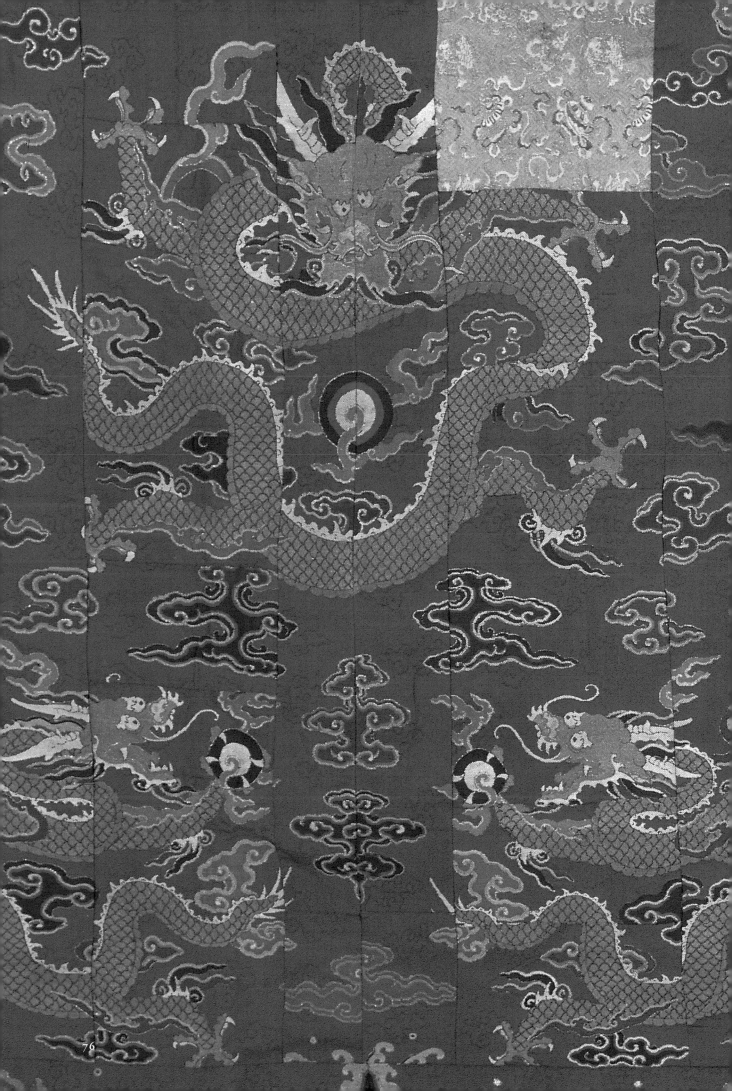

Since the late Ming dynasty, dragon robes were highly prized in Japan. The court robe bestowed upon Hideyoshi Toyotomi when he was named "King of Japan" in the 16th century is preserved at the Myôô-in temple. Reportedly, that four-clawed *mang* robe remained unused because Hideyoshi, insulted, felt he deserved a robe of higher rank.[2] A late Ming dynasty *mang* dragon robe cut and sewn into a *kesa* is preserved in The Victoria and Albert Museum collection.[3] Dragon robe fabrics also figured prominently among the imported Chinese textiles used in the Gion Festival where they were hung from festival carts.[4]

The *kesa* shown here retain the integrity of the original Chinese dragon robe patterns. In the case of no. 77, the original fabric, probably already made up into a robe, was unstitched and the principal dragons from the front and back were positioned side by side; the length was adjusted to meet the requirements of *kesa* construction, and other parts of the original robe were seamed to create a "whole cloth" rectangle. The maker created the required grid of seven vertical segmented panels separated by plain narrow strips

by sewing white silk braid in the proper configuration onto the dragon silk. Visually it suggested the appropriate patchwork. The construction of no. 76 followed a similar plan, but in that case the fabric was actually cut and stitched with tiny seams that do not interrupt the continuity of the original pattern. The patchwork created is a grid of wider and narrower strips surrounded by a framing border.

The dragon pattern of no. 77 combines elements of the late 16th century Ming dynasty style with Qing dynasty tastes of the third quarter of the 17th century. Reminiscent of yoke and band designs, the principal *mang* dragons loop around the shoulders, but the smaller dragons on the lower skirts have been freed from the confines of discrete bands (see nos. 18 and 19). The design is embellished with symbols for long life, flying cranes carrying *lingchi* fungus, each fungus supporting the character *shou* for long life. The *mang* patterns on no. 76, which date from around 1700, present the redefined formula for Qing court robes we have seen in several *jifu* in this catalogue (see nos. 24, 25, 26, 27 and 28).

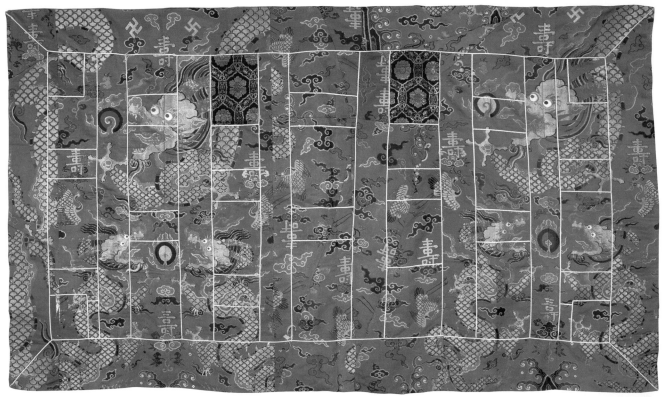

77

1 Kennedy 1991.
2 Kyoto National Museum 1998.
3 Wilson 1986, p. 117, fig. 100.
4 Kajitani 1992.

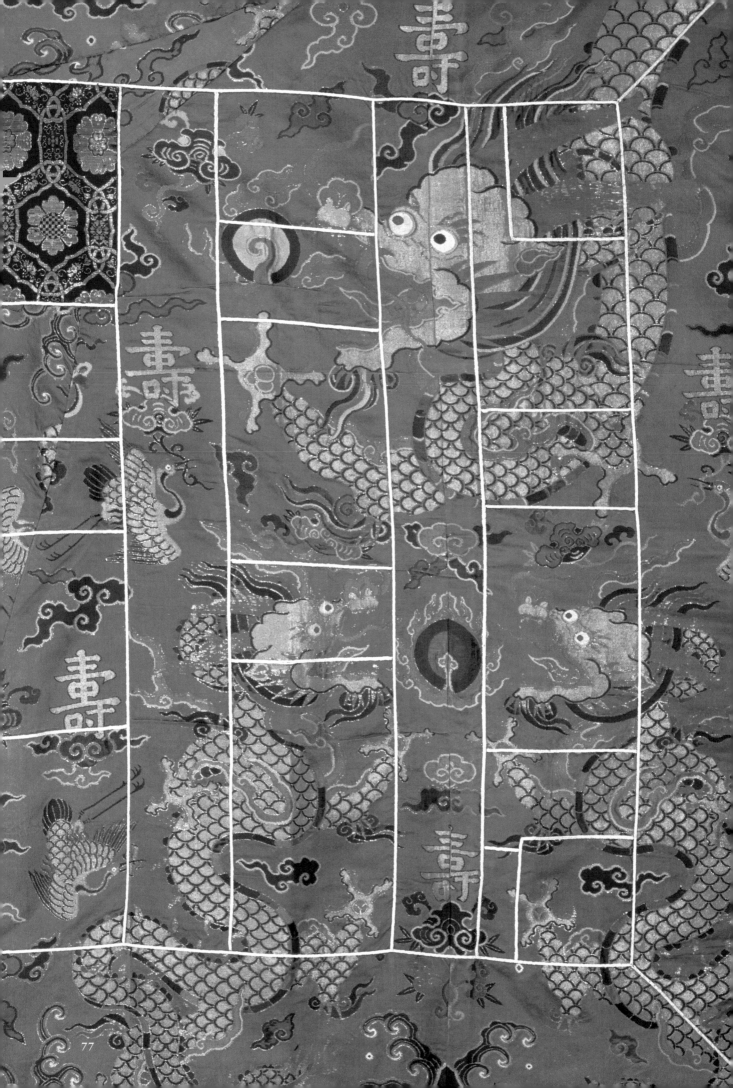

Appendices

(Adapted from Stuart and Rawksi 2001, pp. 124, 132; Cammann 1994; and Dickinson and Wrigglesworth 2000, pp.170-198.)

I
Court rank badges (*buzi*)

CIVIL RANK	EARLY MING (1391 - 1527)	MING/QING (1527 - 1664)	QING (1652-1911)
First	Crane or Golden Pheasant	Crane	Crane
Second	Crane or Golden Pheasant	Golden Pheasant	Golden Pheasant
Third	Peacock or Wild Goose	Peacock	Peacock
Fourth	Peacock or Wild Goose	Wild Goose	Wild Goose
Fifth	Silver Pheasant	Silver Pheasant	Silver Pheasant
Sixth	Egret or Mandarin Duck	Egret	Egret
Seventh	Egret or Mandarin Duck	Mandarin Duck	Mandarin Duck
Eighth	Oriole, Quail or Paradise Flycatcher	Oriole	Quail
Ninth	Oriole, Quail or Paradise Flycatcher	Quail	Paradise Flycatcher

MILITARY RANK			
First	Lion	Lion	Qilin (after 1662)
Second	Lion	Lion	Lion
Third	Tiger or Leopard	Tiger	Leopard (after 1664)
Fourth	Tiger or Leopard	Leopard	Tiger (after 1644)
Fifth	Bear	Bear	Bear
Sixth	Panther	Panther	Panther
Seventh	Panther	Panther	Rhinoceros (after 1759)
Eighth	Rhinoceros	Rhinoceros	Rhinoceros
Ninth	Rhinoceros	Sea Horse	Sea Horse

II
Qing imperial ranks

MALE RANK	INSIGNIA	CORRESPONDING FEMALE RANK	INSIGNIA
Emperor (*Huangdi*)	4 roundels: frontal *long* with sun and moon on shoulders	Empress Dowager (*Huangtaihou*)	2 styles with 8 roundels: 4 frontal *long* and 4 profile *long*
Heir apparent (*Huangtaizi*)	4 roundels: frontal *long*	Empress (*Huanghou*)	2 styles with 8 roundels: 4 frontal *long* and 4 profile *long*
Imperial sons (*Huangzi*)	4 roundels: frontal *long*	Consort, first rank (*Huangguifei*)	8 roundels: 4 frontal *long* and 4 profile *long*
Prince of the blood, first rank (*Heshe qinwang*)	4 roundels: frontal *long* at chest and back; profile *long* at shoulders	Consort, second rank (*Guifei*)	8 roundels: 4 frontal *long* and 4 profile *long*
Prince of the blood, second rank (*Dolo junwang*)	4 roundels: profile *long*	No corresponding female rank	
Prince of the blood, third rank (*Dolo beile*)	2 roundels: frontal *mang*	Consort, third rank (*Fei*)	8 roundels: 4 frontal *long* and 4 profile *gui long*
Prince of the blood, fourth rank (*Gushan beizi*)	2 roundels: profile *mang*	No corresponding female rank	
Prince of the blood, fifth rank (*Fengen zhenguo gong*)	2 squares: frontal *mang*	Consort, fourth rank (*Pin*)	8 roundels: 4 frontal *long* and 4 profile *gui long*
Prince of the blood, sixth rank (*Fengen fuguo gong*)	2 squares: frontal *mang*	No corresponding female rank	
Prince of the blood, seventh rank (*Buru bafen zhenguo gong*)	2 squares: frontal *mang*	Consort, fifth rank (*Guiren*)	8 roundels: 4 frontal *long* and 4 profile *gui long*
Prince of the blood, eighth rank (*Buru bafen fugou gong*)	2 squares: frontal *mang*	No corresponding female rank	
Noble of imperial lineage, ninth rank, grades one through three (*Zhenguo jiangjun*)	2 squares: *qilin*	No corresponding female rank	
Noble of imperial lineage, tenth rank, grades one through three (*Fuguo jiangjun*)	2 squares: lion	No corresponding female rank	
Noble of imperial lineage, eleventh rank, grades one through three (*Feng-guo jiangjun*)	2 squares: leopard	No corresponding female rank	
Noble of imperial lineage, twelfth rank (*Fengen jiangjun*)	2 squares: tiger	No corresponding female rank	
Officials, first through third ranks	2 squares, see fig. 3	Wife of the heir apparent	8 roundels: 4 frontal *long* and 4 profile *long*
Officials, fourth through sixth ranks	2 squares, see fig. 3	Wives and daughters of imperial sons and princes of the blood, first and second rank; princesses, first and second rank	4 roundels to match badges of husband's coat
Officials, seventh through ninth ranks	2 squares, see fig. 3	Wives and daughters of other princes of the blood, nobles and officials, first through third ranks	2 roundels or squares to match badges of husband's or father's surcoat
No corresponding male rank		Wives and daughters of officials, fourth through seventh ranks	2 squares to match badges of husband's or father's surcoat

Technical analysis

by Marie-Hélène Guelton
Textile analyst at the
Musée des Tissus and CIETA in Lyon

1 *Fragment of a sleeve*
Samit,* weft-faced compound twill, 3 complementary wefts (2 of which are interrupted) bound in 1Z2 twill order.

2 *Fragment (three pieces rejoined)*
Warp-faced (single warp) brocaded tabby foundation weave, 1 discontinuous supplementary weft bound in 1S5 twill order (occasionally 1Z5 twill), by 1 warp out of 6. Paired ground wefts are floated across the rear of the motifs every 5-7 picks. Gilded membrane strips. Selvage on the left side.

3 *Fragment*
Figured tabby foundation weave, 1 continuous supplementary weft bound in tabby by 2 warps out of 4. Gilded paper strips.

4 *Garment fragment*
Figured gauze, stencilled with gold foil. Tabby lining; floss silk padding.

5 *Fragment*
Warp-faced (single warp) brocaded tabby foundation weave, 1 discontinuous supplementary weft bound in 1S5 twill order (occasionally 1Z5 twill), by 1 warp out of 6. Paired ground wefts are floated across the rear of the motifs every 5-7 picks. Gilded membrane strips. Selvage on the left side.

6 *Pair of knee pads*
Embroidered tabby. Stitches: interlocking, satin stitch, split-stitch, knot. Needlelooped borders. Tabby lining; floss silk padding.

7 *Garment fragment (two pieces rejoined)*
Kesi slit tapestry, weft-faced tabby weave. Metal-wrapped corroded parchment thread on a silk core.

8 *Man's changpao or unofficial robe*
Damask. Tabby lining.

9 *Man's bufu or court rank robe*
Damask, 5-end satin foundation weave.

10 *Pair of buzi or court rank badges*
(two textiles)
a) Plain gauze, embroidered. Cordonnet silk.
b) Damask, 2Z1 twill foundation weave.

11 *Buzi or court rank badge*
Embroidered and appliquéd loose tabby foundation weave. Filling stitches: encroaching satin stitch, filling couched stitch using paired metal-wrapped thread. Outlining stitches: couched stitch (known as *point de Boulogne*) using paired silk-wrapped thread on a vegetal fiber core, paired cordonnet, or single silk thread. Chain-stitch border. Cotton tabby lining.

12 *Buzi or court rank badge*
Embroidered and appliquéd loose tabby foundation weave. Filling stitches: encroaching satin stitch, filling couched stitch using paired metal-wrapped thread. Outlining stitches: couched stitch using paired silk-wrapped thread on a vegetal fiber core, paired cordonnet, or single silk thread. Chain-stitch border. Cotton tabby lining.

13 *Emperor's buzi or rank badge*
Kesi slit tapestry, weft-faced tabby weave. Metal-wrapped paper thread on a silk core.

14 *Buzi or court rank badge*
Embroidered satin. Filling stitches: encroaching satin, couched stitch using paired metal-wrapped thread on a silk core. Outlining stitches: stem stitch, couched stitch using paired metal-wrapped thread and silk-wrapped thread.

15 *Buzi or court rank badge*
Embroidered 7(?)-end satin foundation weave. Filling stitches: encroaching satin stitch, filling couched stitch using paired metal-wrapped paper thread on a silk core. Outlining stitches: couched stitch. Tabby lining.

16 *Woman's longgua or court surcoat*
(unfinished)
Kesi slit tapestry, weft-faced tabby weave with some overpainted details. Metal-wrapped paper thread on a silk core. Damask lining, twill foundation weave.

17 *Yoke from a woman's robe*
Embroidered and padded appliquéd tabby foundation weave. Filling stitches: encroaching satin stitch, filling couched stitch using paired metal-wrapped paper thread on a silk core. Outlining stitches: stem stitch, couched stitch using paired metal-wrapped thread and cordonnet silk, running stitch for small details.

18 *Fragment of a robe band*
Solid cut velvet, single harness, twill foundation weave, embroidered, appliquéd (couching) and padded. Filling stitches: *point de chausson*, padded encroaching satin stitch, couched stitch using metal-wrapped paper thread on padding over a padded foundation. Outlining stitches: couched stitch. Selvage on the right side.

19 *Fragment of a robe band*
Embroidered and appliquéd (couching) tabby foundation weave. Filling stitches: encroaching satin stitch, filling couched stitch. Outlining stitches: split-stitch, couched stitch using paired silk-wrapped thread.

20 *Man's chaopao or formal court robe*
(composed of several textiles).
A Damask, 5-end satin foundation weave with sections of figured 5-end satin foundation weave with discontinuous (?) supplementary wefts bound in 1S4 twill and in 1Z4 twill. Metal-wrapped paper thread on a silk core.
B Figured 2Z1 twill, 1 continuous weft bound in 1S2 twill. Gilded paper strips.
C Ribbon: appliquéd threads: couched stitch using paired metal-wrapped paper thread on a silk core.
D Sleeves: goffered satin.
E Lining: damask, 5-end satin foundation weave.

21 *Fragment of a longpao or dragon robe*
Embroidered and appliquéd (couching) gauze foundation weave. Filling stitches: encroaching satin stitch, filling couched stitch, counted stitch. Outlining stitches: couched stitch, slit-stitch. Silk-wrapped thread on a peacock tail feather iridescent filament core; metal-wrapped paper thread on a silk core.

22 *Fragments of a longpao or dragon robe*
Brocaded warp-faced 8(?)-end satin foundation weave with discontinuous supplementary wefts bound in weft-faced 1Z7 twill order, or in weft-faced 8(?)-end satin weave for the metal-wrapped paper thread.

23 *Unfinished gua or surcoat*
Figured twill or satin foundation weave (hidden by the pattern wefts) with continuous and discontinuous supplementary wefts bound in 1S4 twill or 1Z4 twill. Metal-wrapped paper thread on a silk core.

24 *Man's jifu or semiformal court robe*
Embroidered satin. Damask lining.

25 *Emperor's jifu or semiformal court robe*
(composed of various textiles)
A Embroidered and appliquéd (couching) 7-end satin weave. Filling stitches: encroaching satin stitch, threading of seed pearls on a silk thread, filling couched stitch using a silk cordonnet (imitation of knotted stitch). Outlining stitches: couched stitch using a silk cordonnet.
B Bias: lampas, satin foundation weave, 1 continuous supplementary weft bound in 1Z2 twill order. Corroded metal-wrapped paper(?) thread on a silk core.
C Appliqué ribbon: couched metal-wrapped paper thread or braid.
D Collar and sleeves: embroidered satin, the same textile as for the body.
E Lining: damask, 3Z1 twill foundation weave.

26 *Emperor's jifu or semiformal court robe*
(composed of various textiles)
A 5-end satin foundation weave, embroidered and appliquéd (couching). Filling stitches: encroaching satin stitch, filling couched stitch using paired metal-wrapped paper thread on a silk core. Outlining stitches: couched stitch using paired metal-wrapped thread or silk cordonnet, stem stitch, running stitch (small details). Collar: same textile.
B Bias: lampas, satin foundation weave, 1 continuous supplementary weft bound in 1Z2 twill order. Metal-wrapped paper thread on a silk core.
C Sleeves: goffered satin.
D Lining: damask, 5-end satin foundation weave.

27 *Man's jifu or semiformal court robe*
(composed of various textiles)
A Embroidered 7(?)-end satin. Filling stitches: encroaching stitch, couched stitch. Outlining stitches: couched stitch using paired metal-wrapped paper thread on a silk core, slit-stitch, knot, *point de chausson*.
B Bias: brocaded 5-end satin foundation weave, 1 discontinuous supplementary weft. Gilded paper strips.
C Sleeves: goffered satin. 5-end satin, embroidered. Metal-wrapped paper thread on a silk core.
D Border: appliquéd (couching) using metal-wrapped paper thread on a silk core.
E Lining: damask, satin foundation weave.

*All textiles referred to are silk unless, as in no. 55, specifically otherwise indicated.

28 *Boy's robe modeled on a* jifu
or semiformal court robe
Embroidered figured gauze. Filling stitches: encroaching satin stitch, filling couched stitch using paired metal-wrapped paper thread on a silk core. Outlining stitches: couched stitch using paired metal-wrapped paper thread. Bias: figured satin, 1 continuous supplementary weft bound in twill. Gilded paper strips.

29 *Throne seat cushion cover*
Brocaded satin weave with supplementary discontinuous wefts bound in 1S3 twill order. Metal-wrapped paper thread on a silk core.

30 *Elements of an elbow cushion*
Kesi slit tapestry, weft-faced plain tabby weave. Metal-wrapped paper thread on a silk core.

31 *Fragment of a furnishing fabric*
Embroidered gauze.

32 *Kang seat cushion cover*
Embroidered damask, satin foundation weave. Filling stitches: encroaching satin. Outlining stitches: stem stitch, couched stitch using paired cordonnet silk. Damask lining, warp-faced 2Z1 twill and weft-faced 1Z4 twill weave.

33 *Fragment of a furnishing fabric*
Voided cut and uncut *(ciselé)* velvet, satin foundation weave, 3 pile harnesses. Damask lining, warp-faced satin foundation and tabby weave.

34 *Woman's* changyi *or semiformal robe*
Kesi slit tapestry, weft-faced plain tabby weave. Tabby lining.

35 *Military banner*
Embroidered warp-faced 5-end satin weave. Filling stitches: encroaching satin, couched stitch using paired metal-wrapped thread and silk-wrapped thread. Sleeve: damask, warp-faced 5-end satin foundation weave. Damask lining, warp-faced 5-end satin foundation weave. Metal-wrapped paper thread on a silk core and silk-wrapped thread on a rigid vegetal core.

36 *Suit of parade armor*
Kesi slit tapestry, weft-faced tabby foundation weave. Metal-wrapped paper thread on a silk core. Appliquéd braids. Bias: embroidered 5-end satin foundation weave. Outlining stitch: two rows of small lines made of four back-stitches regularly pattern the satin ground. Goffered lining tabby foundation weave. Between the *kesi* and the lining, metallic plaques are articulated with metal rivets.

37 *Suit of parade armor*
(composed of 3 textiles)
Figured satin. Velvet: plain cut velvet, twill foundation weave, only one harness. Lampas, satin foundation weave, 1 continuous supplementary weft bound in 1Z2 twill order. Metal-wrapped paper thread on a silk core. Ribbon: warp-faced tabby foundation weave, 1 supplementary pattern warp.

38 *Suit of parade armor*
(composed of various textiles)
A Figured satin foundation weave, 1 continuous supplementary weft of metal-wrapped paper thread on a silk core bound in 1Z2 twill order, embroidered. Filling stitches: encroaching satin stitch, filling couched stitch using paired metal-wrapped paper thread on a silk core. Outlining stitches: couched stitch using paired metal-wrapped thread.
B Facings: plain cut velvet, twill foundation weave, only one harness.
C Bindings: plain satin weave used on bias.
D Ribbon: warp-faced tabby foundation weave, 1 supplementary pattern warp. Metal-wrapped paper thread on a silk core.
E Waistband: cotton tabby.
F Lining: figured tabby and plain satin weave.
G Tapes: card woven band.

39 *Fragment, possibly a* sutra *cover*
Brocaded 5-end satin weave with discontinuous supplementary wefts bound in weft-faced 5-end satin by 1 warp out of 6. Gilded paper strips.

40 *Fragment, possibly a pleated valance*
Kesi slit tapestry, weft-faced plain tabby weave. Metal-wrapped paper thread on a silk core.

41 *Liturgical banner head*
(three textiles)
A Embroidered satin. Filling stitches: encroaching satin stitch, filling couched stitch; metal-wrapped thread on a padded foundation made by encroaching satin stitches. Outlining stitches: couched stitch using single metal-wrapped thread on a silk core.
B Badge: embroidered figured gauze with a high density. Filling stitches: encroaching satin stitch, satin stitch, filling couched stitch; metal-wrapped thread on a padded foundation made by encroaching satin stitches. Outlining stitches: stem stitch, couched stitch using paired or single metal-wrapped threads. Metal-wrapped paper thread on a silk core.
C Borders: figured 7-end satin foundation weave with continuous and discontinuous (?) supplementary wefts.

42 *Gyu-lu che or prime minister's coat*
Kesi slit tapestry, weft-faced plain tabby weave. Metal-wrapped paper thread. Printed cotton tabby lining.

43 *Chuba or man's robe*
Figured 5(?)-end satin foundation weave with continuous (and discontinuous?) supplementary wefts bound in 1S4 twill order. Gilded paper strips. Metal-wrapped paper thread on a silk core. Damask lining, 6(?)-end satin foundation weave.

44 *Chuba or man's robe*
Figured 7-end satin foundation weave with continuous supplementary wefts bound in 1Z3 twill or 1Z6 twill order. Metal-wrapped paper thread on a silk core. Plain tabby lining.

45 *Chuba or man's robe*
(composed of two textiles)
A Brocaded 8-end satin foundation weave with discontinuous supplementary wefts bound in 1Z3 twill order. Metal-wrapped paper thread on a silk core.
B Damask, 7(?)-end satin foundation weave.

46 *Chuba or man's robe*
Brocaded warp-faced 2S1 twill foundation weave with discontinuous supplementary wefts bound in 1S2 twill order. Gilded paper strips. Crepe damask lining.

47 *Dais cover*
Figured 5-end satin foundation weave with discontinuous supplementary wefts bound in 1S4 twill order.

48 *Fragments of a furnishing fabric*
5-end satin foundation weave, embroidered and appliquéd (couching). Filling stitches: encroaching satin stitch. Outlining stitches: couched stitch using paired metal-wrapped paper thread on a silk core. Cotton tabby lining.

49 *Sash*
Figured 5-end satin foundation weave with continuous and discontinuous supplementary wefts bound in 1S4 twill order. Gilded paper strips. Fringes twisted in S direction. Cotton lining: different textiles of plain tabby weave.

50 *Shifuku or pouch for a tea caddy*
Figured satin foundation weave, 1 continuous (?) supplementary weft bound in 1S3 twill order. Gilded paper strips. Braid in silk.

51 *Shifuku or pouch for a tea caddy*
Damask, 5-end satin foundation weave.

52 *Shifuku or pouch for a tea caddy*
Damask, 3S/Z1 twill foundation weave.

53 *Length of fabric*
Damask, warp-faced satin foundation weave. Two selvages.

54 *Border panels from a bedcover*
Kesi slit tapestry, weft-faced plain tabby weave. Metal-wrapped paper thread on a silk core and peacock feather (on second piece).

55 *Bedcover or carpet*
Embroidered cotton tabby. Filling stitches: encroaching satin stitch. Outlining stitches: couched stitch using paired metal-wrapped paper thread on a silk core, or single silk thread, running stitch. Linen tabby lining. Trim: silk and gold-wrapped thread card woven fringe.

56 *Cape for a religious statue*
Embroidered tabby weave. Filling stitches: encroaching satin stitch. Outlining stitches: couched stitch using paired metal-wrapped paper thread on a silk core, or single silk thread, running stitch.

57 *Panel*
Painted plain tabby weave (double warp). Outlines in black.

58 *Hanging*
Kesi slit tapestry, weft-faced plain tabby weave. Metal-wrapped paper thread on a silk core. Two selvages.

59 *Daoist* jiangyi *or vestment for a first degree priest*
Embroidered and appliquéd (couching) satin foundation weave. Damask,

5-end satin foundation weave. Large gilded paper strips, metal-wrapped paper thread on a silk core, silk cordonnet. Filling stitches: needlelooping on a silk core, filling couched stitch using paired metal-wrapped thread. Outlining stitches: couched stitch using paired metal-wrapped thread. Damask lining, satin foundation weave.

60 *Valance and banners*
Embroidered tabby weave (double thread). Filling stitches: encroaching satin, couched stitch using paired metal-wrapped thread on a silk core and silk-wrapped thread on a rigid vegetal fiber core. Outlining stitches: couched stitch using paired metal-wrapped thread and silk-wrapped thread.

61 *Element of a ritual diadem*
Embroidered damask, 5-end satin foundation weave. Filling stitches: encroaching satin stitch, filling couched stitch, chain or split stitch. Outlining stitches: couched stitch, split stitch using cordonnet silk. Metal-wrapped paper thread on a silk core.

62 *Unused fragment*
Embroidered satin weave. Filling stitches: encroaching satin, knotted stitch. Outlining stitches: couched stitch. Metal-wrapped paper thread on a silk core.

63 *Fragment*
Lampas, foundation weave cannot be determined. Supplementary continuous wefts bound in 1S2 twill order. Metal-wrapped paper thread on a silk core.

64 *Pendant or banner head*
Embroidered and figured 5-end satin weave with continuous supplementary wefts bound in 1S4 twill order and discontinuous supplementary wefts bound in weft-faced 5-end satin. Metal-wrapped paper thread on a silk core. Filling stitches: encroaching satin. Outlining stitches: couched stitch using metal-wrapped paper thread and cordonnet silk. Cotton tabby lining.

65 *Thanka of Maitreya*
Brocaded tabby or lampas with discontinuous supplementary wefts bound in weft-faced 1S3 twill order. Gilded paper strips.

66 *Thanka of Vajrabhairava*
Central image: allover embroidered with floss silk, metal-wrapped thread on a silk core and sewn with seed pearls and coral beads. Filling stitch: encroaching satin. Outlining stitches: couched stitch using paired metal-wrapped paper thread on a silk core and cordonnet silk; stem stitch. Inner border: warp-faced satin foundation weave, 1 continuous supplementary weft. Silvered paper thread. Outer border: warp-faced satin foundation weave with discontinuous supplementary wefts bound in twill order.

67 *Thanka of offerings*
Central image: embroidered warp-faced satin foundation weave. Filling stitches: encroaching satin. Outlining stitches: stem stitch, couched stitch using paired metal-wrapped thread. Border: brocaded warp-faced 7-end satin foundation weave with discontinuous supplementary wefts. bound in 1 twill order. Metal-wrapped paper thread on a silk core.

68 *Thanka of Abheda*
Central image: warp-faced satin foundation weave, appliquéd with various figured fabrics (*kesi,* damask, figured silks), embroidered and painted. Outlining stitches: couched stitch using silk-wrapped thread on a rigid vegetal fiber core, stem stitch and knotted stitch. Border: damask, warp-faced 5-end satin foundation weave.

69 *Thanka of Ratnasambhava*
Central image: warp-faced 8-end satin weave, appliquéd with several figured fabrics, embroidered and painted. Outlining stitches: couched stitch. Borders: warp-faced satin foundation weave, 1 continuous supplementary weft bound in weft-faced 5-end satin. Gilded paper strips.

70 *Thanka of Shakyamuni*
Central image: warp-faced satin foundation weave, appliquéd with various figured fabrics, embroidered and painted. Filling stitches: encroaching satin. Outlining stitches: stem stitch, couched stitch using silk-wrapped thread on a rigid vegetal fiber core. Border: brocaded warp-faced 7-end satin foundation weave with discontinuous supplementary wefts.

71 *Fragment*
Figured tabby foundation weave with discontinuous and continuous supplementary wefts bound in 1Z3 twill order, by 1 warp out of 4. Gilded paper strips.

72 *Patchwork panel*
(composed of various textiles)
A Green ground: lampas, satin foundation weave, 1 continuous (?) supplementary weft bound in twill order. Gilded paper strips.
B Yellow, beige, cream and dark brown grounds *(kinran):* figured 3Z2 twill foundation weave, 1 continuous supplementary weft bound in twill order. Gilded paper strips.
C Blue ground *(kinran):* figured 5-end satin foundation weave, 1 continuous supplementary weft bound in twill order. Gilded paper strips.
D Floral motif on a yellow ground: lampas, satin foundation weave with continuous (?) supplementary wefts bound in 1S2 twill.
E Red and ochre grounds: damask, 6(?)-end satin foundation weave.
F Yellow ground with small flowers: figured satin foundation weave with continuous supplementary wefts bound in twill order. Metal-wrapped paper thread on a silk core.
G Dragon pattern: figured satin with continuous (?) supplementary wefts bound in twill order. Metal-wrapped thread on a silk core. Gilded paper strips.

73 *Patchwork* mandala
(composed of various textiles)
A Red, yellow, green and ochre grounds: damask, satin foundation weave.
B Brown, cream, yellow and navy blue grounds: plain satin weave.
C Blue grounds: plain tabby weave.
D Small floral motifs:
1/ figured *liseré* satin, with *liseré* ground weft and continuous (?) supplementary wefts.
2/ lampas, satin foundation weave with continuous (?) supplementary wefts bound in twill order.
E Floral motifs on pale blue or orange ground: figured satin with continuous (?) supplementary wefts bound in twill order. Gilded paper strips.
F Navy blue ground *(kinran):* figured 3Z2 twill (?), 1 continuous supplementary weft bound in twill (?).
G Border with dragon motif: figured damask, satin foundation weave with continuous and discontinuous(?) supplementary wefts bound in 1S4 twill order. Metal-wrapped paper thread on a silk core. Gilded paper strips. Cotton tabby lining.

74 *Patchwork* mandala
(composed of various figured fabrics)
Warp-faced 8-end satin foundation weave with discontinuous (?) supplementary wefts bound in weft-faced 1Z3 twill order. Gilded paper strips. Various fabrics of similar structure. Figured tabby lining.

75 *Altar frontal or hanging*
(composed of various textiles)
A White ground: figured 7-end satin foundation weave with continuous and discontinuous supplementary wefts bound in 1S6 twill order. Silvered paper strips.
B Brown ground: lampas, 2Z1 twill foundation weave with continuous supplementary wefts bound in 1Z2 twill order. Gilded paper strips.
C Yellow ground: figured satin foundation weave with continuous supplementary wefts bound in 1Z3 twill order. Metal-wrapped corroded paper thread on a silk core.
D Red ground: figured 8-end satin foundation weave with continuous (?) supplementary wefts bound in 1S2 twill order. Metal-wrapped corroded paper (?) thread on a silk core.
E Blue ground: figured satin foundation weave with continuous (?) and discontinuous (?) supplementary wefts bound in 1S6 twill order. Metal-wrapped paper thread on a silk core.
F Lining: damask, 8-end satin foundation weave and plain satin weave.
G Fastening: leather.

76 *Kesa or mantle for a Buddhist monk*
(composed of two textiles)
Warp-faced figured tabby, patterned with a gauze weaving, brocaded with discontinuous wefts bound in twill order. Metal-wrapped paper thread on a silk core. Squares: lampas, 5-end satin foundation weave with continuous supplementary wefts bound in 1Z2 twill order. Gilded paper strips. Damask lining, 8-end satin foundation weave.

77 *Kesa or mantle for a Buddhist monk*
(composed of two textiles)
Figured 5-end satin foundation weave with continuous supplementary wefts bound in 1S4 twill order. Lampas. Gilded paper strips. Metal-wrapped paper thread on a silk core. Appliqué: a braid of silk is appliquéd to form the frame and columns of the *kesa.* Squares: lampas, 2Z1 foundation weave with continuous supplementary wefts bound in tabby. Gilded paper strips. Damask lining, 5 (?)-end satin foundation weave.

Bibliography

ANDREWS 1920
F. H. Andrews. "Ancient Chinese Figured Silks Excavated by Sir Aurel Stein at Ruined Sites of Central Asia." *Burlington Magazine* 37, no. 1 (1920), pp. 3-10; 37, no. 2 (1920), pp. 71-77; 37, no. 3 (1920), pp. 147-152.

D'ARDENNE DE TIZAC 1924
J. d'Ardenne de Tizac. *The Stuffs of China, Weavings and Embroideries*. London 1924.

BANGU 1963
Bangu. *Paihutung* (Comprehensive Discussions in White Tiger Hall), in *Pai-tzu Ch'üan-shu* XIV. Taipei 1963.

BARBER 1991
Elizabeth J. W. Barber. *Prehistoric Textiles*. Princeton 1991.

BARTHOLOMEW 1985a
Teresa Tse Bartholomew. *The Hundred Flowers: Botanical Motifs in Chinese Art*. San Francisco 1985.

BARTHOLOMEW 1985b
Teresa Tse Bartholomew. "Botanical Puns in Chinese Art from the Collection of the Asian Art Museum of San Francisco." *Orientations* 16, no. 8 (September 1985), pp. 18-34.

BARTLETT 1991
Beatrice Bartlett. *Emperors and Ministers: The Grand Council in Mid-Ch'ing China, 1723-1820*. Berkeley 1991.

BECKWITH 1987
Christopher I. Beckwith. *The Tibetan Empire in Central Asia: A History of the Struggle for Great Power among Tibetans, Turks, Arabs and Chinese during the Early Middle Ages*. Princeton 1987.

BEIJING ARCHAEOLOGICAL TEAM 1964
Beijing Archaeological Team. "Beijing Nanyuan waizikeng mingdai muzang qingli jianpi" (Notes on the Ming Dynasty Burials at South Park Marsh, Beijing). *Wenwu* 11 (1964), pp. 45-47.

BEIJING MUNICIPAL BUREAU 1958
Beijing Municipal Bureau of Cultural Relics. "Beijingshi shuangta qingshousi chutu de simian zhipin ji xiuhua" (Silk and Cotton Textiles and Embroidery Excavated from the Double Pagoda at Qingshou Temple, Beijing City). *Wenwu* 9 (1958), p. 29.

BEIJING MUNICIPAL BUREAU 2001
Beijing Municipal Bureau of Cultural Relics. *Beijing wenwu jingcui daxi: zhixiu juan* (Gems of Beijing Cultural Relics Series: Textiles and Embroidery). Beijing 2001.

BERGER 1989
Patricia Berger. "A Stitch in Time: Speculations on the Origins of Needlelooping." *Orientations* 20, no. 8 (August 1989), pp. 45-53.

BERGER AND BARTHOLOMEW 1995
Patricia Berger and Teresa Tse Bartholomew. *Mongolia: The Legacy of Chinggis Khan*. London and New York 1995.

BEST 1996
Susan-Mari Best. "Meibutsu-gire Textiles in the Japanese Tea Ceremony," in Jil Tilden, ed., *Silk and Stone, The Third Hali Annual*. London 1996, pp. 136-145.

BODDE 1975
Derk Bodde. *Festivals in Classical China New Year and Other Annual Observances during the Han Dynasty 206 BC-AD 220*. Princeton 1975.

BRANDAUER AND HUANG 1931
Fredrick P. Brandauer and Huang Chun-chieh, eds. *Imperial Rulership and Cultural Change in Imperial China*. Seattle 1931.

BRAY 1997
Francesca Bray. *Technology and Gender: Fabrics of Power in Late Imperial China*. Berkeley 1997.

BREDON 1922
Juliet Bredon. *Peking, A Historical and Intimate Description of its Chief Places of Interest*. London 1922.

BROOK 1998
Timothy Brook. *The Confusions of Pleasure Commerce and Culture in Ming China*. Berkeley 1998.

BROWN 2000
Claudia Brown. *Weaving China's Past: The Amy S. Clague Collection of Chinese Textiles*. Phoenix 2000.

BURNHAM 1973
Dorothy K. Burnham. *Cut My Cote*. Toronto 1973.

BURNHAM 1980
Dorothy K. Burnham. *Warp and Weft: A Textile Terminology*. Toronto 1980.

BUSH 1995
Susan Bush. "Five Paintings of Animal Subjects or Narrative Themes and Their Relevance to Chin Culture," in Hoyt Cleveland Tillman and Stephen H. West, eds., *China under Jurchen Rule*. Albany 1995, pp. 183-215.

CAMMANN 1942
Schuyler V. R. Cammann. "Notes on the Development of Mandarin Squares." *Bulletin of the Needle and Bobbin Club* (1942), pp. 2-28.

CAMMANN 1944
Schuyler V. R. Cammann. "Development of the Mandarin Square." *Harvard Journal of Asian Studies* 8 (1944), pp. 71-130.

CAMMANN 1948
Schuyler V. R. Cammann. "Notes on the Origins of Chinese K'o-ssu Tapestry." *Artibus Asiae* 11, no. 1/2 (1948), pp. 90-110.

CAMMANN 1949
Schuyler V. R. Cammann. "Origins of the Court and Official Robes of Ch'ing Dynasty." *Artibus Asiae* 12, no. 3 (1949), pp. 189-201.

CAMMANN 1953a
Schuyler V. R. Cammann. "Chinese Mandarin Squares: Brief Catalogue of the Letcher Collection." *Philadelphia Museum of Art Bulletin* 17, no. 3 (1953), pp. 5-72.

CAMMANN 1953b
Schuyler V. R. Cammann. "Ming Festival Symbols." *Archives of the Chinese Art Society of America* 7 (1953), pp. 66-70.

CAMMANN 1956
Schuyler V. R. Cammann. "Some Strange Ming Beasts." *Oriental Art*, n.s., 2, no. 2/3 (Autumn 1956), pp. 94-102.

CAMMANN 1962
Schuyler V. R. Cammann. "Embroidery Techniques in Old China." *Archives of the Chinese Art Society in America* 16 (1962), pp. 16-40.

CAMMANN 1974
Schuyler V. R. Cammann. *Spansk korkåpa av kinesiskt broideri* (Spanish cope made of Chinese embroidery). Malmo, Sweden 1974.

CAMMANN 1991
Schuyler V. R. Cammann. "Birds and Animals as Ming and Ch'ing Badges of Rank." *Arts of Asia* (May-June 1991), pp. 88-94.

CAMMANN 2001
Schuyler V. R. Cammann. *China's Dragon Robes*. New York 1952. Reprint, Chicago 2001.

CAPON 1968
Edmund Capon. "Chinese Court Robes in the Victoria and Albert Museum." *Victoria and Albert Museum Bulletin* 4, no. 1 (1968), pp. 17-25.

CAPON 1976
Edmund Capon. "K'o-ssu and its relationship with painting," in Margaret Medley, ed., *Chinese painting and the decorative style: Colloquies on Art and Archaeology in Asia* 5. London 1976.

CHAMPKINS AND SIMCOX 1989
Paul Champkins and Jacqueline Simcox. *The Minor Arts of China IV*. London 1989.

CHANG 1986
Chang Kwang-chih. *The Archaeology of Ancient China*, 4th ed. New Haven 1986.

CH'EN 1964
Kenneth Ch'en. *Buddhism in China*. Princeton 1964.

CHEN 1971
Chen Zhengxiang. *Zhongguo di cansi ye* (The Silk Industry of China). Hong Kong 1971.

CHEN 1979
Chen Juanjuan. "Kesi." *Gugong bowuyuan yuankan* 3 (1979), pp. 22-29.

CHENG 1984
Cheng Weiji, ed. *Zhongguo tangzhi kexue jishu shi, gudai buten* (A History of Chinese Textile Technology, Ancient Section). Beijing 1984.

CHI AND CHEN 1986
Chi Jo-hsin and Chen Hsia-sheng. *Qingdai fushi zhanlan tulu* (Ch'ing Dynasty Costume Accessories). Taipei 1986.

CHINA 1917
China, The Maritime Customs. *Silk: Replies from Commissioners of Customs to Inspector General's Circular* no. 103, second series. Shanghai 1917.

CHRISTIE'S EDUCATION AND BEIJING MUNICIPAL BUREAU 1999
Christie's Education and The Beijing Municipal Bureau of Cultural Relics. *Treasures from Ancient Beijing*. New York and London 1999.

CHUNG 1980
Young Yang Chung. *The Art of Oriental Embroidery*. New York 1980.

CONFUCIUS 1963
Confucius. *Lunyu* (Analects), in James Legge, trans., *The Chinese Classics*, vol. 1. Oxford 1893-95. Reprint, New York 1963.

CPAM 1978
CPAM Zouxian, Shandong province. "Zouxian Yuandai Li Yu'an mu qingli jianbao" (Excavation of the Yuan dynasty tomb of Li Yu'an at Zouxian in Shandong province). *Wenwu* 4 (1978), pp. 14-20.

CYRUS-ZETTERSTROM AND XU 1995
Ulla Cyrus-Zetterstrom and Xu Guohua. *Textile Terminology*.
Stockholm 1995.

DA QING HUIDIAN SHILI 1963
Da Qing Huidian shili (The Collected Institutes and Precedents
of the Great Qing dynasty). Chinese government publication. 1899.
Reprint, Taipei 1963.

DATONG CITY MUSEUM 1978
Datong City Museum. "Datong qindai Ye Deyuan muzang quipi"
(Excavations of the Qing dynasty tomb of Ye Deyuan at Datong
in Shansi Province). *Wenwu* 4 (1978), pp. 1-13.

DEGRAW 1981
Imelda G. DeGraw, ed. *Secret Splendors of the Chinese Court: Qing
Dynasty Costume from the Charlotte Hill Grant Collection*. Denver 1981.

DICKINSON 1991
Gary W. Dickinson. *Chinese Imperial Cushions*. London 1991.

DICKINSON AND WRIGGLESWORTH 2000
Gary W. Dickinson and Linda Wrigglesworth. *Imperial Wardrobe*.
Berkeley 2000.

DIGBY 1950
George Wingfield Digby. "Chinese Court Costume and Dragon Robes."
The Connoisseur part 1 (September 1950), pp. 11-18; part 2
(November 1950), pp. 95-105.

DING LING MUSEUM 1990
Ding Ling Museum, The Institute of Archaeology, CASS and the
Archaeological Team of the City of Beijing. *Ding Ling* (The Imperial
Tomb of the Ming dynasty), 2 vols. Beijing 1990.

DOUIN 1910
G. Douin. "Cérémonial de la Cour et costumes du peuple de Pékin."
Bulletin de l'Association amicale franco-chinoise, no. 2, part 1 (April 1910),
pp. 105-138; no. 3, part 2 (July 1910), pp. 215-237; no. 4, part 3
(October 1910), pp. 347-368.

EBERHARD 1986
Wolfram Eberhard. *A Dictionary of Chinese Symbols: Hidden Symbols
in Chinese Life and Thought*. G. L. Campbell, trans. London and
New York 1986.

EBREY 1999
Patricia Ebrey. "The Ritual Context of Sung Imperial Portraiture"
in Cary Y. Liu and Dora C. Ching, eds., *Arts of the Sung and Yuan:
ritual, ethnicity and style in painting*. Princeton 1999, pp. 63-99.

ELLIOTT 2001
Mark C. Elliott. *The Manchu Way: The Eight Banners and Ethnic
Identity in Late Imperial China*. Stanford 2001.

FAIRBANK AND REISCHAUER 1978
John K. Fairbank and Edwin O. Reischauer. *China: Tradition and
Transformation*. Boston 1978.

FANG 1981
Thomé H. Fang. *Chinese Philosophy: its spirit and its development*.
Taipei 1981.

FERNALD 1946
Helen C. Fernald. *Chinese Court Costumes*. Toronto 1946.

FEUERWERKER 1976
Albert Feuerwerker. "State and Society in Eighteenth-Century China:
The Ch'ing Empire in its Glory." *Michigan Papers in Chinese Studies* 27
(1976).

FONG AND WATT 1996
Wen C. Fong and James C. Y. Watt. *Possessing the Past: Treasures from
the National Palace Museum*, Taipei. New York and Taipei 1996.

FRANCES 1998
Michael Frances. *Textile Art from the Silk Road: Part I: Silk Embroideries,
Brocades and Tapestries, AD 900-1600*. London: Textile Gallery, 1998.

FRANKE 1981
Herbert Franke. "Tibetans in Yuan China," in John Langlois, ed.,
China under Mongol Rule. Princeton 1981, pp. 296-328.

FUJIAN PROVINCIAL MUSEUM 1982
Fujian Provincial Museum. *Fuzhou Nan Song Huang Sheng mu
(The Southern Song tomb of Huang Sheng in Fuzhou)*. Beijing 1982.

FUNG 1952
Fung Yulan. *A History of Chinese Philosophy*, 2 vols. Princeton 1952-53.

GALLOWAY AND SIMCOX 1989
Francesca Galloway and Jacqueline Simcox. *The Art of Textiles*.
London 1989.

GANSU PROVINCIAL MUSEUM 1982
Gansu Provincial Museum and Zhang County Culture Center. "Gansu
Zhang xian Yuandai Wang Shixian jiazu muzang: Jianbao zhi yi"
(Excavations of the Yuan dynasty tombs of the Wang Shixian family at
Zhang County in Gansu Province). *Wenwu* 2 (1982), pp. 1-21 and pls. 1-2.

GAO 1992
Gao Hanyu. *Chinese Textile Designs*. Rosemary Scott and Susan Whitfield,
trans. London 1992.

GAO 1995
Gao Hanyu. "Technical and Artistic Development of Chinese Patterned
Silk" in Hall et al., *Heaven's Embroidered Cloths: One Thousand Years
of Chinese Textiles*, Don J. Cohn, trans. Hong Kong: 1995, pp. 44-49.

GARRETT 1987
Valery M. Garrett. *Traditional Chinese Clothing in Hong Kong and
South China, 1840-1980*. Hong Kong 1987.

GARRETT 1990
Valery M. Garrett. *Mandarin Squares: Mandarins and their Insignia*.
Hong Kong 1990.

GARRETT 1994
Valery M. Garrett. *Chinese Clothing: An Illustrated Guide*.
Hong Kong 1994.

GARRETT 1997
Valery M. Garrett. A *Collector's Guide to Chinese Dress Accessories*.
Singapore 1997.

GARRETT 1998
Valery M. Garrett. *Chinese Dragon Robes*. Hong Kong 1998.

GEIJER 1951
Agnes Geijer. *Oriental Textiles in Sweden*. Copenhagen 1951.

GEIJER 1979
Agnes Geijer. A *History of Textile Art*. London 1979.

GLUCKMAN 1995
Dale Carolyn Gluckman. "Chinese Textiles and the Tibetan Connection,"
in Hall et al., *Heaven's Embroidered Cloths: One Thousand Years of
Chinese Textiles*. Hong Kong 1995, pp. 24-25.

GLUCKMAN 2000
Dale Carolyn Gluckman. "For Merit and Meditation: Selected Buddhist
Textiles in the Los Angeles County Museum of Art." *Orientations* 31,
no. 6 (June 2000), pp. 90-98.

GORDON 1959
Antoinette K. Gordon. *The Iconography of Tibetan Lamaism*. Rutland,
Vermont 1959.

HAKU 1997
Insei Haku et al. *Shikinjo no kohi kyutei-geijutsu: Pekin kokyu
hakubutsuin-ten* (Empresses and their Court Art in the Forbidden City:
from the collection of the Palace Museum, Beijing). Tokyo 1997.

HALL 1995
Chris Hall et al. *Heaven's Embroidered Cloths: One Thousand Years
of Chinese Textiles*. Hong Kong 1995.

HALL 1999
Chris Hall. "Chinese or Korean? The Palazzo Corsini Rank Badges."
Hali 104 (May-June 1999), pp. 66-68.

HAN 1991
Han Wei. "Famensi digong tang dai suizhen yiwu changkao (Tang
dynasty relics from the Famen temple)." *Wenwu* 5 (1991), pp. 27-37.

HANSEN 1993
Henny Harald Hansen. *Mongol Costume*. 1950. Reprint, Copenhagen 1993.

HAYS 1989
Mary V. Hays. "Chinese Skirts of the Qing Dynasty." *Bulletin of the
Needle and Bobbin Club* 72, no. 1/2 (1989), pp. 5-41.

HEILONGJIANG PROVINCIAL INSTITUTE 1989
Heilongjiang Provincial Institute of Cultural Relics and Archaeology.
"Heilongjiang Acheng Juyuan Jindai Qiguo wangmu fajue jianbao"
(Brief report on the excavation of the tombs of Prince Qi of the Jin dynasty
at Juyuan in Acheng, Heilongjiang province). *Wenwu* 10 (1989), pp. 1-10,
45 and pls. 1-4.

HEISSIG 1980
Walther Heissig. *The Religions of Mongolia*. G. Samuel, trans. Berkeley
and Los Angeles 1980.

HEVIA 1993
James Hevia. "Lamas, Emperors and Rituals: Political Implications in Qing
Imperial Ceremonies." *Buddhist Studies* 16, no. 2 (Winter 1993), pp. 243-278.

HONOUR 1962
Hugh Honour. *Chinoiserie: The Vision of Cathay*. New York 1962.

HUANG 1985
Huang Nengfu, ed. *Yin ran zhi xiu shang* (Printing, Dyeing, Weaving
and Embroidery, Part 1) and *Yin ran zhi xiu xia* (Printing, Dyeing, Weaving
and Embroidery, Part 2), in *Zhongguo meishu quanji: Gongyi meishu bian*
(The Great Treasury of Chinese Fine Arts: Arts and Crafts), vol. 6 and 7.
Beijing 1985.

HUANG 1995
Huang Nengfu. *Zhongguo fuzhang shi* (A History of Chinese Costume).
Beijing 1995.

HUANG 1997
Huang Nengfu. "The Emperor's Clothes," in Claire Roberts, ed., *Evolution & Revolution: Chinese Dress 1700s-1990s.* Sydney 1997, pp. 26-39.

HUANG AND CHEN 1994
Huang Nengfu and Chen Juanjuan. *Zhongguo fushi yishu yuanliu* (Origins of the Art of Chinese National Costume). Beijing 1994.

HUANGCHAO 1759
Huangchao liqi tushi (Illustrated Precedents for the Ritual Paraphernalia of the [Qing] Imperial Court). 18 vols. Chinese government publication. Beijing 1759, 1761.

HUGHES 1945
Lindsay Hughes. *The Kuo Ch'in Wang Textiles.* New York 1945.

HUNAN PROVINCIAL MUSEUM 1980
Hunan Provincial Museum. *Changsha Mawangdui yi hao Han mu chutu fangzhi pindi yangjin* (A study of the textile fabrics from Han Tomb Number One at Mawangdui, Changsha). Beijing 1980.

INNER MONGOLIA INSTITUTE 1987
Inner Mongolia Institute of Cultural Relics and Archaeology. "Liao Chenguo gongzhu fuma hezang mu fajue jianbao" (Excavation of the tomb of the princess and her husband of the Liao state of Chen). *Wenwu* 11 (1987), pp. 4-28.

INNER MONGOLIA INSTITUTE 1993
Inner Mongolia Institute of Cultural Relics and Archaeology and Zhelimu League Museum. *Liao Chenguo gongzhu mu* (Tomb of the princess of the state of Chen). Beijing 1993.

INTERNATIONAL EXHIBITIONS FOUNDATION 1981
International Exhibitions Foundation. *Portugal and the East through embroidery: 16th to 18th century coverlets from the Museu Nacional de Arte Antiga, Lisbon.* Washington, DC 1981.

IRWIN AND BRETT 1970
John Irwin and Katharine B. Brett. *The Origins of Chintz.* London 1970.

JACKSON AND HUGUS 1999
Beverley Jackson and David Hugus. *Ladder to the Clouds: Intrigue and Tradition in Chinese Rank.* Berkeley 1999.

JACOBSEN 1991
Robert D. Jacobsen. *Imperial Silks of the Qing Dynasty.* Minneapolis 1991.

JACOBSEN 2000
Robert D. Jacobsen. *Imperial Silks: Ch'ing Dynasty Textiles in the Minneapolis Institute of Arts,* 2 vols. Minneapolis 2000.

JIN 1980
Jin Fengyi. "Liaoning Zhaoyang Qianchuanghu cun Liao mu" (The Liao dynasty tomb at Qianchuanghu village in Zhaoyang County, Liaoning Province). *Wenwu* 12 (1980), pp. 17-29.

JINSHI 1975
Jinshi (History of the Jin dynasty). Chinese government publication. Beijing 1975.

KAHLENBERG 1998
Mary Hunt Kahlenberg ed. *The Extraordinary in the Ordinary: Textiles and Objects from the collections of Lloyd Cotsen and the Neutrogena Corporation.* New York 1998.

KAHN 1971
Harold L. Kahn. *Monarchy in the Emperor's Eyes: Image and Reality in the Ch'ien-lung Reign.* Cambridge 1971.

KAJITANI 1992
Kajitani Nobuko. *Gion matsuri yamaku kenshoin chosa hokokusho* (Report on the imported textiles used in the Gion Festival). Kyoto 1992.

KAWAKAMI 1998
Shigeki Kawakami. "On the Costumes of Crowns of Government Officials of the Ming Dynasty, related to the Appointment of Toyotomi Hideyoshi as King of Japan-Costumes kept in the Myoho-in Temple." *Gakuso* (March 1998), pp. 75-98.

KEAY 1991
John Keay. *The Honorable Company: a history of the English East India Company.* London 1991.

KENNEDY 1983
Alan Kennedy. "Kesa: its sacred and secular aspects." *The Textile Museum Journal* 22 (1983), pp. 67-80.

KENNEDY 1991
Alan Kennedy et al. *Manteau de nuages: kesa japonais XVIIIe-XIXe siècles.* Paris 1991.

KENNEDY AND MAITLAND 1989
Alan Kennedy and Lucy Maitland. "Notes on the Use of Flat Metallic Strips in Central and East Asian Textiles." *The Bulletin of the Needle and Bobbin Club* 72, no. 1/2 (1989), pp. 42-54.

KERR 1991
Rose Kerr ed. *Chinese Art and Design.* London 1991.

KO 1994
Dorothy Ko. *Teachers of the Inner Chambers: Women and Culture in Seventeenth-Century China.* Stanford 1994.

KRAHL 1989
Regina Krahl. "Designs on Early Chinese Textiles." *Orientations* 20, no. 8 (August 1989), pp. 62-73.

KRAHL 1995
Regina Krahl. "Early Bronze Age Dress." *Orientations* 26, no. 5 (May 1995), pp. 58-61.

KRAHL 1997
Regina Krahl. "Medieval Silks Woven in Gold: Khitan, Jurchen, Tangut, Chinese or Mongol?" *Orientations* 28, no. 4 (April 1997), pp. 41-51.

KUHN 1977
Dieter Kuhn. "Die Webstühle des Tzu-jen I-chih aus der Yüan-Zeit" (The Loom of Tzu-jen I-chih of the Yuan dynasty). *Sinologica Coloniensia* 5 (1977).

KUHN 1982
Dieter Kuhn. "The silk-workshops of the Shang dynasty (16th-11th Century BC)," in Li Guohao, Zhang Mengwen and Cao Tianqin, eds., *Explorations in the History of Science and Technology in China: In honor of Dr. Joseph Needham, FRS, FBA.* Shanghai 1982, pp. 367-408.

KUHN 1988
Dieter Kuhn. "Textile Technology: Spinning and Reeling," in Joseph Needham, *Science and Civilization in China* 5, pt IX. Cambridge 1988, pp. 61-155.

KUHN 1997
Dieter Kuhn. *Le Vêtement sous la dynastie des Qing: La Cité interdite, vie publique et privée des empereurs de Chine 1644-1911.* Paris 1997.

KYOTO 1983
Kyoto National Museum. *Zen no bijutsui* (Art of Zen Buddhism). Kyoto 1983.

LAMOTTE 1984
Étienne Lamotte. "Buddhism in Ancient India" in Heinz Bechert and Richard Gombrich, eds., *The World of Buddhism: Buddhist Monks and Nuns in Society and Culture.* New York 1984.

LATTIMORE 1962
Owen Lattimore. *Inner Asian Frontiers of China.* Boston 1962.

LAUMANN 1984
Maryta Laumann. *The Secret of Excellence in Ancient Chinese Silks.* Taipei 1984.

LEAVITT 1968
Ernest E. Leavitt Jr. *The Silkworm and the Dragon.* Tucson 1968.

LEE 1984
Jean Gordon Lee. *Philadelphians and the China Trade 1784-1844.* Philadelphia 1984.

LEE 1995
Rose Lee. "Chinese Textiles Related to Tibetan Buddhism in the Hong Kong Museum of Art." *Arts of Asia* 25, no. 4 (July-August 1995), pp. 70-79.

LEE-WHITMAN AND SKELTON 1983
Leanna Lee-Whitman and Maruta Skelton. "Where Did All of the Silver Go? Identifying Chinese Painted and Printed Silk." *Textile Museum Journal* 22 (1983), pp. 33-52.

LEITE 1994
Fernanda Passos Leite. "Textiles" in *Ricardo do Espirito Santo Silva Foundation.* Lisbon 1994, pp. 116-137.

LEVINSON 1983
Susan B. Levinson. "Discovering an Important Mongol Silk Textile." *Hali* 5, no. 4 (1983), pp. 496-497.

LI 1979
Li Yiyou. "Tan Yuan Jininglu yizhi chutu de sizhiwu" (On the Silk Textiles Excavated at the Yuan period Jininglu site). *Wenwu* 8 (1979), pp. 37-39.

LI 1996
Li Yinghua. "Cong Jiangsu Taizhou chutu wenwu gan Mingtai fushi" (Ming dynasty costume in light of relics excavated from Taizhou, Jiangsu province). *Collector Magazine* 13 (1996), pp. 28-31.

LIANG 1992
Ellen Johnston Liang. "The Development of Flower Depiction and the Origin of Bird-and-Flower Genre in Chinese Art." *Museum of Far Eastern Antiquities Bulletin* 64 (1992), pp. 179-223.

LIANG 1994
Ellen Johnston Liang. "A Survey of Liao Dynasty Bird-and-Flower Painting." *Bulletin of Sung-Yuan Studies* 24 (1994), pp. 57-99.

LIAONING 1975
Liaoning Provincial Museum Archaeological Team. "Faku Yemaotai Liaomu jilue (Excavation of the Liao dynasty tomb at Yemaotai in Faku County, Liaoning Province)." *Wenwu* 12 (1975), pp. 26-36.

LIAOSHI 1974
Liaoshi (History of the Liao dynasty). Beijing 1974.

LIJI 1964
Liji (Book of Rites) in James Legge, trans., *Li Chi,* 2 vols. Oxford 1861. Reprint, Chai Ch'u and Chai Winberg, eds., New Hyde Park 1964.

LIN 1995
Lin Shuxin. *Yi jin xing: Zhongguo fu shi xiang guan zhi yan jiu* (The History of Chinese Textiles, Costumes and Accessories). Taipei 1995.

LIU 1941
Liu Dajun. *The Silk Industry of China.* Shanghai 1941.

LIU 1982
Liu Yuquan. "Dunhuang Mogao ku, Anxi Yulin ku Xixia dongku fenqi" (On dating the Xixia or Mogao, Dunhuang, and Yulin caves, Anxi) in *Dunhuang yanjin* (Essays in Dunhuang Studies) Lanzhou 1982, pp. 273-318.

LIU 1995
Liu Xinru. "Silks and Religions in Eurasia ca. AD 600-1200." *Journal of World History* 6 no. 1 (1995), pp. 25-48.

LU 1987
Buwei Lu. "Ying-t'ung P'ien." In *Lu shih Ch'un-ch'iu* (Master Lu's spring and autumn), vol. 13. Reprint, Taipei 1987.

LU AND LI 1989
Lu Chuangen and Li Wenzhao, eds. *Zhong-guo mei shu quan ji* (The Great Treasury of Chinese Fine Arts), vols. 6 and 7. Shanghai 1989.

LUBO-LESNICHENCKO 1961
Evgeny I. Lubo-Lesnichencko. *Drevniye Kitaiskiye shelkoviye tkani I vyshivki V v. do n.e. - III v n.e. v. sobranii Gosudarstvennom Ermitazha* (Ancient Chinese silk textiles and embroideries, fifth century BC to third century AD in the Collection of the State Hermitage Museum). Leningrad 1961.

LUBO-LESNICHENCKO 1995
Evgeny I. Lubo-Lesnichencko. "Concerning the Chronology and Ornamentation of Han Period Textiles." *Orientations* 26, no. 5 (May 1995), pp. 62-69.

MA 1995
Qiang Ma et al. *Chung-kuo his chu fu chuang tu chi* (Pictorial Album of Costumes in Chinese Traditional Opera). Taiyuan 1995.

MAILEY 1963
Jean E. Mailey. "Ancestors and Tomb Robes." *The Metropolitan Museum of Art Bulletin* 23, no. 3 (November 1963), pp. 101-115.

MAILEY 1971
Jean E. Mailey. *Chinese Silk Tapestry: K'o-ssu, from Private and Museum Collections.* New York 1971.

MAILEY 1978
Jean E. Mailey. *Embroidery of Imperial China.* New York 1978.

MAILEY 1980
Jean E. Mailey. *The Manchu Dragon: Costumes of the Ch'ing Dynasty 1644-1912.* New York 1980.

MATSUMOTO 1984
Kaneo Matsumoto. *Jodai Gire* (7th and 8th century Textiles in Japan from the Shoso-in and Horyu-ji). Kyoto 1984.

MATSUMOTO 1991
Kaneo Matsumoto. "Shoso-in no nishiki" (Patterned silks at the Shoso-in). *Nihon no Bijutsu* 293 (1991).

MCGUINNESS AND OGASAWARA 1988
Stephen McGuinness and Ogasawara Sae. *Chinese Textile Masterpieces: Sung, Yuan, and Ming Dynasties.* Hong Kong 1988.

MEDLEY 1982
Margaret Medley. *The Illustrated Regulations for Ceremonial Paraphernalia of the Ch'ing Dynasty.* London 1982.

MENCIUS 1970
Mencius. *Menzu* (Discourses of Mencius) in James Legge, trans., *The Chinese Classics II: The Works of Mencius,* Oxford 1893-95. Reprint, New York 1970.

MILHAUPT 1992
Terry Milhaupt. "The Chinese Textile Collection at the Metropolitan Museum of Art." *Orientations* 23, no. 1 (January: 1992), pp. 72-78.

MINGSHI 1974
Mingshi (History of the Ming dynasty). 1739. Beijing 1974.

MINNICH 1970
Helen Benton Minnich. *Chinese Imperial Robes at the Minneapolis Institute of Arts.* Minneapolis 1970.

MO 1986
Mo Zhuang. "Report from China: Pearl Robe Discovered in Tomb." *Oriental Art* n.s. 31, no. 4 (Winter 1985-86), pp. 452-453.

MOORE 1995
Oliver Moore. "Arms and Armour in Late Imperial China." *Apollo* 140, no. 396 (1995), pp. 16-19.

MOTE 1999
Fredrick W. Mote. *Imperial China 900-1800.* Cambridge 1999.

MYERS 1989
Myrna Myers. "Silk Furnishings of the Ming and Qing Dynasties," in Krishna Riboud, ed., *In Quest of Themes and Skills-Asian Textiles.* Bombay 1989, pp. 126-140.

MYERS 1996
Myrna Myers et al. *Soieries bouddhiques chinoises, XIVe - XVIIIe siècle / Chinese Buddhist Silks 14th-18th century.* Paris 1996.

NANJING MUNICIPAL MUSEUM 2000
Nanjing Municipal Museum. "Mingchao shoushi guanfu" (Jewelry and Costumes of the Ming dynasty), in *Zhongguo Nanjingshi Bowuguan Cang Wenwu Jingpin Xilie Tul.* Beijing 2000.

NATIONAL MUSEUM OF HISTORY 1977
National Museum of History, Republic of China. *Chinese Costume, Brocade, Embroidery.* Taipei 1977.

NATIONAL PALACE MUSEUM 1981
National Palace Museum. *Guoli Gugong bowuyuan kesi zixiu* (Masterpieces of Chinese Silk Tapestry and Embroidery in the National Palace Museum). Taipei 1981.

NICKEL 1991
Helmet Nickel. "The Dragon and the Pearl." *The Metropolitan Museum Journal* 26 (1991), pp. 139-146.

NUNOME 1973
Junro Nunome. "Sen-shin gidai no kinu-seni oyobi sonota seni ni tsuite" (Studies in Silk Fibres and Other Fibres of the pre-Chin period). *Study Report* 7, no. 1 Kyoto 1973, pp. 74-95.

OGASAWARA 1989
Ogasawara Sae. "Chinese fabrics of the Song and Yuan dynasties preserved in Japan." *Orientations* 20, no. 8 (August 1989), pp. 32-44.

OXNAM 1975
Robert B. Oxnam. *Ruling from Horseback.* Chicago 1975.

PAL 1990
Pratapaditya Pal. *Art of Tibet: A Catalogue of the Los Angeles County Museum of Art Collection.* Los Angeles 1990.

PAL 1994
Pratapaditya Pal. "An Early Ming Embroidered Masterpiece." *Christie's Magazine* (May 1994), pp. 62-63.

PALACE MUSEUM 1983
Palace Museum, Beijing. *Zijincheng dihou shenghou* (Life of the Emperors and Empresses in the Forbidden City). Beijing 1983.

PAN AND YI 1979
Pan Xingrong and Yi Zao. "Yuan Jininglu gucheng chutu de jiaocang sizhiwu ji qita" (The hoard of ancient silk fabrics uncovered at the ancient Yuan city Jininglu and other matters). *Wenwu* 8 (1979), pp. 32-35.

PANG 1989
Anna Mae Pang, ed. *Dragon Emperor: Treasures from the Forbidden City.* Melbourne 1989.

PENG 1982
Peng Hao. "Jiangling Mashan yihao mu suojen zangsu lueshu" (Silk Textile Finds from Tomb 1 at Mashan, Jiangling). *Wenwu* 10 (1982), p. 12.

PENG 1985
Peng Hao. "Jiangling Mashan yihao mu chutu de liangzhong tao dai" (Two Types of Silk Bands unearthed from Tomb 1 at Mashan, Jiangling). *Kaogu* 1 (1985), pp. 88-95.

PRIEST 1943a
Alan Priest. "Prepare for Emperors." *The Metropolitan Museum of Art Bulletin* (Summer) 1943.

PRIEST 1943b
Alan Priest. *Catalogue of an exhibition of imperial robes and textiles for the Chinese court.* Minneapolis 1943.

PRIEST 1945
Alan Priest. *Costumes from the Forbidden City.* New York 1945.

QIDAN GUO ZHI 1983
Qidan guo zhi (History of the Qidan). Probably completed in 1271. Taipei 1983.

RAWSKI 1998
Evelyn S. Rawski. *The Last Emperors: A Social History of Qing Imperial Institutions.* Berkeley 1998.

RAWSON 1984
Jessica Rawson. *Chinese Ornament: The Lotus and the Dragon.* London 1984.

REYNOLDS 1978
Valrae Reynolds. *Tibet: A Lost World.* New York 1978.

REYNOLDS 1981
Valrae Reynolds. "From a Lost World: Tibetan Costumes and Textiles." *Orientations* 12, no. 3 (March 1981), pp. 6-22.

REYNOLDS 1990
Valrae Reynolds. "Myriad of Buddhas: a group of mysterious textiles from Tibet." *Orientations* 21, no. 4 (April 1990), pp. 39-50.

REYNOLDS 1995a
Valrae Reynolds. "Silk in Tibet," in Jil Tilden, ed., *Asian Art: The Second Hali Annual* London 1995, pp. 86-97.

REYNOLDS 1995b
Valrae Reynolds. "The Silk Road: From China to Tibet – and Back." *Orientations* 26, no. 5 (May 1995), pp. 50-57.

REYNOLDS 1995c
Valrae Reynolds. "'Thousand Budddhas' Capes and Their Mysterious Role in Sino-Tibetan Trade and Liturgy," in Hall et al., *Heaven's Embroidered Cloths: One Thousand Years of Chinese Textiles.* Hong Kong 1995, pp. 32-37.

REYNOLDS 1997
Valrae Reynolds. "Buddhist Silk Textiles: Evidence for Patronage and Ritual Practice in China and Tibet." *Orientations* 28, no. 4 (April 1997), pp. 52-63.

REYNOLDS 1999
Valrae Reynolds. *From the Sacred Realm: Treasures of Tibetan Art from The Newark Museum.* Munich 1999.

RHIE AND THURMAN 1996
Marilyn M. Rhie. and Robert A. F. Thurman. *Wisdom and Compassion: The Sacred Art of Tibet.* New York 1996.

RIBOUD 1976
Krishna Riboud. "A Newly Excavated Caftan from the northern Caucasus." *Textile Museum Journal* IV, no. 3 (1976), pp. 44-54.

RIBOUD 1977
Krishna Riboud. "A Closer view of early Chinese silks," in Veronika Gervers, ed., *Studies in Textile History in memory of Harold B. Burnham.* Toronto 1977, pp. 252-280.

RIBOUD 1979
Krishna Riboud. "Quelques problèmes techniques concernant une célèbre soierie façonnée polychrome Han (Lou-lan)." *Bulletin du Centre International d'Etudes des Textiles Anciens* 49 (1979), pp. 27-34.

RIBOUD 1983
Krishna Riboud. "Han Dynasty specimens from Noin-Ula and Mawangdui in looped-warp weave." *Bulletin du Centre International d'Etudes des Textiles Anciens* 57/58, no. 1/2 (1983), pp. 6-38.

RIBOUD 1995
Krishna Riboud. "A Cultural Continuum: A New Group of Liao and Jin Dynasty Silks." *Hali* 82 (August-September 1995), pp. 92-105 and 119-120.

RIBOUD AND VIAL 1970
Krishna Riboud and Gabriel Vial. *Tissus de Touen-Houang conservés au Musée Guimet et à la Bibliothèque nationale.* Paris 1970.

ROSSABI 1975
Morris Rossabi. *China and Inner Asia.* New York 1975.

ROSSABI 1983
Morris Rossabi, ed. *China among Equals: The Middle Kingdom and its Neighbors, 10th-14th Centuries.* Berkeley 1983.

SCHAFFER 1963
Edward Schaffer. *The Golden Peaches of Samarkand.* Berkeley 1963.

SCOTT 1958
A. C. Scott. *Chinese Costumes in Transition.* Singapore 1958.

SHEN 1992
Shen Congwen. *Zhongguo gudai fushi yanjiu* (Examination of Ancient Chinese Costume). Xianggang 1992.

SHENG 1995
Angela Sheng. "Chinese Silk Tapestry: A Brief Social Historical Perspective of Its Early Development." *Orientations* 26, no. 5 (May 1995), pp. 70-75.

SHEPHERD 1981
Dorothy G. Shepherd. "Zandaniji Revisited," in Mechtihild Flury-Lemberg and Karen Strolleis, eds., *Documenta Textilia.* Munich 1981, pp. 105-122.

SHEPHERD AND HENNINGS 1959
Dorothy G. Shepherd and W. B. Hennings. "Zandaniji Identified?" in Richard Ettinghausen, ed., *Aus der islamischen Kunst.* Berlin 1959, pp. 15-40.

SHIBA 1970
Yoshinobu Shiba. *Commerce and Society in Sung China.* Mark Elvin, trans. Ann Arbor 1970.

SHIH 1976
Shih Min-hsiung. *The Silk Industry in Ch'ing China.* Michigan Abstracts of Chinese and Japanese Works on Chinese History, no. 5. E-tu Zen Sun, trans. Ann Arbor 1976.

SHUJING 1971
Shujing (Book of History) in James Legge, trans., *The Chinese Classics* III, IV (London 1865). Reprint, Chicago 1971.

SIMCOX 1989
Jacqueline Simcox. "Early Chinese Textiles: Silks from the Middle Kingdom." *Hali* 11.1 (February 1989), pp. 6-42.

SIMCOX 1994a
Jacqueline Simcox. "Tracing the Dragon: the Stylistic Development of Designs in Early Chinese Textiles," in Alan Marcuson, ed., *Carpet and Textile Arts: the first Hali annual.* London 1994, pp. 34-47.

SIMCOX 1994b
Jacqueline Simcox. *Chinese Textiles.* London 1994.

SIMMONS 1948
Pauline Simmons. *Chinese Patterned Silks.* New York 1948.

SIMMONS 1950
Pauline Simmons. "Crosscurrents in Chinese Silk History." *The Metropolitan Museum of Art Bulletin,* n.s. 9 (November 1950), pp. 87-96.

SNELLGROVE AND RICHARDSON 1968
David L. Snellgrove and Hugh Richardson. *A Cultural History of Tibet.* New York 1968.

SONDAY AND MAITLAND 1989
Milton Sonday and Lucy Maitland. "Technique: Detached Looping." *Orientations* 20, no. 8 (August 1989), pp. 54-61.

SONGSHI 1977
Songshi (History of the Song Dynasty). 1345. Beijing 1977.

SPENCE 1975
Jonathan D. Spence. *Emperor of China: Self Portrait of Kang-hsi.* New York 1975.

STANDEN 1954
Edith Appleton Standen. "Embroideries in the French and Chinese Taste." *The Metropolitan Museum of Art Bulletin* n.s. 13, no. 4 (December 1954), pp. 24-32.

STEIN 1912
Sir Marc Aurel Stein. *Ruins of Desert Cathay: Personal Narrative of Explorations in Central Asia and Westernmost China.* London 1912.

STEVENS 1998
Harm Stevens. *Dutch Enterprise and the VOC, 1602-1799.* Zutphen 1998.

STEVENS 1997
Keith Stevens. *Chinese Gods, the unseen world of spirits and demons.* London 1997.

STUART AND RAWSKI 2001
Jan Stuart and Evelyn I. Rawski. *Worshiping the Ancestors: Chinese Commemorative Portraits.* Washington DC and Stanford 2001.

SYLWAN 1937
Vivi Sylwan. "Silk from the Yin Dynasty." *Bulletin of the Museum of Far Eastern Art* 9 (1937), pp. 119-126.

TANG HUIYAO 1968
Tang huiyao (Records of Tang Institutions). Wuying Dian edition. Reprint, Taipei 1968.

TER MOLEN AND UITZINGER 1990
J. R. Ter Molen and Ellen Uitzinger, eds. *De Verboden Stad / The Forbidden City.* Rotterdam 1990.

TILKE 1957
Wolfgang Bruhn Max Tilke. *Costume Patterns and Designs: A Survey of Costume of All Periods and Nations from Antiquity to Modern Times Including National Costume in Europe and Non-European Countries.* New York 1957.

TOZER 1999
Antonia Tozer. *Threads of Imagination: Central Asian and Chinese Silks from the 12th to the 19th Century.* London 1999.

TUCCI 1980
Guiseppi Tucci. *The Religions of Tibet.* G. Samuel, trans. Bombay 1980.

VAINKER 1996
Shelagh J. Vainker. "Silk of the Northern Song: Reconstructing the Evidence," in Jil Tilden, ed., *Silk and Stone: The Third Hali Annual.* London 1996, pp. 160-175 and 196-197.

VARLEY AND ISAO 1989
Paul Varley and Kumakura Isao, eds. *Tea in Japan: essays on the history of chanoyu.* Honolulu 1989.

VOLLMER 1974
John E. Vollmer. "Textile pseudomorphs on Chinese bronzes" in Patricia L. Fiske, ed., *Irene Emery Roundtable on Museum Textiles 1974 Proceedings, Archaeological Textiles.* Washington, DC 1974, pp. 170-174.

VOLLMER 1977a
John E. Vollmer. *In the Presence of the Dragon Throne: Ch'ing Dynasty Costume (1644-1911)*. Toronto 1977.

VOLLMER 1977b
John E. Vollmer. "Costume and Chinese Portraits." *Canadian Antiques Collector* 12, no. 3 (May-June 1977), pp. 26-29.

VOLLMER 1979
John E. Vollmer. "Sources for Manchu Costume of the Ch'ing Dynasty (1644-1911)." *Bulletin du Centre International d'Etudes des Textiles Anciens*, 47-48 (1979), pp. 47-61.

VOLLMER 1981
John E. Vollmer. *Five Colours of the Universe: Symbolism in Clothes and Fabrics of the Ch'ing Dynasty (1644-1911)*. Hong Kong 1981.

VOLLMER 1983
John E. Vollmer. *Decoding Dragons: Status Garments in Ch'ing Dynasty China*. Eugene, Oregon 1983.

VOLLMER 1986
John E. Vollmer. "China and the Complexities of Weaving Technology," *Ars Textrina* 5 (June 1986), pp. 65-89.

VOLLMER 1998
John E. Vollmer. "Power in the Inner Court of the Qing Dynasty: The Emperor's Clothes," in Chuimei Ho and Cheri A. Jones, eds., *Proceedings of the Denver Museum of Natural History* 3 no. 13 (Summer 1998), pp. 49-54.

VOLLMER 1999
John E. Vollmer. *Chinese Costume and Accessories 17th-20th century*. Paris 1999.

VOLLMER 2000a
John E. Vollmer. "Clothed to Rule the Universe: Ming and Qing Dynasty Textiles at the Art Institute of Chicago" in *Museum Studies* 26, no. 2 (2000), pp. 12-79 and 99-112.

VOLLMER 2000b
John E. Vollmer. *Celebrating Virtue: Prestige Costume and Fabrics of Late Imperial China*, a study guide for a traveling exhibition circulated by The Textile Museum of Canada in cooperation with The Glenbow Museum. Toronto 2000.

VOLLMER 2002
John E. Vollmer. *Ruling from the Dragon Throne: costume of the Qing dynasty 1644-1911*. Berkeley and Hong Kong 2002.

VOLLMER ET AL. 1983
John E. Vollmer, E. J. Keall and Evelyn Nagai-Berthrong. *Silk Roads, China Ships*. Toronto 1983.

VUILLEUMIER 1939
Bernard Vuilleumier. *The Art of Silk Weaving in China: Symbolism of Chinese Imperial Ritual Robes*. London 1939.

WAKEMAN 1975
Frederic Wakeman, Jr. *The Fall of Imperial China*. New York 1975.

WAKEMAN 1985
Frederic Wakeman, Jr. *The Great Enterprise: The Manchu Reconstruction of Imperial Order in Seventeenth-Century China*, 2 vols., Berkeley 1985.

WANG 1982
Wang Zhongshu. *Han Civilization*. New Haven 1982.

WANG 1994
Wang Zhimin. *Longpao* (Dragon robes). Taipei 1994.

WANG 1995
Wang Yarong. "Embroidery in Ancient Chinese Costume," in Hall et al., *Heaven's Embroidered Cloths: One Thousand Years of Chinese Textiles*, Don J. Cohn, trans. Hong Kong 1995, pp. 56-62.

WANG 2001
Wang Xu. "Several Key Problems in the History of Chinese Textiles," in Zhao Feng, ed., *Wang Xu and Textile Archaeology in China: My Education as a Textile Archaeologist*. Hong Kong 2001, pp. 145-156.

WARDWELL 1989
Anne E. Wardwell. "Recently discovered textiles woven in the western part of central Asia before AD 1220." *Textile History* 20, no. 2 (1989), pp. 175-184.

WATSON 1961
Burton Watson. *Records of the Grand Historians of China*, 2 vols. New York 1961.

WATT AND WARDWELL 1997
James C. Y. Watt and Anne E. Wardwell. *When Silk Was Gold: Central Asian and Chinese Textiles*. New York 1997.

WHITFIELD AND FARRER 1990
Roderick Whitfield and Anne Farrer. *Caves of the Thousand Buddhas: Chinese Art from the Silk Route*. London 1990.

WILD 1984
John-Peter Wild. "Some Early Silk Finds in Northwest Europe." *The Textile Museum Journal* 22 (1984), pp. 17-23.

WILD 1999
Anthony Wild. *The East India Company: trade and conquest from 1600*. London 1999.

WILLIAMS 1913
Edward T. Williams. "The State Religion of China During the Manchu Dynasty." *Journal of the North China Branch of the Royal Asiatic Society* 44 (1913), pp. 11-45.

WILLIAMS 1999
C. A. S. Williams. *Outlines of Chinese Symbolism and Art Motives*. Reprint, Edison, New Jersey 1999.

WILSON 1986
Verity Wilson. *Chinese Dress*, Far Eastern Series. London 1986.

WILSON 1995
Verity Wilson. "Cosmic Raiment: Daoist Traditions of Liturgical Clothing." *Orientations* 26, no. 5 (May 1995), pp. 42-49.

WILSON 1998
Verity Wilson. "Chinese Painted Silks for Export in the Victoria and Albert Museum." *Orientations*, 1987. Reprint in *Chinese and Central Asian Textiles, Selected articles from Orientations 1983-1997*. Hong Kong 1998, pp. 20-25.

WRIGGLESWORTH 1991a
Linda Wrigglesworth. *The Accessory: China*. London 1991.

WRIGGLESWORTH 1991b
Linda Wrigglesworth. *The Badge of Rank II: China*. London 1991.

WRIGGLESWORTH 1996
Linda Wrigglesworth. *Making the Grade: The Badge of Rank III*. London 1996.

WU 1995
Wu Hung. "Emperor's Masquerade—'Costume Portraits' of Yongzheng and Qianlong." *Orientations* 26, no. 7 (July-August 1995), pp. 25-41.

XIA 1972
Xia Nai. "Woguo gudai can sang si zhou de lishi" (The History of Silk Making, Mulberry Trees and Cocoons in Ancient China). *Kaogu* 4 (1972), pp. 12-27.

XIA AND CHAO 1992
Xia Hoxiu and Chao Feng. "Damaoqi fasi Jixiang Mingshui mudi judu desi qibin" (Ancient fabrics uncovered at the Ming shui tomb Dasi Jixiang. Damao banner). *Neimengku wenwu kaoku* (Inner Mongolian journal of archaeology and cultural relics) (1992), pp. 1-2.

YIJING 1999
Yijing (Book of Changes) in James Legge, trans. *Yi King*. London 1899. Reprint, New York 1999.

YU 1995
Yu Hui. "Naturalism in Qing Imperial Group Portraiture." *Orientations* 26, no. 7 (July-August 1995), pp. 42-50.

YU 1998
Yu Zhiyong. "Wuxing chu dong fang li Zhongguo" (Five Planets appear in the East) in *Niya yizhi chufu* (Excavations from the lost site of Niya). Shanghai 1998.

YUAN 1996
Yuan Hongqi et al. *Empress Dowager Cixi: Her Art of Living*. Beijing 1996.

YUANSHI 1976
Yuanshi (History of the Yuan dynasty). Beijing 1976.

ZHAO 1999
Zhao Feng. *Treasures in Silk: An Illustrated History of Chinese Textiles*. Hong Kong 1999.

ZHAO 2000
Zhao Feng. "The Chronological Development of Needleloop Embroidery." *Orientations* 31, no. 2 (February 2000), pp. 44-53.

ZHAO 2002
Zhao Feng, ed. *Recent Excavations of Textiles in China*. Hong Kong 2002.

ZHOU 1984
Zhou Xibao. *Zhougguo gudai fushi shi* (History of Chinese Costume and Accessories). Beijing 1984.

ZHOU AND GAO 1987
Zhou Xun and Gao Chunming. *5000 Years of Chinese Costume*. Hong Kong 1987.

ZHOULI 1975
Zhouli (Book of Rites of the Zhou). Edouard Biot, trans. *Le Tcheou-li ou rites des Tcheou*, 3 vols (Paris 1851). Reprint, Taipei 1975.

photographs by
Thierry Prat

drawings by
Richard Sheppard

graphic design by
Tauros / Christophe Ibach

printed by
Blanchard Printing
July 2003

published by
Myrna Myers